What we're doing has little to do with what is thought that we're doing...

JOHN M ARMLEDER

2003 LAC LÉMAN LL

Adia

rewind and fast forward show

JOHN M ARMLEDER
at any speed

EDITED BY MARGRIT BREHM

cantz

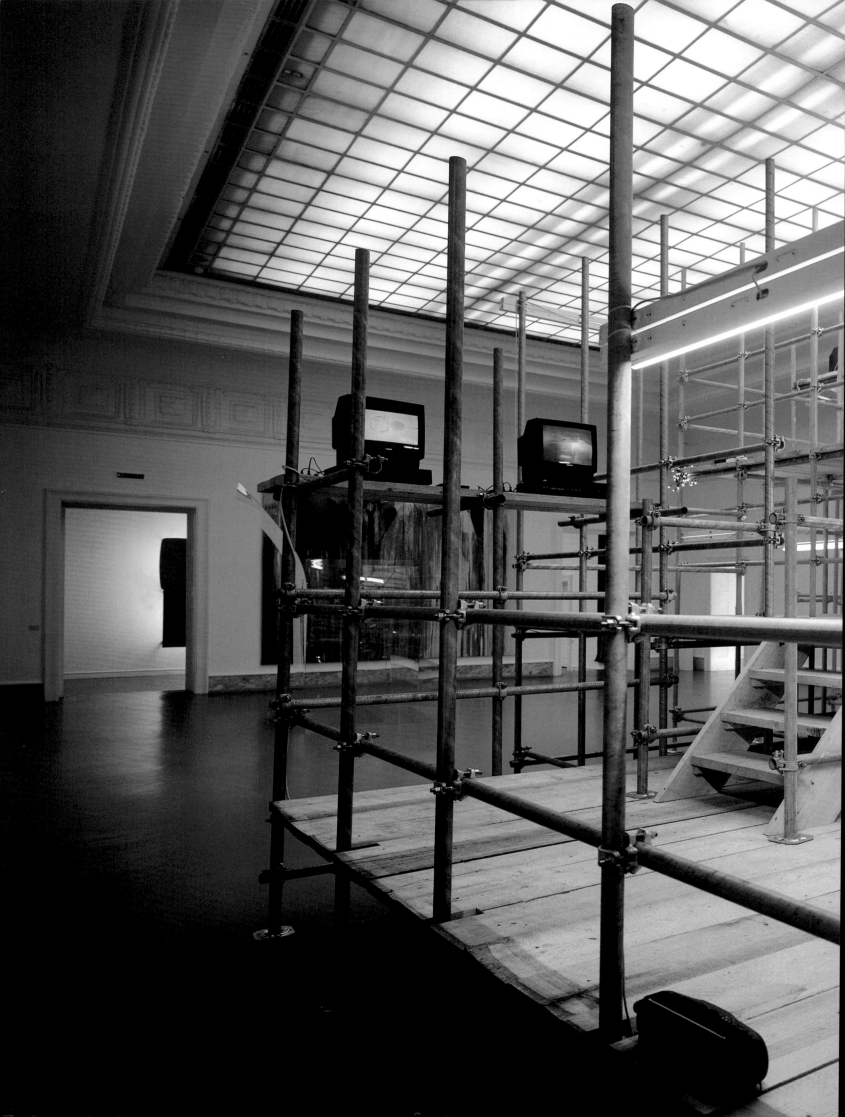

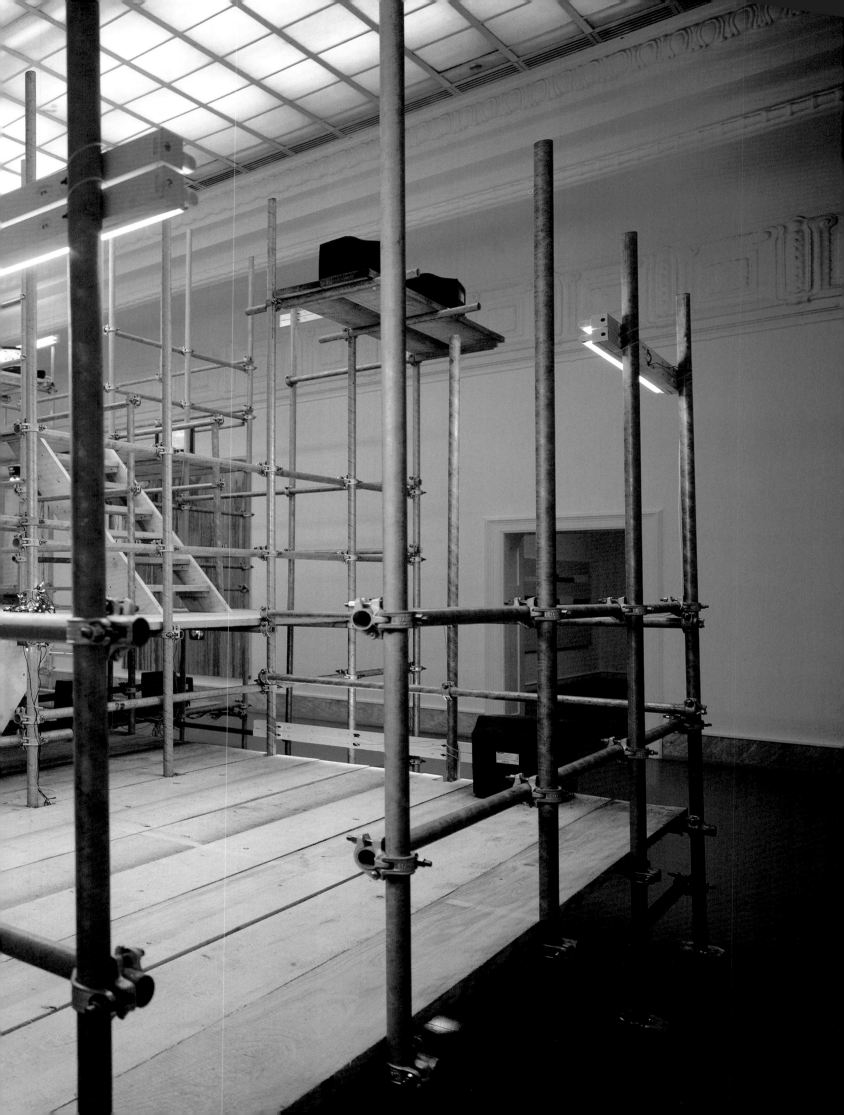

LEIHGEBER / LENDERS

Galerie Art & Public, Genf
Borealis Ausgleichsfond, Basel
Gallery Gilbert Brownstone, Paris
Cabinet des estampes du Musée
 d'art et d'histoire, Genf
Galerie Mehdi Chouakri, Berlin
Galleria Massimo De Carlo, Mailand
Collection De Lancestre, Paris
Collection Sylvie Fleury, Genf
Sammlung Goetz
Collection Pierre Huber, Genf
Galerie Susanna Kulli, St. Gallen, CH
Collection A. L' H., Genf
Sammlung Paul Maenz, Berlin
MAMCO, Genf
Galerie Vera Munro, Hamburg
Galerie Thaddaeus Ropac, Paris, Salzburg
Sammlung Beatrice und Wolfgang
 Schoppmann, Düsseldorf
Galerie Tanit, München
Galerie Daniel Varenne, Genf
Sammlung S. und H. Wickleder, Fellbach
Sammlung Peter Zehnder, Bad Ragaz, CH
Galerie Edition 20.21, Essen
Privatsammlung Bozen, Italien

Wir danken allen Leihgebern, die
diese Ausstellung ermöglicht haben.
We would like to thank all lenders,
who made this show possible.

INHALT / CONTENTS

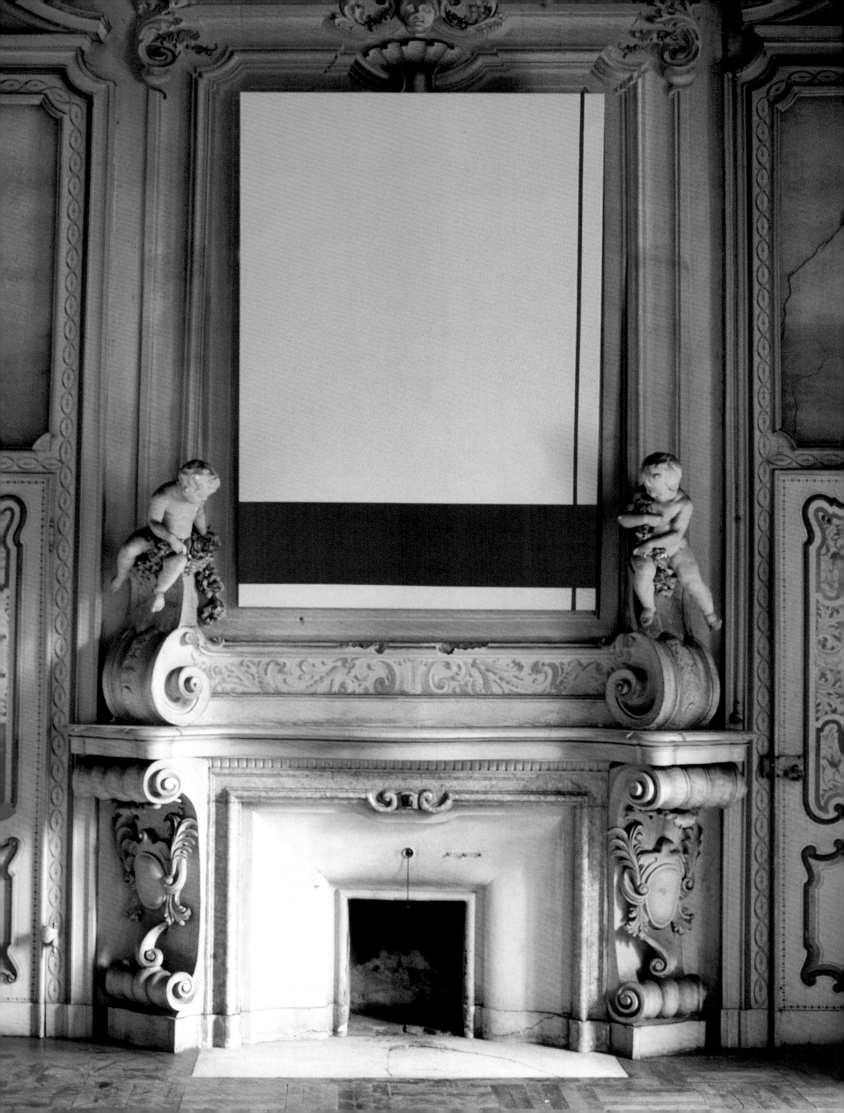

DRAUSSEN NUR KÄNNCHEN MARGRIT BREHM

Ob er ein Werk mache oder Tee trinke, – für ihn gäbe es da keinen Unterschied, sagte John Armleder in einem Künstlergespräch mit Bice Curiger in der Galerie Susanna Kulli in St. Gallen im Herbst 97. Beides geschehe auf der gleichen Kommunikationsebene, entscheidend sei, „Etwas zu tun", „Dinge zu machen", jetzt und hier.

Fast 20 Jahre liegen zwischen dieser Aussage und dem Auftritt John Armleders auf der Biennale in Paris im Jahre 1975, als der Künstler kein Werk zeigte, sondern – sozusagen als création permanente – Tee servierte. Heute reicht eine jüngere Künstlergeneration Speisen und Getränke. Das fasziniert John Armleder, denn es entspricht seiner Einschätzung, daß nicht nur die Künstlerin oder der Künstler, sondern auch die Zeit und der Ort als Faktoren Einfluß auf die Inhalte und ihre Rezeption nehmen. Sollte es je das Kunstwerk in stiller Einfalt und edler Größe gegeben haben, so widerlegt die Kunst unseres Jahrhunderts diese (übrigens nicht etwa von Künstlern erfundene) Idee nachhaltig. Gerade das „autonome Kunstwerk" gibt es nicht ohne einen Kontext. Für John Armleder ist die Kunst nicht zu trennen vom Mit-gedachten im Wieder-gefundenen ebenso wie im Neu-entdeckten. Als Produzent und Rezipient arbeitet er daran, diesen Wahrnehmungsprozeß zu beschleunigen. *at any speed* und mit ebensoviel Lässigkeit wie Engagement hat er sich in der paradoxen Situation eingerichtet, daß es ebenso unmöglich ist Nichts auszusagen, wie eine definitive Antwort zu formulieren. Das System funktioniert immer *rewind and fast forward*.

Seine Überzeugung, Kunst funktioniere im Prinzip wie alles andere auch, hat der nun fünfzigjährige Künstler seit mehr als 30 Jahren in ein vielgestaltiges und konsequentes Werk umgesetzt. Schon mit seinen frühen Kunstaktionen, Performances und der Gründung von Ecart in seiner Heimatstadt Genf, realisierte er Exempel für ein Spiel zwischen Kunst und Leben und ohne Grenzen. Die Forderung des Fluxuskünstlers Robert Filliou, man solle nicht versuchen Anschluß an eine Szene zu finden, die bereits existiere, sondern das Geschehen zu sich holen, neue Räume aufbauen und neue Oberflächen schaffen, war für diese Anfangszeit genauso wichtig wie der Wunsch mit anderen Künstlern zusammenzuarbeiten, Kunst zu machen, eigene und fremde Kunst zu zeigen. »Ich bin der festen Überzeugung, dass die Künstler selber eine wichtige Rolle spielen müssen, und sei es nur deswegen, dass das, worum es geht, auch in ihren Händen bleibt. Und endlich ist dies der letzte kritische Diskurs, der uns außerhalb unseres Werkes bleibt.« Die Bedeutung, die John Armleder der Kommunikation und der Kunst als Kommunikationsform beimißt, zeigt sich nicht nur in seinen Werken, die diesen Aspekt in unterschiedlichsten Facetten und durch die Verwendung disparater Materialien reflektieren, sondern auch in der immer wieder übernommenen Kuratorenrolle. Egal ob er auf der Art in Basel alljährlich mit seinem „Ecart-Stand" einen Kontrapunkt zum Kunstmarktgeschehen setzt, ob er Ausstellungen wie „Ne dites pas non!" im Mamco in Genf inszeniert oder ob er seine Studenten in Braunschweig dazu animiert, internationale Künstler einzuladen und mit Ihnen gemeinsam unter dem Titel „504" auszustellen, es kann kein Zweifel aufkommen: Dieser Mann, gerade er, den die Kritik immer wieder so gern als Häretiker bezeichnet, glaubt an die Kunst. Es ist ein Glaube an die Bedeutung des „Nicht-Nützlichen" im Bewußtsein seiner „Nicht-Nützlichkeit", und es ist die Freude an dem daraus resultierenden „Spiel-Raum".

Wenn John Armleder über seine Kunst spricht, spricht er über das Leben. Nicht sein persönliches Schicksal ist dabei das Thema, sondern seine Wahrnehmung des Alltags, in dem

wir alle leben. Nichts was in unser Bewußtsein wirklich eindringt ist ohne Bedeutung und Folgen. Die Präsenz der Bilder, die fortschreitende Vermischung zwischen Hoch- und Trivial-kultur, die zunehmende Unwirklichkeit des Realen, jedes Befremden manifestiert sich. John Armleder wäre nun aber nicht John Armleder, wenn er nicht durch das feine Spiel der Ironie stets eine entspannte Distanz bewahren würde. Der Inszenierung seiner Werke, dem Schaffen neuer Zuordnungen, entspricht die Setzung seiner Worte, der abrupte Sprung vom Kunst-werk zum Pudding und geradewegs von der Cassata zur Postmoderne. Es geht um Bilder. Und immer wieder geht es um Dinge, die uns zu Bildern geworden sind, im Leben und in der Kunst. Auch wir müssen Distanz wahren. Gesprochen wird indirekt, alle reden durcheinander, haben wir das Entscheidende wieder verpaßt? Noch einmal die *rewind*-Taste. Das Spiel kennt keine Regeln. »Cafeteria is a style«. Und mit einem Augenzwinkern: »Ich nehme die Kunst so ernst und so leicht wie mein Leben.« –

Diese Ausstellung und den hier vorgelegten Katalog zu realisieren, wäre ohne verläßliche Partner nicht möglich gewesen. Daß wir diese in der Firma "Holderbank" Management und Beratung AG fanden, ist ein doppelter Glücksfall. Thomas Schmidheiny, Präsident und Delegier-ter des Verwaltungsrates der "Holderbank" Financière Glaris AG, ermöglichte die Präsenta-tion der Ausstellung John Armleder *at any speed* in Holderbank und schuf eine sichere finanzielle Basis. Derrick Widmer, dem es seit Jahren dank seiner persönlichen Begeisterung und der Gabe diese zu vermitteln, gelingt, in den ehemaligen Werkhallen eines kunstfernen Ortes anspruchsvolle Projekte zeitgenössischer Künstler zu realisieren, bereitete den Weg für die Kooperation. Dafür ebenso wie für ihr Vertrauen in unsere Arbeit gilt ihnen unser herzlicher Dank. Daß wir der Präsentation der Ausstellung in Holderbank so guten Mutes ent-gegensehen, verdanken wir aber auch Heidi Häfeli, ohne deren Planungsgeschick und persön-lichen Einsatz die Übernahme dieser komplexen Inszenierung kaum denkbar gewesen wäre.

Dank der Bereitschaft zahlreicher privater Leihgeber, sich für diese Ausstellung von ihren häufig sehr fragilen Werken zu trennen, ist es möglich gewesen, die Idee der *rewind and fast forward show* umzusetzen und Werke aus allen Schaffensphasen des Künstlers zu präsentieren. Ihnen allen möchte ich an dieser Stelle ebenso danken, wie den Institutionen und Galerien, die außerordentlich kooperativ zum Zustandekommen dieser Ausstellung bei-getragen haben. Mein besonderer Dank gilt Rainer Michael Mason, der es uns ermöglichte, zahlreiche, in Deutschland nie zuvor gezeigte frühe Editionen und Multiples John Armleders aus dem Cabinet des estampes du Musée d'art et d'histoire in Genf nach Baden-Baden aus-zuleihen. Christian Bernard, Franck Gautherot, Xavier Douroux, Jacqueline Burckhardt und Bice Curiger danken wir für ihre kollegiale Unterstützung und ihr Interesse an diesem Projekt.

"Die Kontinuität im Diskontinuierlichen" umschreibt nicht nur einen Aspekt des Werks von John Armleder, sondern realisiert sich auch in seinem Umgang mit Menschen. Die Treue des Künstlers zu seinen Galerien, mit denen er seit Jahren, manchmal sogar Jahrzehnten zusammenarbeitet, hat den Weg zu vielen Leihgaben sehr erleichtert. Es ist mir deshalb ein persönliches Anliegen, Pierre Huber, Susanna Kulli, Vera Munro, Mehdi Chouakri, Gilbert Brownstone, Naila Kunigk und Walther Mollier an dieser Stelle zu danken. Sie haben ebenso zum Gelingen dieses Projekts beigetragen wie die Fondation Nestlé pour l'art Lausanne durch finanzielle Unterstützung, die Firma Layher Gerüste, der wir das Material für den "Tower" verdanken, und die Kunstspedition D'ART.

Für die Bereitschaft sich *at any speed* auf unsere Wünsche und Bitten einzulassen, danke ich Lionel Bovier, Christophe Cherix, Axel Heil, Giacinto Di Pietrantonio, deren Texte im Katalog das *rewind and fast forward* proben, ebenso wie Mary Fran Gilbert & Keith

Bartlett, Charles Penwarden, Hinrich Sachs und Fumiko Wellington, die in ihren Übersetzungen ein perfektes Timing beweisen. Die Gestaltung und den Rhythmus des Katalogs bestimmten Axel Heil – stets in between –, Torsten Schmitt, der eigentlich Salsa-Tänzer werden wollte, und Ilona Hirth als versierte Retterin der Daten und Nerven. Ihnen sei hier ebenso herzlich gedankt wie meinem bewährten Aufbauteam an der Staatlichen Kunsthalle Baden-Baden, das auch in Holderbank Hand anlegen wird.

Während der Vorbereitung dieser Ausstellung hatte ich das Glück John Armleder und Sylvie Fleury (thanks a lot!) zwischen Berlin und Genf in den unterschiedlichsten Ausstellungen, Restaurants, Cafés und natürlich immer wieder in der Villa Magica zu treffen. Bei jeder der Verabredungen, die stets gerade noch zwischen den zahlreichen anderen Verpflichtungen des Künstlers, Professors, Kurators und Weltreisenden Platz fanden, überraschte John mich damit, daß es ihm gelang auch im größten Gedränge, etwa bei Eröffnungen oder auf der Kunstmesse, Contenance zu bewahren. Und nicht nur das, ungeachtet herzlicher Begrüßungen hier und einem kurzen Wortwechsel da, schenkte er unserem Projekt seine „ungeteilte" Aufmerksamkeit, griff den Faden immer wieder genau an der Stelle auf, an der das Telefon zum x-ten Mal geklingelt hatte. In Casinos kann man manchmal Spieler beobachten, die gleichzeitig an vielen Tischen spielen. Sie setzen keineswegs willkürlich. Scheinbar einer eigenen Umlaufbahn folgend, bewegen sie sich mit großer Selbstverständlichkeit und ohne Hast zwischen den Orten des Geschehens und kommen doch immer gerade in dem Moment an, wenn es gilt, eine Entscheidung zu treffen, auch bei dem nächsten Spiel dabei zu sein. Fast scheint es, als ginge es gar nicht ums Gewinnen, sondern um die geistige Präsenz, die die Gleichzeitigkeit der Spiele fordert. Die Aufmerksamkeit für jedes Detail ist hier ebenso wichtig wie die souveräne Distanz, die es ermöglicht, sich in Anbetracht der Vielzahl der Möglichkeiten für die eine zu entscheiden, – und das in jedem Moment aufs Neue.

Diese Offenheit ist Ausgangspunkt und Ziel zugleich – sie schließt alles ein, wofür ich John Armleder danke: die wunderbare Zusammenarbeit während der Vorbereitung des Projekts, sein Engagement bei der Realisierung der Ausstellung in Baden-Baden, die Zeit, die immer für eine Tasse Tee bleibt...

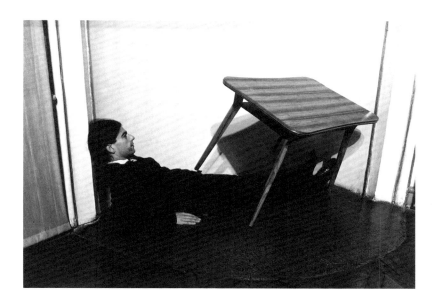

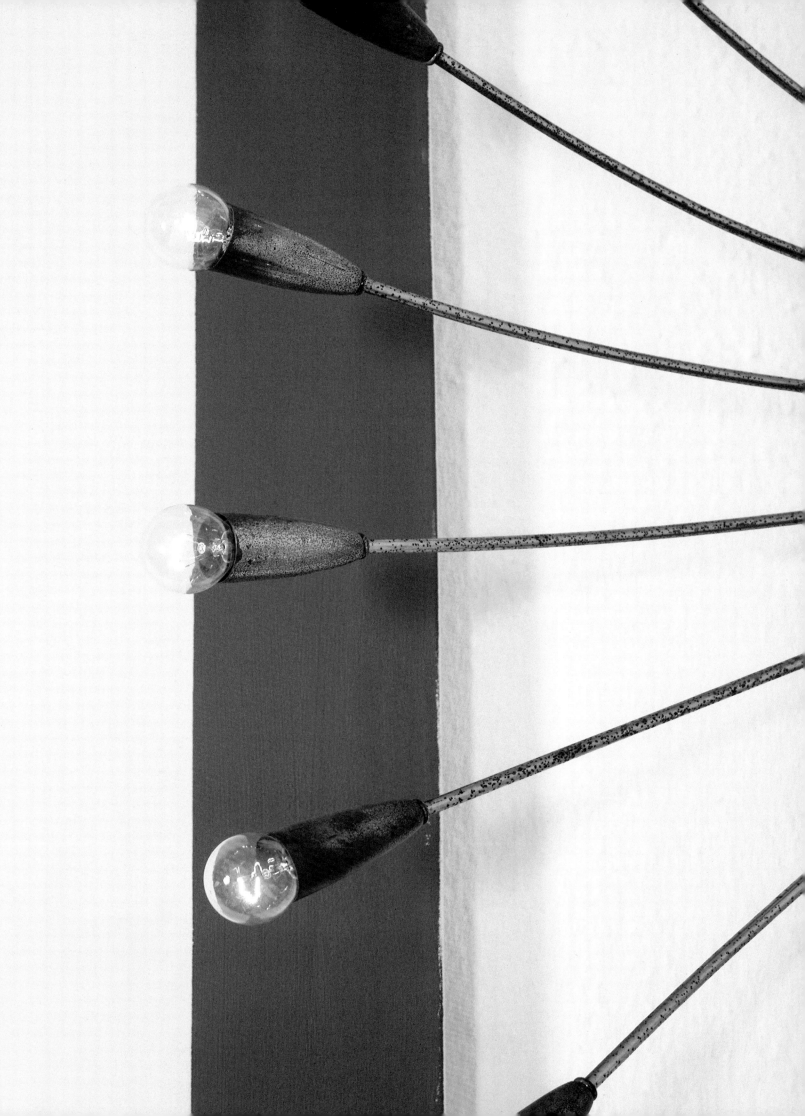

TEA TIME TABLE

MARGRIT BREHM

Whether he's working on a piece or drinking tea – there's no difference as far as he's concerned, John Armleder remarked in a discussion with Bice Curiger at Susanna Kulli Gallery in St. Gallen during the fall of 1997. Both things occur at the same communication level, he argued. The most important thing was "doing something," here and now.

Almost twenty years separate this statement from John Armleder's 1975 appearance at the Paris Biennial. The artist was not showing any pictures at this exhibition. Instead, as a création permanente, so to speak, he was serving tea. Today younger generations of artists hand out the food and beverages. That fascinates John Armleder, for it reflects his own conviction that not only the artist, but time and place too influence content and reception. If there had ever been such a thing as a work of art of "utmost simplicity and noble grandeur," the art of the last century in our millennium emphatically refutes this idea (one which, incidentally, has never been propounded by artists themselves). Art, and above all the "autonomous work of art," is a nonentity without a context. For John Armleder, art cannot be separated from what is revealed, reflected, regained, or rediscovered. As both producer and recipient, his aim is to accelerate this process of perception. *at any speed* and with both casualness and commitment, he has taken up position in a paradoxical predicament: one in which it is equally impossible to say nothing and to formulate a definitive response. The system is set to *rewind and fast forward* constantly.

Armleder holds that art functions along the same lines as everything else, a conviction that the fifty-year-old artist has been putting into practice for over three decades in a multi-faceted oeuvre. Even his early happenings and performances, along with the founding of Ecart in his hometown of Geneva, are exemplary of the interaction between art and life: a game without rules. The demand by Fluxus artist Robert Filliou – that one seek not to join a scene which already exists but rather to make things happen, to build new spaces and to create new surfaces – was as important in those early days as Armleder's desire to work with other artists, produce art and exhibit his own and others' work. »I am firmly convinced that the artist himself must play a seminal role, even if only to ensure that what it's all about remains in his or her hands. And ultimately this is the last critical discourse left to us beyond our work.« John Armleder attaches great importance to communication – and to art as a form of communication. This is not only evidenced by his work (which reflects the aspect in a range of ways) and in the use of increasingly disparate materials), but also in the fact that he repeatedly assumes the role of the curator. It doesn't matter whether – with his "Ecart Stand" – he is providing a counter-current to art business at the Art in Basel every year. Or whether he's organizing exhibitions like "Ne dites pas non!" at Mamco in Geneva; or encouraging his students in Braunschweig to invite international artists to display works in exhibitions with the title "504". There can be no doubt: more than any other, this man believes in art, despite the propensity of critics to decry him as a heretic. His is a belief in the significance of the "non-useful" notwithstanding his awareness of its "uselessness." His is a joy in the resulting scope for experimentation.

When John Armleder talks about his art, he's talking about life. The focus is not, however, his own personal biography, but rather his perception of the everyday world we live in. Nothing that really penetrates our consciousness is without import and consequences.

The intensity of the images, the increasingly blurred boundaries between "advanced" civilization and the cult(ure) of trivia, the growing irreality of the real: we find every facet of alienation manifested here. But John Armleder wouldn't be John Armleder if he didn't maintain a relaxed distance through the sophisticated tool of irony. The playful character of his works and the way they create new constellations corresponds to the positioning of his words and the abrupt switch from art to pudding, from cassata to the Postmoderns. It's all about images. And sometimes it's about things that have been rendered images, in life and in art. We too must maintain our distance. The references in conversation are veiled, everyone's talking at once: have we missed the point again? Press *rewind* another time. The game has no rules, cafeteria is a style. And with a wink of the eye, he adds: »I take art as seriously and as lightly as my life.«

This exhibition and catalogue would never have materialized without the assistance of partners we could depend on. The fact that we were able to find such a partner in "Holderbank" Management and Consulting Ltd. was doubly fortunate. Thomas Schmidheiny, Chairman and Managing Director of "Holderbank" Financière Glaris Ltd. made it possible for John Armleder's *at any speed* to be shown at Holderbank and ensured that the exhibition had a secure financial basis. Derrick Widmer was well equipped to pave the way for the necessary cooperation. Thanks to his own personal enthusiasm and a marked ability to express it, he has for many years now succeeded in organizing ambitious projects with contemporary artists in these former factory halls so far removed from the art world. We would like to express our gratitude and appreciation for their efforts as well as for their faith in our work. The fact that we can so confidently look forward to the exhibition being held at Holderbank is also due to Heidi Häfeli, whose planning skills and personal dedication were vital to this highly complex presentation.

Thanks to the generous willingness of numerous private lenders to part from their – often quite fragile – pieces for this exhibit, it has been possible to turn the idea of a *rewind and fast forward show* into reality and trace John Armleder's evolution throughout his various phases of artistic production. We would like to take this opportunity to thank all those who have dispatched their cherished pieces for the show; just as we are grateful to the institutions and galleries who have been so highly cooperative in putting this exhibition together. My special gratitude goes to Rainer Michael Mason who enabled us to borrow early editions and multiples by John Armleder from the Cabinet des Estampes du Musée d'art et d'histoire in Geneva, works that have never been shown in Germany. We would also like to express our appreciation to Christian Bernard, Franck Gautherot, Xavier Douroux, Bice Curiger and Jacqueline Burckhardt for their encouragement and professional support.

The phrase "continuity in constant change" describes not only one aspect of John Armleder's work; it also sums up the artist's relations with others. His loyalty to the galleries with which he has worked for years and even decades has eased our access to many of the lenders. For this reason, I particularly want to thank Pierre Huber, Susanna Kulli, Vera Munro, Mehdi Chouakri, Gilbert Brownstone, Naila Kunigk and Walther Mollier. They have all made essential contributions to this project, as has the Fondation Nestlé pour L'Art Lausanne through its financial support, the company Layher Gerüste in donating the material for the "Tower", and the art shipping firm D'ART.

For their willingness to respond to our wishes and requests *at any speed* I would like to thank Lionel Bovier, Christophe Cherix, Axel Heil and Giacinto Di Pietrantonio, whose

texts are a trial run of *rewind and fast forward*, as well as Mary Fran Gilbert & Keith Bartlett, Charles Penwarden, Hinrich Sachs and Fumiko Wellington, who demonstrate their perfect sense of timing in their translations. The design and rhythm of the catalogue was set by Axel Heil – always in-between –, Torsten Schmitt, who actually wanted to become a salsa dancer and Ilona Hirth (help in the nick of time). Many thanks are due to them and to my ever-ready set-up team at the Kunsthalle Baden-Baden which will also be lending a hand in Holderbank.

During the preparations for this project, I was fortunate enough to meet with John Armleder and Sylvie Fleury at various locations between Berlin and Geneva and at various exhibitions, cafés, restaurants – and, of course, at the Villa Magica. At each of these moments – sandwiched as they were between the many other obligations of an artist, professor, curator and globetrotter – John surprised me time and again by maintaining his composure even when the pressure was at its peak, e.g. at openings, or at the art fair. And not only that. Aside from a warm hello here and a brief exchange there, he devoted his "undivided" attention to our project, always picking up the thread exactly where we'd left off when the phone rang the umpteenth time. In casinos, one occasionally sees gamblers who play simultaneously at a number of tables. There is nothing random about their method. Following an orbit all their own, they move unhurriedly and with the greatest of ease between the scenes of action, somehow always arriving in perfect time to decide whether to join the next game. It almost seems as if winning is not the point; the challenge lies in being on the ball, achieving the concentration demanded by simultaneous play. It's equally important to register every detail as it is to maintain the distance required to choose objectively from the many alternatives – and to do so over and over again.

This is something I realized while working with John Armleder, and I thank him from the bottom of my heart. For it applies to everything: the wonderful cooperation during the planning phase, his commitment to realizing the exhibition in Baden-Baden, the time he always found for that cup of tea...

Translated from the German by Mary Fran Gilbert & Keith Bartlett

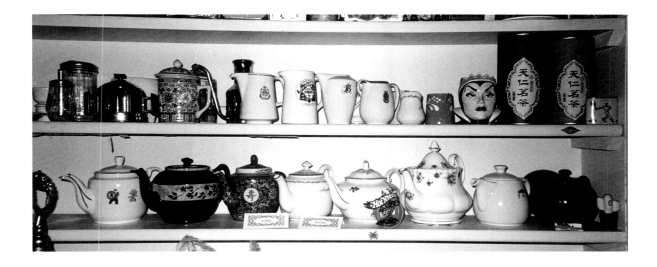

"Oder es dünkt ihm der Sinn des Henkels zu sein,
das Zusammentreffen der Welt des Kunstwerks
mit der des praktischen Lebens zu symbolisieren." [1]

REWIND AND FAST FORWARD

DIE RELATIONALE ORDNUNG DER DINGE

MARGRIT BREHM

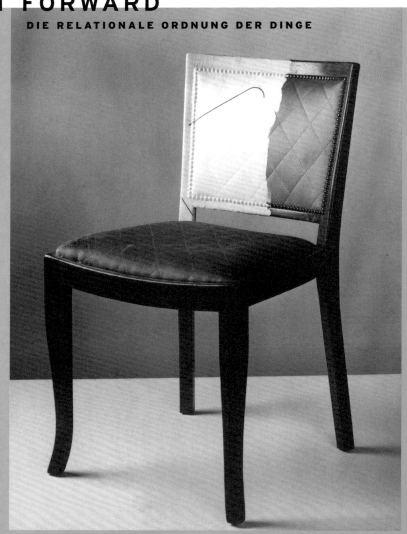

NIEMAND SPRACH VON DESIGN, und „Die Ordnung der Dinge"
hatte noch nicht Eingang in den wissenschaftlichen Diskurs gefun-
den, als Georg Simmel zu Beginn dieses Jahrhunderts anfing, den
Dingen eine besondere Aufmerksamkeit zu schenken. Immer wieder
kreisen seine philosophischen Betrachtungen, etwa „Der Henkel",
„Brücke und Tür" oder „Die Mode" um die Frage des Verhältnisses
zwischen Mensch und Objekt, funktionaler Gestalt und symbo-
lischem Gehalt. Weil – so Simmel – die Form an sich das Allgemeine
gegenüber der speziellen Bestimmtheit ihrer Inhalte verkörpert, ist
jeder Gegenstand zugleich Objekt des Handelns und des Begehrens
ebenso wie Objekt des theoretischen Erkennens und der ästheti-
schen Wertung. Aber Simmel stellt nicht nur die Hierarchie zwischen
den Dingen – und damit auch zwischen dem Alltagsgegenstand und
dem Kunstobjekt – in Frage, sondern geht noch weiter, indem er den
Zusammenhang von Kunst und Gesellschaft nicht aus inhaltlichen
Übereinstimmungen oder Formanalogien zweier getrennter Sphären
entwickelt, sondern aus der Produktion herleitet, die nicht so sehr
eine Produktion von Dingen (von Kunstwerken oder Wirtschaftspro-
dukten) als vielmehr eine Produktion von Beziehungen ist. Für die
Kunstwerke gilt damit ebenso wie für die Dinge, daß sie „Produkte
des Handelns", also „in Ruhe gestellte Bewegung" sind,– und das ist
das Problem: Der Prozeß der Gestaltwerdung endet nicht mit der
Objektivierung, sondern mit der Erstarrung, dem Ausstieg aus dem
lebendigen Beziehungsgeflecht [2]. »Meist aber bleiben die Menschen
der innigen wechselseitigen Verbindung zwischen den vom Lebens-
ganzen abgespaltenen Stücken nicht eingedenk. Diese werden viel-
mehr für unabhängig erklärt und verdichten sich allmählich zu starren
Einheiten, deren Bedeutung sich unlöslich an mehr oder minder will-
kürlich aus ihrer Bedeutungstotalität herausgegriffene Merkmale
heftet« [3]

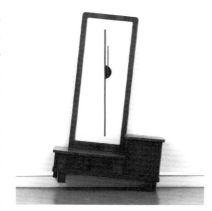

Seit mehr als 30 Jahren arbeitet John M Armleder daran, die
Dinge in Bewegung zu bringen oder zu halten. Vielfältiger und um-
fassender als Georg Simmel sich das hätte vorstellen können sind
dabei die von ihm geflochtenen Beziehungen zwischen Kunst und
Wirklichkeit. Und dennoch gibt es gute Gründe, gerade Simmel als
Zeugen aufzurufen: Als Zeitgenosse der Wegbereiter der Moderne
entwarf er ein Weltbild, in dem – ohne daß er sich dessen auch nur
bewußt gewesen wäre – die Kunst zugleich das Objekt entdecken
und sich ihrer Abbildungsfunktion entledigen konnte. Könnte man in
diesem Sinn davon sprechen, daß der Philosoph den Zeitgeist der
Avantgarde zu Beginn des Jahrhunderts traf, auf die Armleder in
vielen seiner Werke rekurriert, so verbindet die beiden mehr noch
die spielerische Bereitschaft „die Dinge weiterzudenken". Für Arm-
leder, den Produzenten, der anfängt Kunst zu machen als die Moder-
ne schon wirkmächtige Vergangenheit und der Alltagsgegenstand
bereits in der Kunst etabliert ist, bietet sich ein weites Panorama.

1 | Siegfried Kracauer über
Georg Simmel, in: Das Ornament der
Masse, Frankfurt 1963, S. 233.

2 | Für Simmel galt diese
Konsequenz nur in bezug auf die
Alltagsgegenstände, da er zwar
den »Produktionsprozeß« aller
»Dinge« parallelisierte, aber dem
Kunstwerk nach seiner Vollendung
Souveränität zusprach.

3 | Siegfried Kracauer, s. Anm. 1,
S. 215.

Die Pioniertaten sind in die Geschichte eingegangen, die Kunstwerke haben ihren Platz im Museum gefunden, das bildnerische Vokabular ist verfügbar, das Leben ist woanders. Die späten sechziger Jahre, die Politisierung und der Aufstand der Jugend, die Fluxusbewegung und ihre Maxime „Alles ist Kunst", aber auch die siegessicher über den großen Teich wehende Popart prägen seinen Zugang zur Kunst und seinen Umgang mit Kunst und Wirklichkeit. Wichtiger als die Erfindung wird das Finden. Das Vorhandene, das scheinbar Bekannte wird zum Ausgangspunkt eines Erkenntnisprozesses, der nicht teleologisch seiner Vollendung im Werk zustrebt, sondern dessen Charakteristikum es ist, das Werk selbst zum Ort der Überprüfung des künstlerisch Formulierten zu machen. Material, Technik und Stil sind nicht Hilfsmittel auf dem Weg zur abstrakten „Botschaft", sondern bestimmen aufgrund ihrer je eigenen, durchaus widersprüchlichen Assoziationsspektren die Erscheinungsweise. Das Kunstwerk wird zum Ausdruck komplexer Relationen, die über das Objekt hinausweisen.

»My art is defined by its culturally conscious statement«[4], schreibt John Armleder 1993. »Die eine Grundlage der Kunst ist die Kunst, was immer das auch ist. Offengestanden, ich genieße das und ich beschäftige mich mit Musik, Gartenpflege, Architektur, Mode u.s.w. Und natürlich interessieren mich die Werke und die Ausstellungen von Künstlern, die ich nicht kenne, ebenso wie die von jenen, um die ich mich besonders kümmere, und ich habe ein Verlangen nach neuen Werken, die mich mein eigenes Werk kritisch sehen lassen.«[5] „Kunst-machen", die Methode, basiert bei Armleder also auf seinem gesamten Wahrnehmungsspektrum. »Ich glaube, daß das Leben als permanente Orientierung für jeden dient, der sich wirklich damit beschäftigt; die äußersten Grenzerfahrungen ebenso wie die kleinen alltäglichen Taten und Untaten.«[6] Das Kunstwerk selbst reflektiert diese Wahrnehmung, sei es durch vermittelte Verweise oder dadurch, daß es Versatzstücke der Wirklichkeit beinhaltet. Die De-Kontextualisierung der Zeichen oder Objekte leugnet aber keineswegs deren Geschichte, sondern fügt eine weitere Sinnschicht als Möglichkeit hinzu. »Vielleicht formuliert dies den Lebensreichtum der Menschen und der Dinge; denn dieser ruht doch in der Vielfachheit ihres Zueinandergehörens, in der Gleichzeitigkeit des Drinnen und Draußen, in der Bindung und Verschmelzung nach der einen Seite, die doch zugleich Lösung ist, weil ihr die Bindung und Verschmelzung nach einer anderen Seite gegenübersteht.«[7]

1979, rund zehn Jahre nach der Gründung der Gruppe Ecart mit Patrick Lucchini und Claude Rychner, nach zahlreichen Kunstaktionen und Performances, die unter dem Einfluß von Fluxus standen[8], nach unterschiedlichsten Ausstellungsprojekten mit einer Vielzahl internationaler Künstler in der Ecart-Galerie und doch zugleich als

4 | J. A. in: Briefinterview mit John Armleder und Doris Rothauer, März 1993, in: John M Armleder, Ausst. Kat. Wiener Secession, Wien 1993, S. 58.

5 | J. A., s. Anm. 4, S. 58, übersetzt aus dem Englischen von M.B.

6 | J. A., s. Anm. 4, S. 58.

7 | Georg Simmel, Der Henkel, in: ders., Philosophische Kultur, Leipzig 1911, S. 135.

8 | »Bis zum Ende der siebziger Jahre ist meine Arbeit radikal antiformalistisch; dann kommt es zu einer Umkehrung, der Formalismus sieht sich auf einmal in der Rolle aufgewertet, die ihn in gewisser Weise zuvor disqualifizierte.« J. A. im Interview mit Suzanne Pagé, in: John M Armleder, Ausst. Kat. Kunstmuseum Winterthur u. a., Winterthur 1987, S. 57.

konsequente Weiterentwicklung der bis dahin entstandenen Zeichnungen, bemalt Armleder die Hälfte der Rückenlehne eines Stuhles und stellt ihn auf ein weißes Podest. Schon „Furniture Sculpture (FS 1)"[9], spielt auf mehreren Ebenen, scheint einen Schwebezustand zwischen Kunst und Wirklichkeit dauerhaft besetzen zu wollen. Die Gleichzeitigkeit des Ungleichzeitigen und die Tatsache, daß Nichts das ist, was es vielleicht sein könnte, kennzeichnet die Kunst John Armleders. Da ist der Stuhl, kein Design-Klassiker, eher Dutzendware, ein gefundenes Objekt (objet trouvé?), das in den Kunstraum gestellt wird (ready made?). Er weist Spuren der Benutzung auf (Vanitas?). Jetzt steht er auf einem Sockel, kaum höher als zuvor (das menschliche Maß?), aber doch keine Sitzgelegenheit mehr, stattdessen Bildträger (Support / Surface?). Mit dickem Pinsel (Geste?) ist die weiße Farbe über einen Teil des gesteppten Rückenkissens, einige Polsternägel, ein Stück des Holzrahmens gemalt. Sie bildet den Bildgrund für zwei präzise ausgeführte lineare Zeichen. Die blaue Diagonale (Konstruktivismus – Aufstreben – Bewegung – Fortschritt!) endet mit einem Abwärtsbogen (? – Charlie Chaplins Stöckchen), während die rote so lang ist, daß sie die Frontseite des Holzsteges überspannt. Die Reduktion der Farbigkeit des Bildes (Mondrian? Malewitsch?) wird durch das Holzbraun und das etwas derangierte Gold des Bezugstoffes (Nouveau Realisme?) konterkariert. Das Objekt ein „Rebus" eines „pictor doctus?" Der Künstler ein Freibeuter auf dem Kunstteich? Das Werk ein Eldorado für den Kunsthistoriker, der nur noch aufzählen muß, was nur allzu offensichtlich angeboten wird? Nein, es sind nicht die einzelnen Zeichen, sondern ihre Organisation, das, was gerade aus der Überlagerung entsteht, die Methode ist das Eigentliche. John Armleders „Material" ist das Wissen, sein Ziel ist es nicht, dieses Wissen vorzuführen. »Meine Bilder sind völlig unvernünftig, sie entziehen sich jeglichen intelligenten, diskursiven Verständnisses ... Was wir tun hat nur wenig mit dem zu tun, was man glaubt, daß wir tun.«[10]

Zur Ausstellung „Peinture abstraite", die John Armleder 1984 in den Räumen von Ecart, also nach der Schließung der Galerie, mit abstrakten Bildern unterschiedlicher Künstler[11] realisiert, schreibt er: »Wenn dies nicht genau ein Manifest ist, sehe ich darin zumindest eine Stellungnahme, ein ›erklärtes‹ Umsetzen in Praxis.«[12] Als „Manifestation einer Praxis" läßt sich die Art wie Armleder arbeitet – also die „Produktion eines Kunstwerks", ebenso wie die Einrichtung einer Ausstellung eigener oder fremder Kunst – wohl auch am besten bezeichnen. Schon die Heterogenität der einzelnen Werkgruppen, die scheinbare Differenz zwischen den geplanten, geometrischen und den geschütteten Bildern, die Vielzahl möglicher Kombinationen von Bild, Fundstück oder nach Maßgabe des Künstlers von fremder Hand ausgeführtem Objekt, verweist darauf, daß hier der „Stil" – und ein solcher ist eindeutig feststellbar – aus der Idee des Handelns und

9 | In früheren Publikationen findet sich auch der Titel »7 Juin 1980 (FS 1)«, 1979, womit ein direkter Bezug zur Ausstellung »7 Juin 1980« im Centre d'Art Contemporain, Genf, hergestellt wird, in der die Arbeit zum ersten Mal gezeigt wurde. John Armleder nannte seine Installation »La Chambre d'Eirc Estia« und verwies damit auf den Bezug zwischen der »Musique d'ameublement« von Eric Satie und seiner Idee der Furniture Sculptures. Satie schrieb: »Nous, nous voulons établir une musique faite pour satis-faire les besoins ›utiles‹. L'art n'entre pas dans ces besoins ...« (zit. n. Jean Michel Foray, John M Armleder, Ausst. Kat. le capitou, Centre d'art contemporain, Fréjus, Mailand 1994, S. 151).

10 | J. A. im Interview mit Christoph Schenker, Flash Art, 130, Mailand 1986, S. 68, übersetzt aus dem Englischen von M.B.

11 | Gezeigt wurden Werke von John M Armleder, Helmut Federle, Lucio Fontana, Sol Lewitt, Verena Loewensberg, Robert Mangold, Gerhard Merz, Olivier Mosset, Robert Motherwell, Blinky Palermo, Gerwald Rockenschaub, Robert Ryman, Jean-Frédéric Schnyder und Otto Zitko.

12 | J. A., Presseerklärung zur Ausstellung, zit. n. John M Armleder, Ausst. Kat. Kunstmuseum Winterthur u. a., Winterthur 1987, S. 150.

nicht aus der Anwendung eines festgelegten Handlungsmusters resultiert. Von Bedeutung ist für Armleder der Entstehungsprozeß als Realisierungsmoment, als aktuelles Zusammentreffen der zuvor gefaßten Idee und der die Ausführung begleitenden Umstände / Zufälle. Distanz zum Werk ist eine Bedingung. Die Arbeit am Bild als Selbstbehauptungsakt des individuellen Schöpferwillens liegt ihm fern. »Der Prozeß ist als Projekt für das Bild von Bedeutung, aber nicht in seiner Ausführung. Natürlich habe ich Freude daran, ein Bild zu malen, und ich finde beim Malen neue Dinge heraus, aber es ist einfach Arbeit, ein völlig normaler Prozeß. Wenn ich ein neues Werk produziere, führe ich es nur aus, ich ändere meine Meinung nicht, ich korrigiere nicht die Farben: Tatsächlich korrigiere ich meine Werke nie. Das Werk ist wie es ist und so wie es ist, so wurde es gemacht, so arbeite ich an Bildern. Ich füge keine neuen Fragestellungen hinzu. Wenn Probleme auftauchen, nutze ich sie vielleicht für ein neues Bild.«[13] John Armleder hat kein Atelier. Seine Arbeiten entstehen in Galerien oder Museen, meist gezielt für eine Ausstellung. Die Nutzung fremder Räumlichkeiten ist keine Ersatzlösung. Sind es angenehme Begleiterscheinungen, daß keine Räumlichkeiten unterhalten werden müssen, die Verantwortung für die Lagerung der Objekte delegiert werden kann, so ist der Tausch der − immer noch − auratisch besetzten Ateliersituation gegen einen neutralen, aktuell zur Verfügung stehenden Raum Ausdruck der künstlerischen Strategie. John Armleder pflegt den Status des Gastes im Leben wie in der Kunst. Die feine Austarierung zwischen privat und öffentlich, die dem Sohn einer Genfer Hoteliersfamilie wohl schon in die Wiege gelegt wurde, hilft dabei den Verzicht auf die Sicherheit, die das Vertraute bietet, als Vermeidung des lähmenden Immergleichen zu begreifen und in der Notwendigkeit sich auf das Gegebene einzulassen, die Chance zu erkennen, immer in Bewegung zu bleiben, ***at any speed***.

John Armleder hat sich nie dagegen gewehrt, daß ihn die Kritik als „Zitat-Künstler"[14] bezeichnet hat und an seinen Werken besonders den ironischen oder zynischen Umgang mit anderen Kunststilen betonte. Gleichwohl widerlegen seine in Interviews gemachten Statements ganz deutlich diese Einschätzung, die dem Künstler geradezu eine Kunstmarktstrategie zwischen Wiedererkennungseffekt und Überraschungsmoment unterstellt. Für Armleder ist aber nicht entscheidend, daß Kunst sich aus Kunst entwickelt − was ohnehin außer Frage steht − sondern seine Überzeugung, daß „Alles" in der einen oder anderen Form schon einmal gemacht worden ist. »Die Kunst, die ich mache, respektiert die Normen, die der Kunst generell, anhand der Massierung von Kunst bis heute, und von denen, die sie erfaßt haben, gegeben worden sind. Ich mache nichts anderes als das, was andere schon einmal gemacht haben. Es gibt eine gesellschaftliche Besessenheit im Überwinden der Norm oder im Glauben, dass es möglich sei, aus ihr herauszukommen.«[15] Armleder erteilt

13 | J. A., s. Anm. 10, S. 69.

14 | Armleder zitiert nicht. Nicht nur ist keine seiner Kompositionen auf ein »Vor-Bild« zurückzuführen, sondern auch die Definition im Wortsinn trifft nicht zu. Ein Zitat gibt eine fremde Idee »original« wieder und muß als solches erkennbar sein; es wird entweder eingesetzt, um eine aufgestellte These zu stützen / zu sanktionieren oder um durch die These widerlegt zu werden. Bei John Armleder geht es dagegen keineswegs um eine »Richtigstellung«, − ein Begriff, der nicht nur aufgrund seiner Statik schon von vornherein kaum zur dynamischen Werkidee des Künstlers paßt.

15 | J. A., s. Anm. 8, S. 64.

der Sucht nach dem Neuen eine Absage und verdeutlicht zugleich, daß nicht der Umstand „daß", sondern die Methode, „wie" das historisch gewachsene Repertoire angewendet wird, entscheidend ist. Auf der Basis des Wissens und des daraus resultierenden Handelns in der Gegenwart entsteht das Werk. Diese Zeitbezogenheit schließt auch aus, daß die Werke eine Kritik an der Vergangenheit sind. »...selbst wenn ich diese Kunst mit ihrem Idealismus verwende, so basiert meine Kunst doch auf einer ganz anderen Vorgehensweise, genauer gesagt der heutigen Praxis. Die Ironie meines Werks richtet sich nicht gegen die Kunst dieser Zeiten, im Gegenteil: Diese Werke sind unser kulturelles Erbe, das ich bewundere und respektiere.«[16] Der kritische oder ironische Unterton richtet sich vielmehr gegen das Kunstspiel als solches und betrifft damit die eigenen Werke ebenso wie die der anderen. »Es ist ein spielerischer Kommentar, der verdeutlicht, daß der Raum, in dem, und die Grundlagen, auf denen wir arbeiten, weniger begrenzt sind, als man gemeinhin denkt.«[17] Am Ende dieses Jahrhunderts, in dem Kunstreproduktionen weltweit und in jeder Form feilgeboten werden, die Kunst der wichtigste Ideenlieferant des Werbedesigns ist und die Auktionsergebnisse den Stellenwert von Aktienkursen haben, arbeiten nicht nur Künstler im Bewußtsein der ständigen Präsenz der „world of pictures". »Man sucht in einem Kunstwerk das, was darin aussergewöhnlich ist, und in gewisser Weise ist es nicht das, was ich suche ... ich meine, dass man in der einen oder anderen Weise beim Betrachten eines Kunstwerks nach einer Identifikation mit ihm sucht, was es weniger aussergewöhnlich macht: es entgeht uns nicht, es ist uns nicht fremd, es ist so banal wie wir auch.«[18] Die Verfügbarkeit der Bilder hat aber nicht nur die Kunstwerke entauratisiert und das „Kunst-machen" verändert, sie hat auch dazu beigetragen, daß die Diskrepanz zwischen der Bedeutung, die persönlich der Kunst beigemessen wird und ihrer gesellschaftlichen Wirkungslosigkeit / realen Bedeutungslosigkeit deutlicher hervortritt. Spielt Armleder mit diesem Zwiespalt, wenn er erzählt, daß ihn die radikalen Setzungen von Malewitsch oder Ad Reinhardt faszinieren und hinzufügt »aber besonders mag ich, daß Radikalität in der Kunst absolut keine Konsequenzen hat«[19], so erweist sich die hier implizit angedeutete Freiheit, die darin liegt, aus der Verantwortung entlassen zu sein, bei den Statements zu seinem eigenen Werk als Ambivalenz. »Trotz dieser Überzeugung, praktischen Erfahrung in gewisser Weise, dass Kunst eine ernsthafte Angelegenheit ist und dass man sie gut machen muss, glaube ich nicht, dass sie wesentlich ist. Das ist widersprüchlich: es ist unwesentlich, weil es nichts mit dem Überleben zu tun hat, aber es berührt doch etwas, was andauert, bei mir und den anderen.«[20] Besonders in den Gesprächen mit Helmut Federle kommt er immer wieder auf dieses Thema zu sprechen. »Ebenfalls komme ich von der Vorstellung nicht los, daß wenn ich ein ganz bestimmtes Werk mache, dieses genausogut ein anderes sein könnte. Doch parallel zu dieser

16 | J. A., s. Anm. 10, S. 69.

17 | J. A., s. Anm 10, S. 69.

18 | J. A., s. Anm. 8, S. 64.

19 | J. A., s. Anm. 10, S. 68.

20 | J. A., s. Anm. 8, S. 63.

offenbar zynischen Einstellung gibt es das totale Engagement meinerseits, das auch den Schaffensprozeß mitbestimmt, dieses kleine Etwas, das ich zu einem bestimmten Augenblick leiste, was mir ermöglicht, alles andere hintanzustellen.«[21]

Die »immerwiederkehrenden Widersprüche zwischen Glauben – Nichtglauben, Formalismus – Trivialität, hoher Qualität – Ramsch, der Konzentration – der Relativität unserer Arbeit und der Rezeption derselben«[22] sind es, die Armleders Haltung zur Kunst bestimmen und die sich als dialektische Spannung zwischen Ordnung und Freiheit, Plan und Zufall, Respekt und Ironie, Kontinuität und Bruch, Anteilnahme und Distanz in seinen Werken wiederfinden. Das definitive Werk, die Synthese, die alles zuvor Gemachte in sich vereint und aufhebt, kann es nicht geben. Deshalb sucht Armleder auch nicht durch die Anlage von Serien und Varianten nach Bestätigung für ein Werk. Die Bilder sind in ihrer Mehrzahl Einzelstücke. Wenn bereits verwendete Elemente oder Formulierungen wieder auftreten, dann in einer völlig anderen, oft entgegengesetzten Anwendung. Die Idee einer Entwicklung im Sinne eines Fortschritts, die Möglichkeit, sich auf der Zielgerade zu bewegen und damit unausweichlich einem Endpunkt zuzusteuern, führt Armleder mit jedem neuen Werk ad absurdum, das zugleich Setzung und Dementi ist. Es gibt »kein absolutes, oder nicht einmal – wenn man ihm glauben soll – provisorisches Gelingen«[23]. Die Entscheidung für die Unvollkommenheit als Möglichkeit (dynamisch) und damit gegen die Vollkommenheit als Notwendigkeit (statisch) realisiert sich im „Fehler", der als vitales Element an der Schnittstelle zwischen Kunst und Leben, Ordnung und Chaos, erkannt wird[24]. Als virulente Kraft wirkt er der Erstarrung entgegen. »Was ich zu sagen versuche ist, daß wir alle, als Individuen und als Künstler eine Haltung haben, die wir konstant radikalisieren oder uns zumindest bemühen dies zu tun. Die Zeit arbeitet gegen die Radikalisierung, sie verwischt sie zur Unwirksamkeit. Die Werke, die Setzungen werden mit Gewicht befrachtet, werden ein Genre, ein altgedienter Diskurs, eine akademische Pose. Irgendwie ist es die Revanche der individuellen Intrige gegen die einmalige, universale Geste, was immer das heißen mag. Aber indem ich das sage, ist mein Vertrauen in den Widerspruch ungebrochen.«[25] Und so arbeitet Armleder mit einer kultivierten oder natürlichen, aber absolut zuverlässigen Sorglosigkeit weiter daran, das gerade Formulierte in Frage zu stellen.

Die Werke, die für die ***rewind and fast forward show*** ausgesucht wurden, exemplifizieren aber nicht nur das kontinuierliche „Hakenschlagen", sondern zeigen, sozusagen als zweites, antagonistisches Grundprinzip, wie das „Repertoire" immer wieder und wieder neu ins Spiel gebracht wird. Im Mittelpunkt der daraus resultierenden Kontinuität im Diskontinuierlichen stehen nicht die Dinge oder

21 | J. A., in: Gespräch zwischen John Armleder und Helmut Federle, Zürich 25./26. August 1984, in: Zeichen Fluten Signale – neukonstruktiv und parallel, Ausst. Kat. Galerie nächst St. Stephan, Wien 1984, S. 10.

22 | J. A., s. Anm. 21, S. 10.

23 | Ausst. Kat. Peinture 1985, Galerie Marika Malacorda, Genf, Neudruck in: s. Anm. 8, S. 154.

24 | »Je pense parfois que l'échec (›fêlure‹) est grandement nécessaire dans la réalisation d'une de mes pièces. Non pas des erreurs corrigées, des ratés. Simplement l'échec, une part de fiasco.« J. A. in: John Armleder, Helmut Federle, Olivier Mosset 1968 – 1987, Ecrits et Entretiens, Maison de la Culture et de la Communication, Saint Etienne, u. a., Grenoble 1987, S. 233.

25 | J. A., s. Anm. 4, S. 59.

ihr mit leichter Hand inszeniertes Zusammen-
treffen, sondern der Rezipient, der als Teil der
geschaffenen Wahrnehmungssituation seinen
Platz stets neu bestimmen muß. Geradezu
programmatisch ragt dabei der „Tower" im
Hauptsaal empor, eine begehbare Gerüstkon-
struktion, bestückt mit farbigen Neonröhren,
blitzenden Spiegelkugeln, Lichterketten, blauen
und orangefarbenen Signallampen, Ghetto-
blastern und Monitoren. Wer auf das Gerüst
steigt, den multimedialen Parcours antritt,
wird nicht nur „Teil des Kunstwerks", das die
Perspektive auf die dargebotenen „Ereignis-
se" und den Raum verändert, sondern durch
die exponierte Position auf dem Turm zu-
gleich auch „Objekt der Betrachtung" für die
anderen Ausstellungsbesucher. Auch ohne
von Boccionis „Universalem Dynamismus" zu
wissen, „sieht" sie oder er wie Bewegung
und Licht die Materialität der Körper zer-

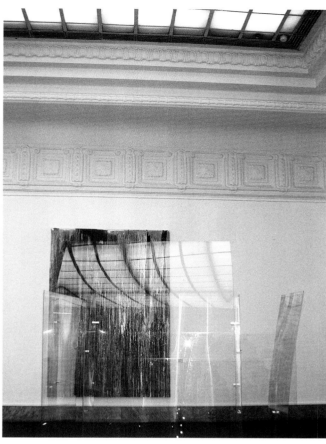

stören. »Genauso dringen die Straßenbahnen in die Häuser ein, wel-
che sich wiederum in den Straßenbahnen spiegeln und sich mit ihnen
bewegen.«[26] Die ganz anderen „neuen Anwendungen fluoreszieren-
den Lichts" verändern den Raum, die an den Wänden hängenden Pour-
Paintings und dekonstruieren so nebenbei die minimalistischen Ideen
Dan Flavins. Konstruktive Elemente und destabilisierende Lichtwir-
kungen treten in ein Spannungsverhältnis: Kaum zu sehen wäre die
transparente Plexiglasskulptur „Labyrinth (Ersatz-Tatlin)", 1996,
würden die Reflexionen ihr nicht optisch (und damit je nach Per-
spektive wechselnd) Volumen und Oberfläche verleihen. Schon im
Titel dieser Arbeit steht die Anspielung auf den „Tatlin-Turm", das
„Denkmal der III. Internationale", 1919, das den Ausgangspunkt für
das Arbeitskonzept „Tower" bildete. 1967 hatte John Armleder eine
(nicht mehr erhaltene) Paraphrase auf diese architektonische Idee
realisiert. Damals ebenso wie 1996 benutzte er Plexiglasscheiben
und formulierte damit die von Vladimir Tatlin angestrebte „Transpa-
renz" des Stahlskelettbaus auf anderer Ebene und experimentierte
mit dem „Unsichtbaren" als Äquivalent zur „realen Unwirklichkeit"
des nie gebauten Turms. Wäre der 400 m hohe „Skyscraper", Symbol
des Fortschritts und der gesellschaftlichen Veränderung jemals ge-
baut worden, vielleicht wäre dann sein Einfluß auf die Kunst der
nachfolgenden Generationen geringer gewesen. Als Architekturutopie
behauptet der Tatlin-Turm seine Bedeutung; die Zeichnungen, Mo-
delle und Photographien gliedern das ambitionierte Projekt formal
in die innovativste Schaffensphase des russischen Konstruktivisten
und Suprematisten ein, der auch als Erfinder der Eck-Konterreliefs
und Wegbereiter der Idee, daß „alles Material und Objekt" sein kann,

26 | Umberto Boccioni, Futuristi-
sche Malerei und Bildhauerei, 1914,
zit. n. Boccioni und Mailand, Ausst.
Kat. Kunstmuseum Hannover, Mailand
1983, S. 47.

als ein Bezugspunkt im Werk John Armleders gesehen werden kann. So ist es auch nicht verwunderlich, daß Armleder immer wieder neue Variationen des „Towers" entwirft und immer andere Aspekte in seine eigene Bildsprache übersetzt. Die „Tribune de Genève", der Turm, den der Künstler 1996 im Le Consortium in Dijon errichten ließ (und der in gewisser Weise auch der Prototyp für die Baden-Badener Variante ist), war die erste begehbare Gerüstkonstruktion. Mit Pour-Paintings bestückt war er zugleich Kunstwerk, Aussichts-plattform und Ausstellungsfläche. Die Dynamik, die Tatlin seinem Entwurf durch die diagonale Ausrichtung und vier, sich in unter-schiedlichen Rhythmen drehenden, übereinanderliegenden Räumen (Halbkugel, Zylinder, Kugel und Würfel) geben wollte, bringen bei Armleder die rotierenden Disco-Balls und Signallampen ins Spiel, die Lichtblitze aussenden und so das dynamische Prinzip mit der Flüch-tigkeit der Wahrnehmung in Beziehung setzen.

Die Installation wird so zur Plattform, auf der formale Probleme der Moderne im Bewußtsein ihrer Bedeutung, Vergangenheit und Verfügbarkeit verhandelt werden, – aber nicht nur, auch die „Wirk-lichkeitserfahrung" im Zeitalter des Zapping, die von Armleder hochgeschätzte Melange aus Kultur und Kult, aus „High and Low", hat ihren Platz auf dem Turm gefunden. Auf zehn Monitoren laufen unterschiedliche Videos gleichzeitig, deren Ton durch die eindring-lichen Klänge des Gagaku überlagert wird. Klingt die japanische Hof-musik, selbst in schlechter Qualität und aus quietschfarbenen kleinen Ghettoblastern dringend, für westliche Ohren ernst und rituell und sind die Besucher daher eher geneigt ihr die Aufenthaltsgenehmi-gung im Kunstraum zu geben als den Science-Fiction-Filmen aus den 50er, 60er und 70er Jahren, so ist auch das nur eine Frage der Rezeptionsperspektive. „Gorgo"[27] oder „This Island Earth"[28] sind heute Kult, Gagaku berieselt tagein tagaus Millionen von Einkäufern in asiatischen Kaufhäusern. John Armleder interessieren diese Spiel-arten des Wirklichen, die Illusionen und ihre Bruchstellen. Bewußt wählt er meist B-Pictures, die häufig im Set einer großen Produktion, sozusagen als Zugabe gedreht wurden, ohne Stars ohne aufwendige Ausstattung, – eine Art Reste-Essen, bei dessen Zubereitung der Stehgreif-Kreativität keine Grenzen gesetzt sind. Zu unwichtig sind diese Billigproduktionen, als daß jemals nachgefragt worden wäre, nach der „Qualität", nach der Botschaft. Eine Grauzone jenseits der moralischen Parabeln und deshalb gerade in ihrer Banalität eine Ent-sprechung des Lebens in dieser B-Society am Ende des zwanzigsten Jahrhunderts, in der Fiktion und Wirklichkeit zu einem Medienbrei verschmolzen sind. Es gibt kein „Außerhalb" mehr, alles ist hier und jetzt und wir mittendrin. Im Freistil segelt John Armleder durch die Bilderflut, getragen von den Wellen, ohne Anstrengung gegen den Strom manövrierend, im Blick die glitzernde Fläche und die sich darin spiegelnde vorbeitreibende Welt.

27 | Gorgo, VCI, 1960, NR, 75 min. Dir: Eugene Lourie. »You get to witness some of the coolest man-in-a-monster suit mass destruction ever filmed west of Tokyo.« zit. n. James O'Neill, Sci-Fi on tape, A Complete Guide to Science Fiction and Fantasy on Video, New York 1997, S. 96.

28 | This Island Earth, MCA / Uni-versal, 1955, NR, 85 min. Dirs: Joseph Newman, Jack Arnold. »The only really A-budgeted Universal sci-fi film from this period, this has gorgeous color and flashy special FX but is terribly slow and drawn-out. Arnold reportedly stepped in at eleventh hour and direc-ted all the scenes on Metaluna, which explains why they're so tense and exciting when compared to the rest of the film.« zit. n. s. Anm. 27, S. 213.

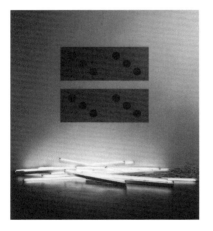

Immer wieder und in jüngster Zeit verstärkt hat John Armleder 29 | J. A., s. Anm. 8, S. 63
mit Glas, Plexiglas und Spiegeln gearbeitet. Ihn faszinieren diese
Materialien, weil sie durch ihre reflektierenden Oberflächen auf jede
Erscheinung reagieren und so auf eigentümlich stumme Weise mit
der Welt kommunizieren. So entstehen Bilder ohne Dauer und ohne An-
spruch auf Wahrheit, Momentaufnahmen des Zufälligen. Das gefällt
Armleder, aber es ist nicht genug: Erst der Einsatz von konkaven
oder facettierten Spiegeln, erst die Verformung der Plexiglasscheiben
garantieren die Brechungen, die notwendige Distanz, die wir zur
Wirklichkeit brauchen, um sie als Illusion erkennen zu können. Die
spezifische Art, in der John Armleder seine Combines, Installationen
und Furniture Sculptures arrangiert, entspricht in vielem diesen
„Reflexionen". Stets wird ein ungewohntes, „verzerrtes" Bild der
(Kunst-) Welt gegeben. Unsere Erwartungen werden enttäuscht,
aber unsere Neugier geweckt. Der Schritt in der ungewohnten Kom-
bination, im Chaotischen nicht das „falsche" Bild, sondern eine
„neue" Ordnung zu sehen, ist möglich. Der Begriff der Ordnung wird
damit „relativiert", von jeglichem hierarchischen Ballast befreit und
als Relation zwischen den Dingen begriffen. Jedes Element hat seine
Eigenheit, Autonomie und besondere Gestalt, die durch die Differen-
zen zwischen dem, was aufeinander bezogen wird, noch deutlicher
hervortreten.

Aber die Arbeit am Rande der Unsichtbarkeit, das Spiel mit
Transparenzen und Spiegelungen hat auch noch einen anderen
Aspekt: »Ich tue Dinge, obwohl es nicht so aussieht, und soweit wie
möglich, ohne es zu formulieren. Selbst wenn ich Arbeiten mit
großen Abmessungen mache, versuche ich, das in einer Weise zu
tun, dass man sie nicht sieht.«[29] Die Distanz
zwischen Künstler und Werk bleibt ebenso
erhalten wie die zwischen Betrachter und
Werk. Eine Begegnung ist möglich, wird aber
nicht erzwungen. John Armleder mag die
Vorstellung der völligen Loslösung des Pro-
dukts von seinem Produzenten, die Rück-
führung des Kunstwerks in die Anonymität
der Dinge. Der Grenzen dieser „Emanzipa-
tion" ist er sich sehr wohl bewußt. Aber geht
es überhaupt darum ihm zu „glauben", wenn
er sagt, es sei sein Wunsch, die eigene Ar-
beit nicht zu erkennen, »auf etwas Leeres
zuzugehen«, von einem Kunstwerk angezo-
gen zu werden, um dann auf dem Schildchen
zu lesen:
»John M Armleder«?

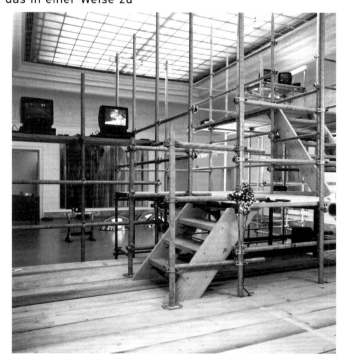

REWIND & FAST FORWARD

MARGRIT BREHM

THE RELATIONAL ORDER OF THINGS

»Or it appears to him that the point of the handle is to symbolize the meeting between the world of the artwork and the world of real life.« [1]

No one was talking about design, and "The Order of Things" had not yet found its way into the academic debate when Georg Simmel began to pay special attention to things. His philosophical writings such as "Der Henkel" (The Handle), "Brücke und Tür" (Bridge and Door) and "Die Mode" (Fashion) return repeatedly to the relationship between human being and object, functional form and symbolic content. Because – in Simmel's view – form per se embodies the general versus the distinctive specificity of its content, every thing is at the same time an object of action and desire as it is similarly the object of theoretical perception and aesthetic valuation. Yet Simmel not only questions the hierarchy between things and hence that between the everyday object and the objet d'art. He goes one step further, postulating a connection between art and society not based on an identity of content or a formal analogy. His premise is production: less the generation of things (works of art or consumer products) and instead the production of relationships. It is equally true of artworks and things that they are "products of action," i.e. "movement made stationary" – and that is the crux of the problem. The process of taking shape does not end with objectivization; it stops with rigidity, the departure from the active exchange of interdependent relationships. [2] "Most of the time people are not consistently mindful of the close mutual connections between the pieces that split off from life's whole. These pieces are usually declared independent only to crystallize into rigid units whose meaning becomes irrevocably attached to characteristics chosen more or less at random from their sum meaning ... " [3]

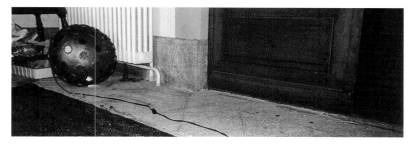

For more than thirty years now, John Armleder has been working on putting or keeping things in motion. The artist's interconnections between art and reality exhibit a diversity and scope far beyond what Georg Simmel could imagine. And still there are good reasons to cite Simmel as a witness: he was a contemporary of modernity's harbingers. Without even being aware of it, he championed a world vision in which art was allowed to discover the object and discard its

1 | Siegfried Kracauer on Georg Simmel in Das Ornament der Masse (Frankfurt, 1963), p. 233.

2 | For Simmel, this consequence applies only to everyday objects, for although he draws parallels between the "production processes" of all "things," he accorded the work of art autonomy upon its completion.

3 | Siegfried Kracauer, see note 1, p. 215.

mirroring function. One might postulate in this context that the philosopher captured the avant-garde zeitgeist prevailing at the beginning of this century, that very same zeitgeist that recurs in many of Armleder's works. And one might further conclude that the two also have in common an open-ended approach, a willingness to let one thought lead to another – and arrive at new conclusions. A broad panorama is laid out before Armleder the producer when he starts to make his art; the Moderns have already been consigned to the alchemical past and everyday phenomena have long become established in art. By this time the pioneering accomplishments have gone down in history, the pieces are safely deposited in museums or collections, their vocabulary available to all; by this time life is taking place on another stage. Many factors are at play in the late 'sixties: the growing politicization, youth revolts, the Fluxus movement and its maxim, "Everything is art," plus the triumphant arrival of Pop Art made in America. These combine to condition Armleder's own access to art, and the way he deals with art and reality. It's more important to find than to create; to take the givens, the ostensibly familiar, as the starting point for a process of perception not aimed in a teleological sense at consummation within the artwork. Instead, it seeks to render the work itself the venue at which the artist's hypothesis is reviewed. Material, technique and style are not tools towards communicating an abstract "message"; due to their own quite contradictory associative spheres they themselves determine the manifestation. The artwork becomes the expression of complex relations that extend beyond the object itself.

»My art is defined by its culturally conscious statement,«[4] John Armleder wrote in 1993. »One of the backgrounds to art is art, whatever this is. But plainly, I keep on enjoying it, and I guess my mind is busy on it. That's music, gardening, architecture, fashion and so on. And obviously, I am involved in experiencing the works and shows of artists I don't know as much as the ones I especially care for, and have that craving for new artists' works that tell me critically about my own.«[5] Armleder's method of "making art" is therefore based on the entire spectrum of perception and experience. »I guess life serves as a permanent orientation to anyone who goes on experiencing it. Its farthest limits, but also its little silly daily doings, and undoings.«[6] The artwork itself reflects this perception, because it either conveys allusions or contains set pieces lifted from reality. Taking the symbols and objects out of context by no means negates their own story; in essence it adds a further potential layer of meaning. »Maybe this formulates the richness of humans' and things' lives. It grows from the multidimensionality of their belonging, in the simultaneity of inside and out; in the attachment and fusion on the one side which is detachment as well, because it is opposed by attachment and fusion on the other.«[7]

4 | J. A. in a written interview with John Armleder and Doris Rothauer, March 1993, in John M Armleder (catalog), Wiener Secession (Vienna, 1993), p. 58.

5 | Ibid.

6 | Ibid.

7 | Georg Simmel, "Der Henkel," Philosophische Kultur (Leipzig, 1911), p. 135.

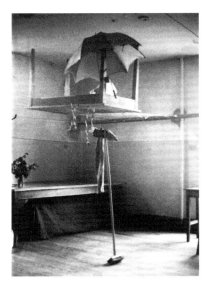

In 1979, some 10 years after founding the Ecart group with Patrick Lucchini and Claude Rychner; after being involved in numerous happenings and performances influenced by Fluxus[8] and a wide variety of exhibition projects at the Ecart Gallery with various international artists, John Armleder paints half a chair back, taking the next step forward from his drawings. "The Furniture Sculpture 1"[9] (FS 1) plays on various levels as well, seeming to lay permanent claim to a state of suspension between art and reality. The simultaneity of the non-simultaneous and the fact that nothing is what it might be represent signal characteristics of John Armleder's

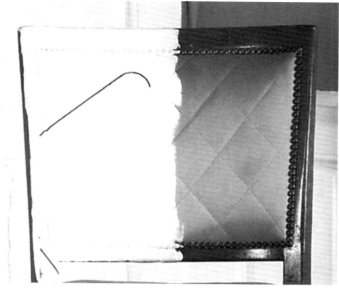

work. Here is a chair, by no means a designer piece; instead simply a run-of-the-mill chair, a found object (objet trouvé?) that is placed within an art context (readymade?). It reveals traces of use (Vanitas?). Now it's been raised on a platform, barely higher than before (the human measure?) – but now it is no longer a "seat." It is instead the "canvas" (support/surface?). With a thick brush (gesture?) the white paint has been applied to a portion of the quilted back cushion, a few of the upholstery nails, a piece of the wooden frame. This supplies the background for two precisely painted lines. The blue diagonal (Constructivism – ascending – moving – progress!) ends with an upward curve (? – Charlie Chaplin's walking stick ???), while the straight red line is so long that it wraps around the front of the wooden stile. The reduction of the "painting's" colors (Mondrian? Malevich?) is contrasted by the brown wood tone and the somewhat faded gold of the upholstery material (Nouveau Realisme?). The object as a "rebus" of a "pictor doctus?" The artist a beachcomber on the shores of an art(ificial) lake? The work an eldorado for art historians who need only enumerate what is so obviously on display? No, these separate clues will not lead us to the treasure. This is about their organization, the product of overlayering and overlapping: the method is the meaning. Armleder's "material" is the knowledge; his goal is not to exhibit this knowledge. »My paintings are fully unreasonable, they escape all intelligent, discursive comprehension ... What we're doing has little to do with what is thought that we're doing.«[10]

Writing on his 1984 exhibit "Peinture abstraite" showing abstract paintings by a range of artists[11] on the Ecart premises (after the gallery had closed), Armleder noted, »If this isn't exactly a manifest, at least I see it as a statement, a ›declared‹ putting into practice.«[12] "Manifestation of a practice" is also a highly apt way of describing how Armleder works, i.e. the way he "produces an artwork" or puts

8 | »By the end of the 'seventies, my work was radically anti-Formalist; then there's a turnabout, and Formalism becomes enhanced in the role that basically disqualified it before.« J. A. in an interview with Suzanne Pagé in John M Armleder (catalog) Kunstmuseum Winterthur et al. (Winterthur, 1987), p. 57.

9 | In early publications one also encounters the title »7 Juin 1980 (FS 1),« 1979, which establishes an explicit reference to the exhibition »7 Juin 1980« at the Centre d'Art Contemporain in Geneva, where the piece premiered. Armleder christened his installation »La Chambre d' Eirc Estia,« referring to the connection between Eric Satie's "Musique d'ameublement" and his own idea of the Furniture Sculptures.

10 | J. A. in an interview with Christoph Schenker, Flash Art, No. 130 (Milan, 1986), p. 68.

11 | With works by John Armleder, Helmut Federle, Lucio Fontana, Sol Lewitt, Verena Loewensberg, Robert Mangold, Gerhard Merz, Olivier Mosset, Robert Motherwell, Blinky Palermo, Gerwald Rockenschaub, Robert Ryman, Jean Frédéric Schnyder and Otto Zitko.

12 | J. A., press release on the exhibition. Quoted in John M Armleder (see note 8), p. 150.

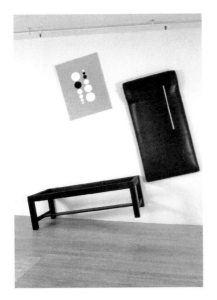

together an exhibit of his own or other people's art. Look at the heterogeneity of the individual work groups, the ostensible discrepancy between the planned geometric pieces and the pour paintings, the highly diverse combinations – of paintings, found pieces, and objects made by others following the artist's instructions. They all indicate that the "style" here (and there obviously is one) ensues from the idea of an action and not from the application of a fixed pattern for execution. For Armleder, the evolutionary process is the moment of realization, the point in time when a preformed idea meets up with the circumstances/coincidences accompanying its execution. Being detached from the work is one precondition for achieving this moment. Farthest from his mind is the idea that working on the painting could be an act of self-affirmation. »The process is important as a project for the painting, but not in its execution. Naturally I have pleasure in painting a picture, and I obviously find out new things while I'm painting, but this is just work, a completely normal process. When I produce a new piece, I just execute it, I don't change my mind about it, I don't correct the colors: in fact I never correct my works. The piece is made the way it is, and it is the way it's made when I'm working on a painting. I don't add new problems. When problems arise, I perhaps use them for a new painting.«[13] John Armleder does not have a studio. His works are produced in galleries or museums, usually for a specific exhibition. The use of alien rooms is not a viable solution. Whereas it is obviously an enjoyable byproduct that one need not maintain premises and can delegate the responsibility for storing the objects to others, exchanging an atelier setting (which is still associated with a certain aura) for a neutral, currently accessible space, is an expression of an artistic strategy. John Armleder cultivates the status of being a guest – in life and in art. Born into a Geneva hotel dynasty, he probably mastered the skill of balancing public and private early on. This faculty allows one to interpret forfeiting the security born of familiarity as a way of escaping the crippling effects of sameness – and as a way of finding (in the necessity of going with the flow, as it were) opportunities to keep moving, at any speed.

John Armleder has never specifically defended himself against critics labeling him a "Zitatkünstler"[14] whose works provide an ironic and cynical comment on other artistic styles. On the other hand, the statements he has made in interviews clearly contravene this assessment, which virtually accuses the artist of pursuing an art-market-oriented strategy positioned between "Madeleine"-style recognition and the element of surprise. What is most relevant for Armleder is not that art evolves from art – that goes without saying – but rather his own conviction that everything has already been done in one form or another. »The art I do respects the norms that are given to art in general, based on the accumulation of art to date and by those who have chronicled it. I'm not doing anything different from what

13 | J. A., see note 10, p. 69.

14 | Armleder does not "quote" or "copy." None of his compositions can be traced to a predecessor; nor does the definition apply in its literal meaning. A quotation presents a third-party idea as an "original" and must be recognizable as such; either it is used to support or sanction a hypothesis or asserted to contradict that hypothesis. In John Armleder's work the issue is by no means a "correction" – a term that, even by virtue of its static nature, is fully inconsistent with the dynamic idea behind this artist's work.

others have already done. There's a social obsession in surpassing the norm or in the belief that it is possible to escape from it.«[15] John Armleder categorically rejects the pervasive addiction to the new, at the same time revealing that the issue is not the simple fact "that" but rather the method how the historically evolved repertoire is utilized. A work of art is the product of knowledge and the resultant act performed in the present. This relative relationship to time also precludes that the work represents a criticism of the past. » ... even when I use components of that art, with its idealism, my art is based on quite different practices, namely today's practice. The irony of my work is not aimed at the art of those times; on the contrary, those works make up a cultural background that I admire and respect.«[16] The critical or ironic undertone targets instead the "art game" as such and hence refers to one's own works as well as those of others. »It's a playful comment pointing out that the space and basis on which we're working is less limited than one would normally think.«[17] Our century now ending has been one in which art reproductions are available around the world and in every shape and form. Art is the most important source of ideas for advertising design, and the auction reports are watched as closely as the stock exchange prices. Today's artists are not the only people who work with a heightened awareness of the omnipresent world of images. »People look at an artwork and try to find out what makes it unusual, and in a certain sense that's not what I'm trying to find... I mean, in one way or another when you look at an artwork, you're seeking to identify with it, which is what makes it less unusual: it doesn't escape us, it's not alien, it's just as banal as we are.«[18] The accessibility of images has not only robbed artworks of their aura and changed the nature of "art-making;" it has also helped highlight the disparity between the significance personally attributed to art and its actual lack of social significance, i.e. its irrelevance in the real world. On the one hand, Armleder plays with this discrepancy when he talks about how he's fascinated by the radical statements of Malevich and Ad Reinhardt, adding »... but I really like the fact that radicality (sic) in art has absolutely no consequences.«[19] Conversely, the implicit freedom that dwells in being relieved of all responsibility is revealed – in the statements on his own work – to be ambivalent. »Despite this conviction, despite this practical insight if you will, that art is a serious matter and you need to do it well, I don't think art is essential. That's a contradiction: it's not essential because it has nothing to do with survival, but it does touch on something lasting, in me and others.«[20] Particularly in conversations with Helmut Federle, he returns repeatedly to this issue. »I can't shake off the idea that when I do a specific work it might just as well be a different one. But parallel to this openly cynical attitude is a total commitment on my part which also helps shape the creative process, that little something that I accomplish at a certain point in time that allows me to put aside everything else.«[21]

15 | J. A., see note 8, p. 64.

16 | J. A., see note 10, p. 69.

17 | J. A., see note 10, p. 69.

18 | J. A., see note 8, p. 64.

19 | J. A., see note 10, p. 68.

20 | J. A., see note 8, p. 63.

21 | J. A. in "Gespräch zwischen John Armleder und Helmut Federle, Zürich, August 25/26, 1994," in Zeichen Fluten Signale – neukonstruktiv und parallel, catalog, Galerie nächst St. Stephan (Vienna, 1984), p. 10.

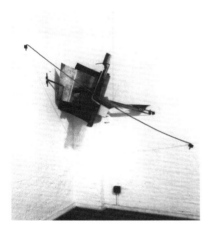

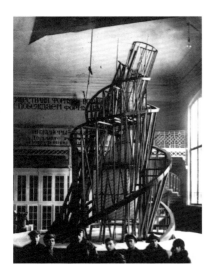

The »recurring contradictions between believing – not believing, formalism – triviality, high quality – junk, concentration – the relativity of our work and its reception«[22] are what define Armleder's attitude towards art. These dichotomies are reflected in his work in the shape of a dialectic tension between order and freedom, plan and coincidence, respect and irony, continuity and interruption, empathy and detachment. The definitive work, the crowning synthesis that subsumes and cancels out all that went before it, is an impossibility. That is why Armleder does not seek confirmation by creating series and variants. Most of his paintings stand alone. If elements or formulations do reappear, then in a completely different – and often opposing – application. The idea of development as progress, i.e. the possibility of moving along a straight road, never deviating and hence ever aiming for a single, final destination, is a phenomenon Armleder takes ad absurdum in every new piece, rendering it at once thesis and antithesis, affirmation and denial both. There is »nothing absolute, not even – if you were to believe in it – short term success.«[23] The decision to choose imperfection as a possibility (dynamic) over perfection as a necessity (static) is manifested in the error revealed to be the vital element at the interface between art and life, between order and chaos.[24] A virulent force, it combats rigidity and ossification. »Well, I guess what I'm trying to say right now is that we all have as individuals, and artists, some kind of line that we constantly radicalize or tend to do so. Time doesn't serve radicalization, it blurs it into ineffectiveness on its early reading. The works, the statements are clogged by that kind of weight, and become a genre, a veteran discourse, an academic pose. Somehow, it's the revenge of the individual intrigue versus the one-time universal gesture, whatever that means. But, saying that, my confidence in contradiction is still untouched.«[25] Hence Armleder continues to chip away at freshly asserted hypotheses with casual aplomb; be this assured approach cultivated or natural, it is in any case absolutely dependable.

The works chosen for the rewind and fast forward show exemplify not only these "looping maneuvers;" they also illustrate – in the manner of a second antagonistic basic principle – how the "repertoire" is changed and brought into play over and over again. At the center of the resultant discontinuous continuity are not the things or their easily orchestrated encounter; it is the recipient who, as part of the perception play, must repeatedly redefine his or her place. The "Tower" stands tall, even programmatic, in the main hall, an accessible scaffold construction parading its finery: colored neon tubes, glittering mirrored balls, Christmas tree lights, blue and orange signal lamps, ghetto blasters, and monitors. Those who climb up the scaffolding, taking on this multimedia parcours, become "part of the artwork" – and this changes their perspective on the ongoing "events" and the room itself. Moreover, the exposed situation on the

22 | Ibid.

23 | Catalog Peinture 1985, Galerie Marika Malacorda, Geneva, reprint, see note 8, p. 154.

24 | »Sometimes I have the feeling that error forms a very important part of realizing my works. Not the errors that are corrected. Just the mistake as such, part of the fiasco.« J. A., see note 21, p. 11.

25 | J. A., see note 4, p. 59.

tower renders them "objects" on display for the other people at the exhibition. Even without knowing anything about Boccioni's "universal dynamism," the visitor will see how motion and light destroy corporeal materiality. »This is exactly the way streetcars penetrate buildings – that are conversely reflected and moved by those same streetcars.« [26] The completely different, »new uses for fluorescent light« alter space and the pour paintings hanging on the walls, in the process just happening to deconstruct the minimalist ideas of a Dan Flavin. Constructive elements and destabilizing light effects together generate tension: the 1996 transparent Perspex sculpture "Labyrinth (Ersatz-Tatlin)" would be virtually invisible were it not for the reflections lending it a visual volume and surface structure that vary with the perspective taken. The very title of this work alludes to the Tatlin Tower, the "Monument to the Third International" (1919) that provided one starting point for this tower's genesis. As early as 1967, John Armleder produced a (no longer existing) variation of this architectonic idea. Then – as in 1996 – he implemented Perspex sheets, hence formulating on a different level the same "transparency" of the steel skeleton superstructure Vladimir Tatlin had striven for: an experiment equating the "invisible" with the "real irreality" of the original tower that was never built. Had the 400-meter high "skyscraper," conceived as a symbol of progress and social change, ever actually been erected, its influence on the art of coming generations may well have been diminished. The Tatlin Tower's significance lies in the fact that it remained architectural utopia. The surviving drawings, models and photographs formally position this ambitious project within the Russian artist's most innovative creative period. Regarded as the inventor of the "counter-relief," the Constructivist and Suprematist was also the precursor of the idea that "everything can be material and object," a point of reference for John Armleder's work. Hence it comes as no surprise that Armleder keeps generating further variations of the "Tower" and translating their new aspects

26 | Umberto Boccioni, »Futuristische Malerei und Bildhauerei« (1914), quoted in Boccioni und Mailand, catalog, Kunstmuseum Hannover (Milan, 1983), p. 47.

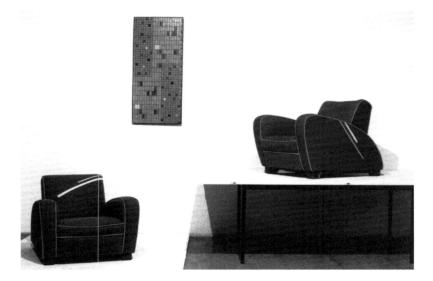

into his own artistic vocabulary. The "Tribune de Genève" erected in 1996 in the Dijon Consortium (in some ways the prototype for the Baden-Baden version) was the first scaffold construction which could be entered. Decorated with pour paintings, the tribune was artwork, observation platform and exhibition space in one. The sense of momentum Tatlin incorporated into his own plans – generated by an emphasis on the diagonal and the inclusion of four volumes (hemisphere, cylinder, ball and cube) revolving at different speeds – finds its pendant in Armleder's spinning disco balls and signal lamps. The flashing lights roaming over all the room's surfaces "reflect" the dynamic principle, playing with the transience of perception.

The installation becomes a podium where the formal problems of art in our century are debated – but not only that. The "reality experience" in the age of zapping, the juxtaposition of the "highs and lows" of culture and cult that Armleder revels in, also have their home on the tower. Ten videos are shown simultaneously on ten monitors, their soundtracks subdued by the penetrating strains of gagaku. This Japanese court music – bad quality emanating from garishly colored baby ghetto blasters – sounds somber and ritualistic to Western ears. Visitors nonetheless tend to permit it access to the art forum more easily than the science fiction films from the 'fifties, 'sixties and 'seventies; it's all a question of perspective. Today "Gorgo"[27] and "This Island Earth"[28] are cult; gagaku lulls shoppers in Asian department stores around the clock. John Armleder is interested in these reality games, in illusions and their discrepancies. His choice of B movies for his video installations is a deliberate one: this genre is usually filmed on the set of a major production, a by-product sans stars and expensive props, a meal of leftovers whose on-the-spot preparation lets the imagination run free. These low-budget films are too insignificant to attract the interest of the censors; no one reviews the "quality" of these stories or "messages." Being so far removed from the parables of righteous morality and, ironically, being so very hackneyed, they are ideally suited to portray life in the B-society at the end of the 20th century: a place where fiction and reality have become melded to form an indivisible conglomerate. There is nothing "outside," anymore, everything is here and now (nowhere/now here) and we're smack dab in the middle. We're inundated with images, swept along by the flow of information. But John Armleder wings it through the tide in freestyle, borne up by the waves, maneuvering with ease against the current, his eye trained on the sparkling surface of the water and the world mirrored on its moving masses.

In the past and particularly more recently, John Armleder has used Perspex sheets and mirrors. He's fascinated by these materials because their reflecting surfaces respond to every nuance and hence communicate silently with the world. They produce short-lived

27 | Gorgo, VCI, NR, 75 min. Dir.: Eugene Lourie. "You get to witness some of the coolest man-in-a-monster suit mass destruction ever filmed west of Tokyo." Quoted by James O'Neill, Sci-Fi on Tape, A Complete Guide to Science Fiction and Fantasy on Video (New York, 1997), p. 96.

28 | This Island Earth, MCA/ Universal, 1955, NR, 85 min., Dirs.: Joseph Newman, Jack Arnold. "The only really A-budgeted Universal sci-fi film from this period, this has gorgeous color and flashy special FX but is terribly slow and drawn-out. Arnold reportedly stepped in at eleventh hour and directed all the scenes on Metaluna, which explains why they're so tense and exciting when compared to the rest of the film." Ibid, p. 213.

images without claim to truth, candids born of coincidence. While this pleases Armleder, it's not enough: only concave and beveled mirrors, only warped perspex sheets guarantee the distortion, the distance we need to put between ourselves and reality in order to recognize it as an illusion. The specific way Armleder arranges his combines, installations and furniture sculptures has much in common with these "reflections." His works invariably present an unusual, "distorted" picture of the (art) world. Our expectations are not met, but our curiosity is aroused. It is, after all, possible to see beyond this "false" image and catch a glimpse – in this unusual combination – of a "new order" in this supposed chaos. Order is rendered relative, liberated from hierarchic ballast and grasped as a relation between things. Each individual element has its own character, autonomy and unique shape serving to further highlight the differences between the parts that relate within the whole.

But working on the brink of invisibility and playing with transparencies has another dimension too: »I do things although it doesn't look like it, and if possible without formulating them. Even if I make works with large dimensions, I try to do it in a way that you can't see them.«[29] The distance between the artist and the work is maintained, as is that between the viewer and the work. An encounter is possible, but there is no coercion. John Armleder likes the notion of a product being completely detached from its producer, of an artwork being restored to the anonymity of being a "thing." He is thoroughly aware of the limits of that "emancipation", even if he sometimes pretends otherwise. Or is he just pulling our leg, making a different point when he claims that he'd rather not recognize his own work? That he'd rather be attracted to a piece, "approach something empty" and then – lo and behold! – discover »John M Armleder« on the plaque?

29 | J. A., see note 8, p. 63.

**Translated from the German by
Mary Fran Gilbert & Keith Bartlett**

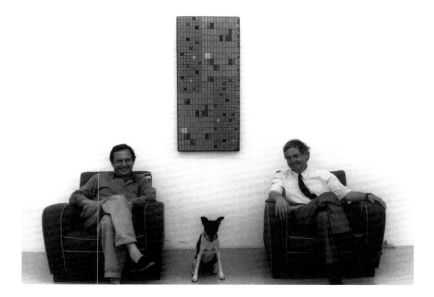

Parker Williams meets John Armleder
on the Shores of Lake Como. Summer 1996

THE BOTANICAL SPEEDBOAT EXPERIENCE
INEVITABLE

JOHN ARMLEDER
PARKER WILLIAMS

PARKER WILLIAMS I am surprised about how you shuffled your previous scaffolding experiences around to fit them, or program them within the Villa Carlotta.

JOHN ARMLEDER I was surprised myself about how came out the early version anyway. But in fact, I am not sure what kind of a relationship they share.

PW Well then, let's check the story. If I am right, you started a few years ago working on a construction planned for a show at the gallery Massimo De Carlo in Milan. The gallerist said you talked about a sort of Tatlin Tower (The Monument to the 3rd International), that one could walk into and climb up, but built in a clumsified Jessica Stockholder style ... This did not happen there, but eventually was staged in a show at the Consortium in Dijon. The one in Milan was replaced by an almost invisible perspex construction of panels arranged into a floor based impenetrable shut labyrinth tower. In Dijon, you sent a documentation about Tatlin's project to the workers of the municipality for them to imagine how to build a three story level self-standing tower, using the scaffolding materials available. The piece, was ultimately planned to be used by the visitors, staging them in it as part of the system, and as they pursued their visit up the tower, a set of events would be available to them at different view levels. Paintings hung on the side, recto or verso, shelves had TV monitors showing a set of eight B movies of the Fifties and Sixties, S8 films were projected on the paintings and on the steps, disco-balls hung above and below the construction. Perspex sheets reflected a symmetrical mirror view of the architectonics of the proceeding, a battery of six ghettoblaster tape-decks were asyncromatically diffusing the whole works of the Mamas & Papas, and so on. The whole construction functioned as a funky vista-point for tourists that, from peek level, offered a view on a huge pour-painting hanging across on a wall, to be seen from above as an extravagant waterfall.

JA Well, you got much of it, I see!

PW Yes, I figure I should also mention the lights, fluorescent tubes at a diagonal following the steps leading on each floor (the only orthogonal elements), the nests of flickering Christmas illumination lights arranged as strange knots, alien inflicted stars, plus the disco lights provided by the spotlights on the disco balls, the scattered reflections they induce, the shivering lights diffused by the TV screens and the films projected, plus the music. Quite electronical all that.

JA Ok, you got it somehow.

PW This installation seemed somewhat more baroque than the one at the Villa Carlotta.

JA This latter operation used similar devices into a different set of strategies. The earlier construction is based on a metaphorical procedure involving the related Tatlin model (modernist ideological epic), the post-modern elaboration (Stockholder), the panoramic vista-point (sculpture threshold pedestal for the viewer to gaze

Ok, you got it somehow.

upon abstract paintings turned into landscape extravaganzas), all of this given to in the no-ties architectural stage of the white box contemporary art gallery setting. The focus was totally on the monster landed in the cipher space of the no-man's land of art-spiel. The use of kaleidoscopic memory technics, of abuse of pregiven sets and mental decors turn out being the most substantial event, undirected by any other purpose or production. In the Villa Carlotta production, the whole program is angled by an ambient foreplay. This foreplay is the intellectual arousal of the happening, inasmuch as the sensual one.

PW Wow! so I get why this is all so sexy. Glistening giant lizards, blowing rockets, spy speedboats, disco-globes, jungle greens and purple flowers, crystal chandeliers, pompeian frescoes, suave ripples of the lake kissing the shores below the magnificent gardens ...

JA Let your mind behave! It seems that once that slurpy gate is opened, there is no way of calming you down.

PW All right then. But after all, your pieces are quite physical, to the visitors that is. And the provided inputs quite sensual... So, tell me how this vessel of yours was designed?

JA To land where it was to be experienced. The structure is a rough being. A sketch, a model and a usable vehicle as such, like a "Bad Max" custom mechanic. It's mimetical to the formal architectonical proposals the hall provides. It's an unlikely bridge as in a jungle movie episode, but the leads are set within. One crosses from over the bridge that licks the floor to the three upper levels, step by step in a symmetrical mirror cast to face the TV monitors displaying an encapsulated escape.

PW These are the cult movies and the two local tapes.

JA The movies on the north side were wonders of mechanical inventions at play: flying saucers, rockets from outer space and Abbate speedboats. On the south promontory, the organic world lead the story with alien creatures rampaging, of giant batrahians and leafy greens wildly exposed in the Villa's gardens.

PW That were filmed by you ...

JA The tape was a production shot for the exhibition by students of the summer course together with me.

PW And what were the other films?

JA The "Organic" program included "The Monster of Piedras Blancas" and "Gorgo", the spaceships side featuring "This Island Earth," "Earth vs the Flying Saucers" together with the Tullio Abbate demonstration tape.

PW The spectator, having climbed up all the way, was engulfed in the ceiling's vault and its delicate pompeian arabesques, and when facing the bay-windows had his view to the garden partially obliterated by the monitors (including one showing Abbat's boats on the lake observable outside, and another the gardens themselves also in direct sight); when turning to look back upon the room itself the chandeliers cleared away the unobstructed appreciation of the space.

The visitor leaning and hopping to catch a glance at all sights ... But, all that going on still left a fearly contemplative act to be experienced compared with the Dijon affair.

JA Apart from other implications we often talked about, these works use in different ways an overloaded stream of information, of significations and events. Any evidence, all of them conglomerate in a jellified offering, with the characteristic translucid shine. Perhaps the earlier version was more opera-circus patterned as fancied by John Cage with congregations that remind me of Gottschalk. Talking about his "Fête champêtre cubaine" he described composing a "Triumphal Hymn" and a "Grand March": "My Orchestra consisted of 650 performers, 87 choristers, 15 solo singers, 50 drums, and 80 trumpets. That is to say nearly 900 persons bellowing and blowing to see who could scream the loudest. The violins alone were seventy in number, contrabasses eleven, violoncellos eleven!"

PW I would have thought you'd relish on Gottschalk as a composer. He used to stage what he calls "Monster Concerts" after all!

JA How could I resist a musician arranging the March from Tannhäuser for fourteen pianos! Furthermore, once a young patronized youth was imposed to him to play in such an ensemble, and obliged to let him play, Gottschalk had the mechanism of the piano removed by the tuner before the concert so that the young lad could play with all stamina his unnoticeable muted instrument among the thirteen other pianists ...

PW And I understand that in your view the pathetic agitation of that player was not a minor contribution to the meaning of the event. Talking about transcriptions, I should quote now in that perspective a former conversation we had in which you said the following: »The cartographers in the onirical land that Sylvie and Bruno wander throughout in Lewis Carroll's last fiction suffer to match with the fidelity they seek, the map transcriptions in small scale of the territories drafted. One is familiar with the tribulations that follow: the maps are made larger and larger finally matching the 1:1 scale of the land itself, and as the farmers angrily protest as their fields are shaded by the unfolding of the maps, the cartographers decide to use the actual ground as the map itself. So to say, reality understood as a transcription. Now the step today probably implies that reality doesn't match itself. Our planet is not itself anymore. It's no more the Earth. We use it for other purposes. It is a set for shooting B series. Finally! We should carefully watch the parachutist in all the Killer Tomatoes sequels as he demonstrates an unheard version of Art as a prothesis, an icaresque prothesis as a wreck.« (in Che fare? Never Say never, Offizin Verlag, Zürich 1996).

I believe the story has still a romantic punch, since you display festive "plateaux" as extravagant features and provide dissoluting mediums for evanescent seizures.

JA Here you go again!

How could I resist ...

P W I must run to catch

J A In a porridge world, running stops you, sinks you like in quick-
sands. You'd better beaming your mind into its marshmallow condi-
tion and then float around to enjoy: aren't earthlings just yet some
innocent planetoids in storage for fun adventures …

*Parker Williams trifft John Armleder
an den Ufern des Comer Sees, Sommer 1996*

DAS BOTANISCHE SPEEDBOAT-ABENTEUER
– UNVERMEIDLICH

PARKER WILLIAMS Ich bin überrascht, wie Du es geschafft hast,
Deine früheren Gerüsterfahrungen so umzugestalten, daß sie in die
Villa Carlotta hineinpassen.

JOHN ARMLEDER Ich war selbst überrascht, sogar schon über
die frühere Version. Aber Tatsache ist, ich bin mir gar nicht mehr
sicher, in welcher Beziehung sie zueinander stehen.

P W Also dann, laß uns die Geschichte mal aus der Nähe betrach-
ten. Wenn ich mich recht erinnere, hast Du vor einigen Jahren be-
gonnen an einer Konstruktion zu arbeiten, die für eine Ausstellung
in der Galerie Massimo De Carlo in Mailand gedacht war. Der Galerist
erzählte, Ihr hättet über eine Art Tatlin Turm (Das Denkmal der III.
Internationale) gesprochen, in den man hineingehen und den man
besteigen kann, der aber in einer Art klobigem Jessica Stockholder-
Stil gebaut war.… Das hat dann zwar nicht dort, aber in einer Aus-
stellung im Consortium in Dijon geklappt. In Mailand gab es statt-
dessen eine nahezu unsichtbare Plexiglas-Konstruktion aus einzelnen
Scheiben, die ein auf dem Boden stehendes, unzugängliches Laby-
rinth bildeten. Nach Dijon, an die Arbeiter des dortigen Bauhofs, hast
Du eine Dokumentation über das Tatlin Projekt geschickt, um Ihnen
eine Vorstellung davon zu geben, wie man einen freistehenden, drei-
stöckigen Turm mit den vorhandenen Gerüstteilen bauen kann. Das
Werk sollte von den Besuchern genutzt werden, sie "inszenieren",
zum Teil des Systems machen, und bei ihrem Aufstieg sollten unter-

schiedliche Attraktionen für sie auf den verschiedenen Ebenen erreichbar sein. Gemälde hingen an den Seiten, richtig herum und auf dem Kopf, auf Regalen standen Monitore, auf denen acht B-Movies aus den 50er und 60er Jahren liefen, S8-Filme waren auf die Bilder und die Treppenstufen projiziert, Spiegelkugeln hingen über und unter der Konstruktion. Plexiglasscheiben reflektierten eine symmetrische Spiegelung der Architektur und des Geschehens, sechs Ghettoblaster vermischten „asynchromatisch" die Titel der Mamas & Papas usw. Die ganze Konstruktion diente als verrückter Aussichtsplatz für Touristen, von dessen höchstem Punkt sich der Blick auf ein großes Schüttbild bot, das gegenüber an einer Wand hing und von oben wie ein extravaganter Wasserfall aussah.

J A Okay, Du hast ziemlich viel davon mitgekriegt.

P W Ja, ich denke, ich sollte auch die Lichter erwähnen, fluoreszierende Röhren, die diagonal den Stufen folgten, die von einer zur nächsten Ebene führten (die einzigen orthogonalen Elemente), die Nester flackernder Lichterketten, die zu komischen Knoten verschlungen waren, seltsam verstrickte Sterne, und das Discolicht, das von den Spotlights auf den Spiegelkugeln kam, die abgehackten Reflexionen, die sie produzierten, das Flimmern der Bildschirme und der projizierten Filme, plus die Musik. Ziemlich elektronisch, das Ganze.

J A Gut, Du hast es irgendwie verstanden.

P W Diese Installation erschien irgendwie mehr barock, als die in der Villa Carlotta.

J A Diese spätere Aktion nutzte die gleichen Mittel in einem anderen strategischen Zusammenhang. Die erste Konstruktion basierte auf einem metaphorischen Verfahren und bezog das verwandte Tatlin-Modell (modernistisch, ideologisch, episch) ebenso mit ein, wie seine post-moderne Bearbeitung (Stockholder) und den Panorama-Blick (Skulptur, Schwelle, Sockel für den Besucher, um auf abstrakte Gemälde zu schauen, die sich in Landschafts-Extravaganzen verwandelten), und all das fand statt auf der wenig eleganten architektonischen Bühne, die den white cube, den Ausstellungsraum für zeitgenössische Kunst charakterisiert. Im Zentrum stand das gestrandete Monster, das im „Nullraum", im Niemandsland des Kunst-Spiels gelandet war. Die Verwendung von kaleidoskopartigen Erinnerungstechniken, der Mißbrauch von vorgegebenen Regeln und geistigen Ausschmückungen erweisen sich als das eigentliche Ereignis, das unabhängig von einem anderen Zweck oder einer Produktion bleibt. In der Villa Carlotta ist das ganze Programm durch die Atmosphäre bestimmt, die das Ambiente vorgibt. Diese Atmosphäre ist der Ursprung der intellektuellen Erregung, ebenso wie der sinnlichen.

P W Wow! Jetzt weiß ich, warum das alles so sexy ist! -
Schimmernde große Eidechsen, fliegende Raketen, Spione in Speedboats, Disco-Kugeln, grüner Dschungel und purpurrote Blumen, Kristallkronleuchter, pompejanische Fresken, weiche Wellen, die die Ufer des Sees jenseits der wundervollen Gärten küssen

...irgendiwe mehr barock

JA Reiß Dich zusammen! Wenn diese Schleusen einmal geöffnet sind, gibt es keine Möglichkeit mehr, Dich zu bremsen.

PW Okay, okay, aber trotzdem: Deine Arbeiten sind ungeheuer körperlich, oder sie wirken zumindest auf die Betrachter so. Sie sind sehr sinnlich aufgeladen... Aber jetzt erzähl mal, wie Du Dein Luftschiff entworfen hast.

JA Es sollte dort landen, wo es wahrgenommen würde. Seine Struktur ist eher grob, eine Skizze, ein Modell und ein nützliches Hilfsmittel, eine veraltete Mechanik wie ein „Mad Max". Es paßt sich den architektonischen Vorgaben des Raums an. Es ist mit diesen unglaublichen Brücken aus Dschungelfilmen vergleichbar, hat aber eine eingebaute Wegführung. Man überquert die Brücke, die den Boden mit den drei oberen Ebenen verbindet, und kommt so Schritt für Schritt in eine symmetrisch spiegelnde Szene hinein, während auf den TV-Monitoren aussichtslose Fluchten ablaufen.

PW Das sind die „Kult-Filme" und die lokalen Filme.

JA Die Filme auf der Nordseite zeigten Wunder mechanischer Erfindungen: fliegende Untertassen, Raketen aus dem All und Abbate Speedboats. Das südliche Kap beherrschte die organische Welt mit tobenden Außerirdischen, gigantischen Echsen und der grünen Hölle des Gartens der Villa.

PW Das wurde von Dir gefilmt ...

JA Das Band war eine Gemeinschaftsproduktion der Studenten des Sommerkurses und mir für die Ausstellung.

PW Und die anderen Filme?

JA Im „organischen Programm" liefen „Die Monster von Piedras Blancas" und „Gorgo". Die Weltraumseite zeigte „This Island Earth", „Earth vs the Flying Saucers" und das Tullio Abbate Werbetape.

PW Der Betrachter, der den ganzen Weg hinaufgestiegen war, wurde von dem Deckengewölbe und den eleganten, pompejisch Arabesken verschlungen. Wenn er vor den sich zum Garten öffnenden Fenstern stand, so wurde die Aussicht teilweise durch die Bildschirme verstellt (ein Monitor zeigte Abbate's Boote, die auch draußen zu sehen waren und ein anderer die Gartenanlage selbst) und blickte er ins Innere, so versperrten die Kronleuchter die freie Sicht in den Raum. Der Besucher mußte Verrenkungen machen, um verschiedene Einblicke zu erhaschen.... Aber, obwohl so viel passierte, war die Stimmung doch eher kontemplativ im Vergleich mit den Erfahrungen in Dijon.

JA Abgesehen von anderen gedanklichen Verbindungen, von denen wir oft gesprochen haben, benutzen diese Arbeiten auf verschiedene Weise ein Übermaß an Informationen, an Bedeutungen und Ereignissen. Es gibt keine Eindeutigkeit, alles wird als glibberiges Konglomerat mit dem typischen transluziden Schein angeboten. Vielleicht war die frühere Version mehr wie ein Opernzirkus nach dem Geschmack von John Cage und mit Zutaten, die mich an Gottschalk erinnern. Als wir über seine "Fête champêtre cubaine" sprachen, beschrieb er seine Art zu komponieren als „Triumphalen Hymnus" und „Großen

Marsch" und sagte: „Mein Orchester bestand aus 650 Performern, 87 Sängern, 15 Solisten, 50 Schlagzeugen und 80 Trompeten. Das bedeutet fast 900 Personen, die brüllend und blasend herauszufinden versuchten, wer am lautesten schreien könnte. Es gab allein 70 Geigen, 11 Kontrabasse und 11 Celli!"

P W Das hätte ich mir denken können, daß Du Gottschalk als Komponisten schätzt. Er war es ja, der das, was man „Monster Konzerte" nennt, auf die Bühne brachte!

J A Wie könnte ich einem Musiker widerstehen, der den Marsch von Tannhäuser für vierzehn Klaviere arrangiert hat! Und was noch besser ist: Einmal wurde ihm ein Protegé für sein Ensemble aufgedrängt, und nachdem er sich verpflichtet fühlte, ihn spielen zu lassen, hat Gottschalk den Verstärker des Klaviers vor dem Konzert abgeschraubt, so daß der Junge mit seiner ganzen Leidenschaft, aber unhörbar, das stumme Instrument inmitten der dreizehn anderen Pianisten spielen konnte ...

P W Und mir ist klar, daß aus Deiner Sicht der überschwengliche Einsatz dieses Pianisten kein geringer Beitrag zur Bedeutung des Ganzen war. Wenn wir aber schon über „Transkriptionen" sprechen, sollte ich jetzt aus einem unserer früheren Gespräche zitieren, in dem Du gesagt hast: »In Lewis Carrolls letztem Roman klagen die auf Genauigkeit bedachten Kartographen des Traumlands, das Sylvie und Bruno durchwandern, über den kleinen Maßstab, in den das zu vermessende Land übertragen werden muß. Die betrüblichen Folgen sind bekannt: Die Karten werden größer und größer, bis sie das Land im Maßstab 1:1 abbilden und die Bauern sich zornig beschweren, daß ihre Felder beim Aufklappen der Karten zugedeckt würden, woraufhin die Kartographen beschließen, das Land selbst als Karte zu benutzen: Die Wirklichkeit als Transkription ihrer selbst. Die jüngste Entwicklung ist nun wohl die, daß die Wirklichkeit sich selbst nicht mehr ähnelt. Und der Planet ist ja nicht mehr er selbst. Dies ist nicht mehr die Erde. Wir nutzen sie für andere Zwecke. Sie ist ein Drehort für B-Movies. Zu guter Letzt! Wir sollten den Fallschirmspringer in all den ›Killer-Tomaten‹-Folgen aufmerksam beobachten, denn er zeigt uns eine noch nie dagewesene Darstellung von Kunst als Prothese, eine ikareske Prothese, die in Fetzen hängt.« (in: Che fare? Never Say Never, Offizin Verlag, Zürich 1996)

Ich glaube, die Geschichte hat noch einen romantischen Touch, seit Du auch noch festliche „Plateaux" als extravagante Reißer zelebrierst und verwirrende Medien bereithältst für vergängliche Größen.

J A Jetzt fängt das wieder an!

P W Ich muß jetzt los ...

J A In einer Haferbreiwelt, bremst Dich das Losrennen, Du sinkst ein wie im Treibsand. Es ist besser Du versetzt Deinen Geist in einen Marschmallow-Zustand und schwebst dann umher, einfach nur um zu genießen: Sind die Erdlinge nicht doch nur unschuldige Planetoiden auf Lager gelegt für lustige Abenteuer.

Ich muß jetzt los . . .

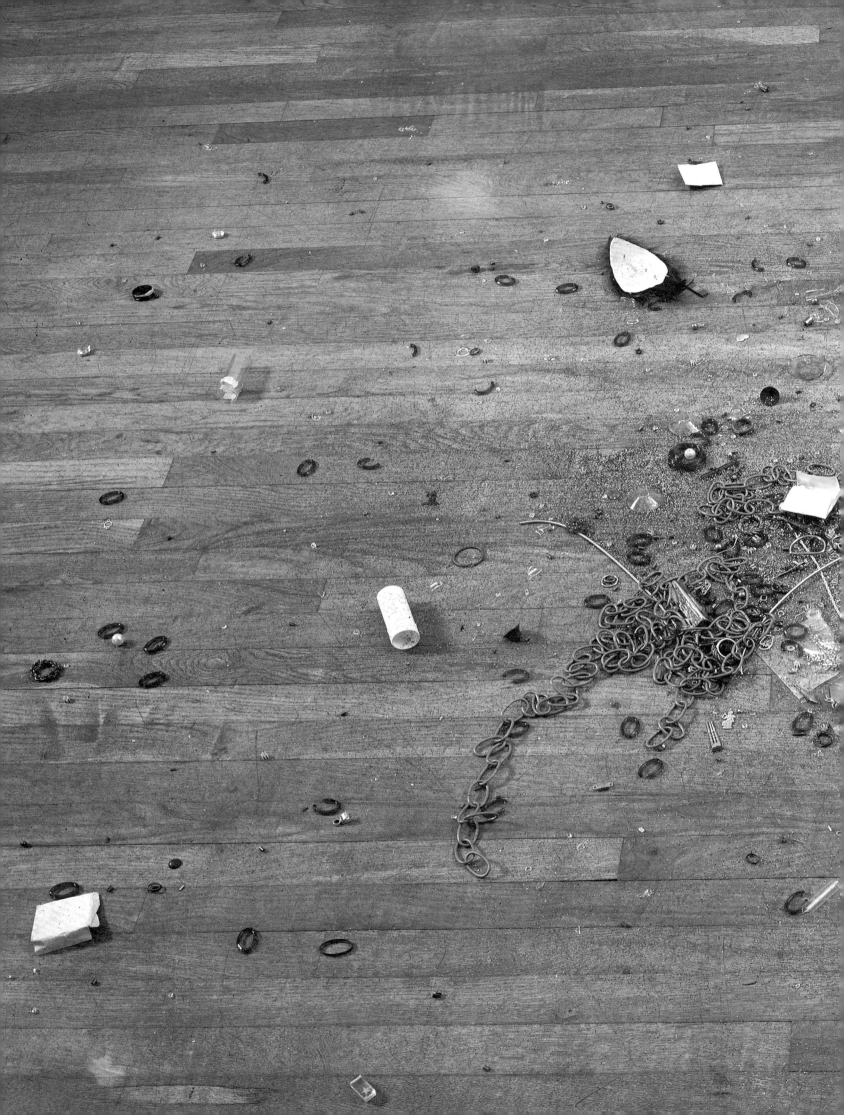

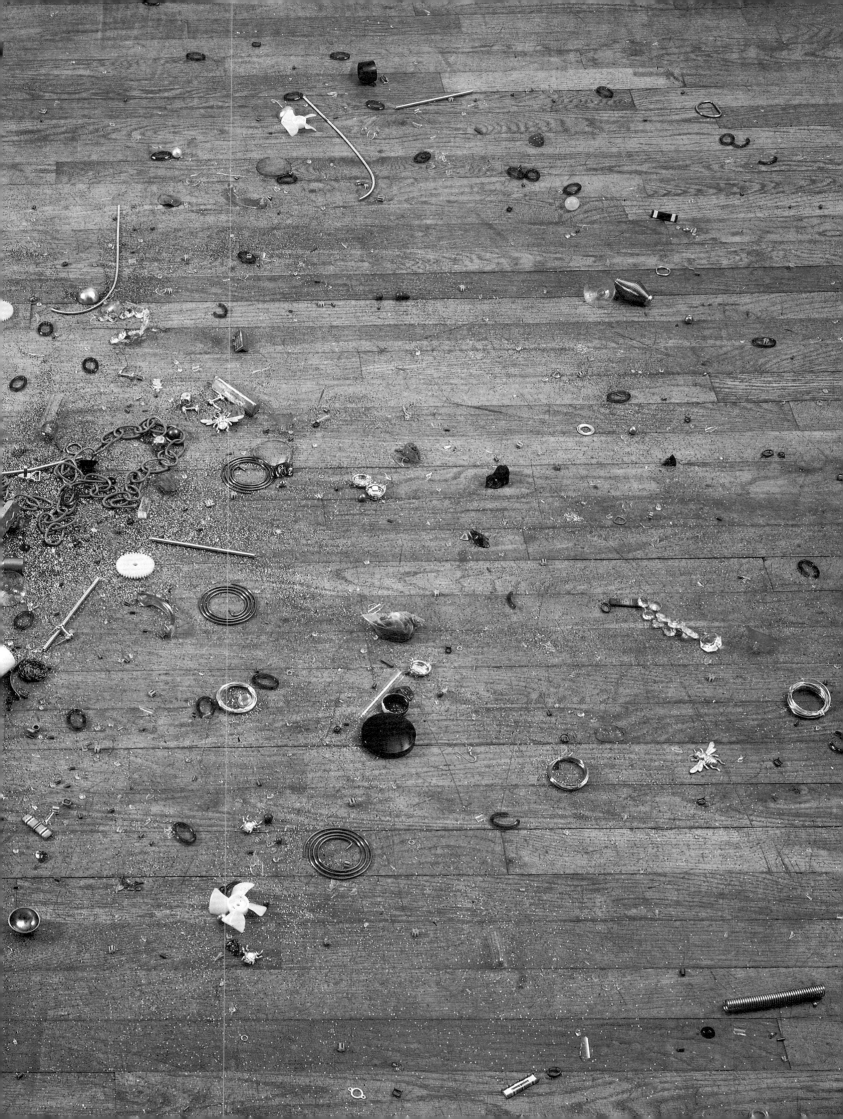

GENIESSEN, SCHAFFEN, KOMMUNIZIEREN: JOHN ARMLEDER

GIACINTO DI PIETRANTONIO

SCHON DIE ART, in der John Armleder sein Werk zu einem expressiven Fluidum zwischen Kunst und Leben macht, zeigt, daß er ein Künstler ist, der die Wende dieses Jahrhunderts mit allergrößter Wachsamkeit beobachtet. Wenn die Kunst eine Möglichkeit darstellt, dann ist das Leben eine Notwendigkeit, die diese Möglichkeit bedingt. Aus diesem Grund sind die Werke von John Armleder weniger Formen zum Anschauen, als vielmehr Bilder, Orte, Ereignisse, die eine direkte Teilnahme fordern. Hier geht es um das Verhältnis zwischen Kunst und Leben, das zahlreiche Avantgarden und Post-Avantgarden dieses Jahrhunderts zu realisieren versucht haben, von denen wir Spuren im Werk Armleders finden. Nicht zufällig hat der Künstler gerade im Umfeld von Fluxus Position bezogen, wo diese Beziehung eine Grundlage der poetischen Praxis ist. Aber während die Avantgarden sich darauf konzentrierten, mit neuen Möglichkeiten zu experimentieren, um andere Wege zu finden, Kunst zu machen und die Welt zu verändern, zielt Armleder auf die Vermittlung der vitalen Idee selbst. Weil Kommunikation eines seiner Hauptanliegen zu sein scheint, gründete Armleder zu Beginn seiner künstlerischen Karriere zusammen mit Lucchini und Rychner 1969 in Genf die Gruppe Ecart. Eine Künstlergruppe, deren Ziel nicht so sehr die Vermarktung der eigenen Werke, sondern die anderer Künstler war. Dieser kleine, große Zusammenschluß organisierte Ausstellungen, publizierte Bücher, Kataloge, Schallplatten, Kassetten, Multiples, – kurz alles, was notwendig ist, um die zeitgenössische Kunst im allgemeinen und besonders die der Künstler, die aus dem Fluxus-Umfeld kamen oder dort ihren Schwerpunkt hatten, zu verbreiten.

Diese Art zu leben und Kunst zu machen entspricht der Idee von Kunst im Zeitalter ihrer technischen Reproduzierbarkeit, in dem – wie schon Walter Benjamin festgestellt hat – die Aura des Einzelwerks durch die neuen Wege der Kommunikation und Distribution bedroht ist, durch die das vervielfältigte Produkt aber zugleich eine kommunikative Qualität erlangt, indem es eine größere Anzahl Menschen außerhalb der Museen oder Galerien erreicht und überraschend in ihr alltägliches Handeln eingreift. Aus diesem Grund integriert Armleder alltägliche Gesten in sein Werk, das Servieren von Tee auf der Biennale in Paris 1975 oder Haushaltsgegenstände wie etwa Möbelstücke.

Obwohl der Gegenstand ein „Material" ist, das im Kunstkontext dieses Jahrhunderts – und verstärkt gegen dessen Ende hin – häufig zum Einsatz kommt, hat sich Armleder einen eigenen Zugang bewahrt und verwendet stets anonyme Objekte, keine Designerware, sondern Benutztes aus zweiter Hand. Die Verwendung des bereits Gebrauchten garantiert, daß das Objekt nicht länger als Ware betrachtet wird und unterstreicht zugleich die Tatsache, daß nicht die Form an sich, sondern das Erfahrene, seine Geschichte von Interesse ist. Um diesen

Bezug zwischen Kunst und Leben vermitteln zu können, wählt Armleder den direktesten Weg: die Übermalung der Objekte mit abstrakten Bildern oder die Kombination mit abstrakten Bildern. Er versucht damit, dieses Konzept nicht nur einem beschränkten Kreis Kunstbeflissener zu vermitteln, sondern auch einem breiteren Publikum. Jeder hat ein Bild zu Hause an der Wand, über dem Sofa oder neben einer Anrichte hängen, ein Bild, bei dem es sich nicht notwendigerweise um ein Original handelt und das nicht vom Leben abgetrennt ist wie jene, die in Museen und Kunstgalerien ausgestellt sind. Außerdem kann diese Vorgehensweise des Kombinierens ebenso als Kommentar auf das Kunstwerk im Zeitalter seiner technischen Reproduzierbarkeit gelesen werden, in dem die Einzigartigkeit (Schöpfung) des Bildes und die Reproduzierbarkeit des Objekts (Produktion) konfrontiert werden.

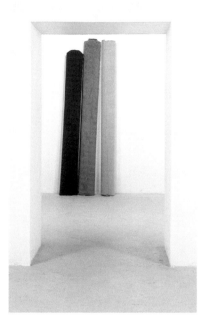

Stets sollte in der Entwicklung des Werks von Armleder die Bedeutung berücksichtigt werden, die seiner Aktivität in der Künstlergruppe und noch mehr dem Galerieraum Ecart zukommt, in dem zugleich das Kunstwerk und das Konzept des Ausstellungsraumes zur Diskussion gestellt wurden: Gefragt war keine architektonische Hülle, an deren weißen Wänden Bilder aufgehängt werden konnten, sondern ein Arbeitsraum für die Produktion und Verbreitung von Kunst, Zeuge einer neuen Epoche, in der Botschaft und Kommunikation von grundlegender Bedeutung sind. Hiermit stellte Armleder ein Paradox der Avantgarde zur Diskussion, nämlich zugleich auf das Leben zugehen zu wollen und sich doch von ihm fernzuhalten. Er dagegen versucht diese Diskrepanz zu lösen. Um genauer zu sein: Er formt die Idee des Raumkontextes von Duchamp um, der uns gelehrt hat, wie ein kunstfremdes Objekt („ready made") durch die Präsentation in einem Ausstellungsraum im Kunstsystem zu plazieren ist, indem er einem Alltagsgegenstand ein modernes Bild, sei es abstrakt oder informell, zuordnet.

Wie weit das „ready made" schon wieder zurückliegt, machen diese Kombinationen von Objekt und Gemälde deutlich, indem sie nicht mehr Metapher sind, sondern ein häusliches Mikroambiente reproduzieren, einen alltäglichen Innenraum; wir sind nicht mehr in Gegenwart eines Objekts im Kunstraum, sondern in einem kleinen Raumabschnitt, der an das Leben und seine Beziehungen erinnert. Diese Verschiebung der Wahrnehmung bildet die Grundlage, um die linguistische Transformation zu verstehen, die auf dem Weg von der Moderne zur Postmoderne und folglich zwischen der Epoche des Experimentierens und der der Kommunikation, zwischen Relation und Partizipation vollzogen wurde. Es steht außer Zweifel, daß Duchamps Geste einen experimentellen Wert hat und ein neues Terrain eröffnet, zugleich ist sie aber – wie alle Experimente – schwer zu verstehen, ohne die Kenntnis der Theorie, auf die sie aufbaut und

ohne den Kontext, in den sie gehört und außerhalb dessen sich das „ready made" wieder in ein simples Objekt zurückverwandelt.

Andererseits ist es klar ersichtlich, daß Armleder die Duchampsche Geste in eine faktische Komposition umformuliert, indem er deutlich macht, daß ein Objekt nicht außerhalb seines Kontextes gesehen werden kann, zugleich aber den Eindruck erweckt, daß es durch Zufall Teil der Inszenierung wurde, – ein Schicksal, das so manches „ready made" ereilte. Sicher ist dieses Mißverständnis ein Paradox der Zeitgenossenschaft, das geklärt werden muß, damit sich nicht noch mehr Vorfälle ereignen wie auf der Biennale 1978 in Venedig, als Duchamps „Tür" von nichtsahnenden Handwerkern frisch gestrichen wurde. Etwas in einen Kontext einzufügen, bedeutet einen Platz besetzen und etwas etablieren; ein Objekt – sei es ein Stuhl, ein Tisch, ein Musikinstrument oder eine Jalousie – mit einem Bild kombiniert, fordert von uns eine unmittelbare Wahrnehmung des Verhältnisses des Einzelnen zum Ganzen, wodurch es zum integralen Bestandteil des Werks wird. Das Werk selbst ist es, das uns hier interessiert, da die Rückkehr zum Kunstwerk geradezu ein Charakteristikum dieses Jahrhundertendes zu sein scheint, und Armleder darüber hinaus das Problem ganz anders angeht als der Neo-Expressionismus. Obwohl beide die Aufmerksamkeit vom Kontext weg und auf das Werk hinlenken, so agieren sie doch auf ganz unterschiedlichen Kommunikationsebenen.

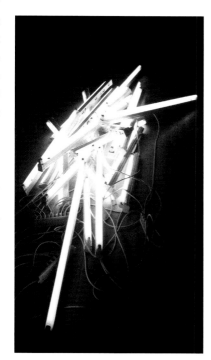

„Ein Kunstwerk ist ein Kunstwerk", scheinen die Werke John Armleders zu behaupten. Der Künstler verhält sich damit zu dem „Erfinder" Marcel Duchamp wie der Informatiker Bill Gates zum „Wissenschaftler" Albert Einstein. Von Bedeutung sind Zwischenfälle, die den Umwandlungsprozeß von realen Objekten in Kunstwerke begleiten. Wenn die Werke dennoch von vielen Rezipienten mit realen Dingen verwechselt werden, so geschieht das, weil sie symptomatisch für den Bezug zwischen Realität und Fiktion stehen und den Status der Massenwahrnehmung zeitgenössischer Kunst enthüllen. Solange für die meisten Menschen die Kunst vom wirklichen Leben getrennt bleibt, kann es nicht überraschen, daß eine alte Tür sich plötzlich frisch gestrichen wiederfindet. Das ist eine der Fehlstellen, die die Künstler heute zu minimieren versuchen, indem sie ihr künstlerisches Handeln vom Experiment auf die Kommunikation verlagern, also den relationalen Aspekt höher bewerten, den das Werk zum Benutzer herstellt, der ja nicht nur ein Kunstwerk anschaut, sondern zugleich die öffentliche Ästhetik, die es vermittelt und produziert.

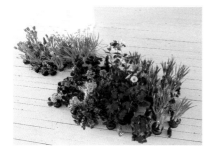

Die poetische Praxis neu zu definieren, ist die Aufgabe eines jeden Künstlers, weil es nicht mehr nur um das Finden von Formen geht, sondern mehr um Wahrnehmungsmöglichkeiten und das Be-

nutzen der Form selbst, – zumal in einer Zeit, in der die Entdeckung neuer Materialien für die Kunst nicht wichtig ist, weil das Material die Kommunikation selbst ist. Wenn also Armleder Duchamp aus dem „inneren" Bereich der Kunst und des damit verbundenen Systems in den Bereich der Kommunikation überführt, also den „äußeren" Bereich des Lebens, handelt er auf einer Kommunikationsebene und macht damit die zeitgenössische Kunst zu einer alltäglichen Tatsache, die für alle erreichbar ist.

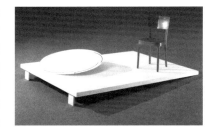

Wie ich schon ausgeführt habe, umfaßt Armleders Werk Malerei und Objekte, die er auf zwei Arten verwendet: In der ersten Phase, die 1979 beginnt, bemalt Armleder die Rückenlehne eines Stuhls zur Hälfte mit einem abstrakten Bild (FS 1, 1979), in der darauffolgenden Phase ist das Objekt neben einem Bild plaziert. Zu Beginn ist der Gegenstand zugleich Bildträger und ersetzt die Leinwand, während er später selbst Teil der malerischen Komposition ist. Dieser „modus operandi" verbindet Gesten aus Leben und Kunst, die von der Malerei bis zum Anstreichen reichen, oder mit anderen Worten gesprochen vom „Combine Painting" – etwa Rauschenbergs „Pilgrim" –, bis zum oben erwähnten Vorfall bei der Biennale in Venedig. Aber ein Bild auf ein Objekt zu malen, stellt zugleich den Versuch dar, die Einzigartigkeit der schöpferischen Geste wieder zu bestätigen, indem der seriell gefertigte Gegenstand durch seine Bemalung der Anonymität entrissen wird.

Hierbei muß betont werden, daß der Stuhl ein wiederkehrendes Element im Schaffen von Armleder ist, wahrscheinlich sogar das am häufigsten auftretende, woraus verschiedene Fragen resultieren und sich Vergleiche nicht nur mit der bildenden Kunst, sondern auch mit dem Design ergeben. Aus der Kunst bekannt sind Kosuths „One and Three Chairs", ein Werk, das die Theorie von realem, ironischem und linguistischem Wissen illustriert, oder – enger mit dem Werk Armleders verbunden – George Brechts „Chair Event", das den existentiellen Aspekt dieses Gegenstands in den Mittelpunkt rückt. Im Design, das eine Disziplin des 20. Jahrhunderts – nicht zufällig der Epoche des Objekts – ist, nimmt der Stuhl, wie in der Kunst, einen besonderen Platz ein, weil er ein theoretisches Modell ist, mit dem sich alle Designer und Designer-Architekten auseinandergesetzt haben, weil er einen Mikrowohnbereich, ein Mikro-Environment darstellt. Während heute zum Beispiel Le Corbusiers „Unité d'habitation" in St. Etienne, Alvar Aaltos „Viipuri Bibliothek" oder das „Ulmer Hochschulgebäude" Max Bills (heute ein Krankenhaus für Geistigbehinderte), nur den Studenten und Experten der Architektur bekannt sind, hatten die „Chaiselongue" des

Ersten, der geschwungene Holzstuhl des Zweiten und der „Sgabillo" des Dritten einige Zeit nicht nur einen hohen Bekanntheitsgrad, sondern wurden auch von vielen benutzt. Ganz zu schweigen vom „Rot-Blauen-Stuhl" Rietvelds oder – vielleicht noch einsichtiger – den Stühlen, die Alessandro Mendini in Objekte verwandelte, indem er sie (aber auch Armsessel und andere Möbel) pointillistisch oder abstrakt bemalte und damit manifestierte, was die Kunst schon lange zuvor propagiert hatte, nämlich, daß die Form nicht länger der Funktion folgt, sondern der Kommunikation.

Hatten diese Künstler noch versucht, aus dem banalen Alltagsgegenstand mit Hilfe der künstlerischen Geste, ein für die Theorie taugliches Modell zu machen, so ist Armleder sich darüber im Klaren, daß das Bewußtsein der Moderne mehr durch Gegenstände als durch Architektur geprägt wurde. Aus diesem Grund bahnt er sich einen Weg aus der Duchampschen Museumsgalerie, einem architektonischen Raum, hin zu der Verbindung von Gegenstand und Bild und definiert diesen Schritt als maßgeblich, um die realisierte Moderne im Zeitalter der Postmoderne zu kommentieren. Es geht um eine Epoche, die – zu Unrecht – der Rückwärtsgewandtheit angeklagt wurde, während es doch gerade die Hypermodernität der Realität ist, welche als Antithese den Blick zurück hervorbringt. In dieser Situation bewahrt Armleder etwas von der Geste der Moderne in der Kunst, indem er keine „edlen" Design-Objekte verwendet, sondern Dinge, deren Design anonym ist und die Spuren der Benutzung aufweisen. Die Tatsache, daß es sich um Second-hand Ware handelt ist nicht nur insofern bedeutsam, als der Gegenstand wirklich benutzt wurde, sondern weil er damit dem „Objet d'auteur" – also etwa den Beispielen, die ich oben angeführt habe – gleicht oder eine Variante davon ist. Einen Gegenstand zu verwenden, der bereits in Sammlungen und Museen ist, würde dagegen Bedeutungsebenen miteinbringen, die zu stark wären und die Zuordnung zu einem Gemälde nicht rechtfertigten; – es ist also der gleiche Grund, der auch Duchamp davon abhielt ein „Objet d'auteur" als „ready made" zu verwenden: Es handelt sich ja schon per se um ein Kunstwerk.

Wenn also das Kunstwerk eine Alltäglichkeit und Vertrautheit haben soll, also eine Art Äquivalent zu dem bildet, was früher das Stilleben war, so schafft Armleder zeitgenössische Stilleben, in denen statt Äpfeln und Birnen, Objekte und Gegenstände den Platz einnehmen. Leben diese Objekte und Gegenstände aus der Beziehung zueinander und zu dem Bild – und viele seiner Werke wurden in bezug zu einem Gemälde oder einer Sache entwickelt – so gibt es andere Werke, die ihre malerische Qualität durch die Art der Ausstellung oder durch ungewöhnliche Kombinationen erlangen, wie zum

Beispiel das Bild mit den Plüschquasten, das ihn auf das Cover von „Flash Art International" brachte. Mit dieser Arbeitsweise unterstreicht der Künstler, daß es eine Verbindung zwischen Kunst und Leben gibt, ganz einfach, weil die Kunst durch die ästhetische Diffusion der Bilder und Objekte, aber auch durch natürliche Prozesse ins Leben eindringt. Selbst wenn Armleders Arbeiten Kommentare zu und Kritiken an der Massengesellschaft sind, so verwendet er doch auch Versatzstücke aus der echten Natur, also Pflanzen und Blumen, oder plaziert die Werke selbst in einem natürlichen Kontext. Für das Projekt „Territorio Italiano", zu dem Armleder eingeladen war, um ein Werk dauerhaft an einem Platz seiner Wahl in Italien zu installieren, entschied er sich, eine runde Zementscheibe ans Ufer des Po bei Piacenza zu legen. Die Arbeit, die periodisch vom Wasser überspült und dadurch verändert wird, ist ein offenes Kunst-

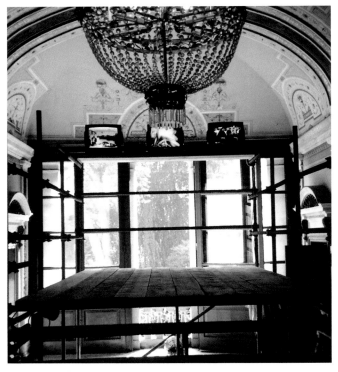

werk, das sich verändert, auf das atmosphärische Schwankungen, etwa der Wechsel der Jahreszeiten, Einfluß haben und das dadurch wie eine Pflanze von den metereologischen Bedingungen abhängig ist. Es ist ein „relatives" Werk, „relativ" wie die heutige „Zeit" – die vierte Dimension nach Einstein –, die die Künstler als einen Hinweis auf das Leben in vielfältiger Weise in ihre Kunst einzubringen und zu vermitteln versuchen. Wenn dieses Jahrhundertende uns von einer experimentellen zu einer kommunikativen Haltung gebracht hat, so liegt das auch daran, daß wir die Moderne, die von der Politik dominiert war, zugunsten einer Postmoderne hinter uns gelassen haben, in der die Ästhetik ihren Einfluß auf die Realität durch die Präsenz einer überwältigenden Masse ästhetisch gestalteter Bilder und Geräusche vergrößert hat. Wir leben in einer Zivilisation, in der die synergetische Erfahrung der totalen Kunst ein alltägliches Phänomen geworden ist, in der der futuristische Wunsch, den Betrachter ins Bild hinein zu bringen, Wirklichkeit geworden ist. Die Installationen Armleders zeigen dies deutlich. Für die Ausstellung im Consortium in Dijon, 1996, etwa realisierte er eine Installation, für die Gerüst-rohre und Holzplanken zu einer spiralförmigen Struktur zusammen-gefügt wurden, die von Tatlins „Denkmal der III. Internationale" inspiriert war. Es ist ein Werk, das sich orthogonal in den Raum schraubt und zugleich eine Ausstellungs- bzw. Inszenierungsstruk-tur bildet, die in ihrer modularen Variabilität auf zukünftige Schöp-fungen und Entwicklungen vorausweist.

Es ist ein Kunstwerk, es konstituiert ein Kunstwerk und es beher-bergt andere Werke, ebenso wie früher der Ausstellungsraum Ecart. Die Arbeit ist aber mehr als nur das Grundgerüst, sie ist auch das,

was darin untergebracht ist: Videos, Spiegel-
kugeln, fluoreszierendes Licht, Bilder, Drähte,
– es scheint, als sei das ganze Leben und
seine Kunst in diesem Ensemble zu einer
Synthese gebracht. Eine Synthese, die sich
noch deutlicher in der Inszenierung im Piano
nobile in der Villa Carlotta[1], Menaggio,
während des „Corso Superiore di Arti Visive"
der Stiftung Antonio Ratti im Juli 1996 zeigte:
eine ausladende Struktur aus Gerüstrohren
und Holzdielen, die den gesamten langezoge-
nen Salon einnahm. Hier ist die Form durch
die „Lenin-Tribüne" von El Lissitzky angeregt
und führt in stufenhaft angelegten Ebenen
nach oben. Das konstruktivistische Motiv ist
nicht neu im Werk Armleders, der seinen
konstruktivistischen Bildern Objekte und
Gegenstände so zuordnete, daß sie der bild-
internen Ausrichtung folgten, die, wie wir
wissen, im Konstruktivismus die Diagonale

ist. Die Diagonalität war in der Moderne ein Synonym für Bewegung,
Flucht nach vorne und zugleich Ausdruck der mechanischen Bewe-
gung, die die neue Welt erfüllen sollte. Es ist eine Welt, die den Blick
fest in die Zukunft und damit zugleich nach oben richtet, – und
manchmal hängt auch Armleder die Dinge ganz hoch, fast unter die
Decke, so daß sie den ganzen Raum beherrschen, genau so, wie es
die Konstruktivisten und die Suprematisten gemacht haben.

Aber diese konstruktivistische Inspiration durch die „Lenin-Tribü-
ne" ist zugleich Ausdruck des besonderen Interesses Armleders an
Kommunikation – war doch die Tribüne eine Art moderne Kanzel,
von der aus der Vater der Revolution sich den Volksmassen zuwandte
und ihnen die Botschaft der neuen Gesellschaft brachte. Weil Armleder
aber weiß, daß unsere Gesellschaft sich von einer gottgegebenen in
eine bürgerliche und von dort in eine Massengesellschaft verwandelt
hat und sich nun als öffentliche Gesellschaft im Medienzeitalter prä-
sentiert, übertreibt er die Tribünen / Kanzel-Situation und macht sie
zum Spektakel. Indem er Teile verwendet, die aus dem Gerüstbau
stammen, also mit der harten Arbeitswelt und ihrer Ideologie, dem
Kommunismus, assoziiert werden, macht er in seiner Kunst den Weg
von der Politik zur Ästhetik deutlich, ein Charakteristikum dieser
Jahrhundert- und Jahrtausendwende.

Es ist eine Modifikation, die visuell Boccionis „Città che sale"
(Die aufsteigende Stadt) heraufbeschwört, indem sie den Standort
der Betrachter von außen nach innen verlegt und so die Aufforde-
rung Boccionis, den Betrachter ins Zentrum des Werks zu setzen,
konkretisiert. Die Leute, das Publikum, deren Leben ästhetisiert

1 | Erstabdruck des Original-
textes in: „John M Armleder",
Fondazione Ratti, Como 1997.
Übersetzt aus dem Italienischen
von Margrit Brehm

wird, stehen nicht mehr außerhalb, sondern sind mittendrin, können hinauf und hinabsteigen oder umherlaufen. Sie beobachten die Spiegelglaskugeln, die am „Bauch" des Werks angebracht sind und deren Reflexe Lichterkreise auf ihre Körper malen und dem ganzen Ambiente mit den Fresken aus dem achtzehnten Jahrhundert neue Farbwerte verleihen. Hier trifft die „abstrakte Malerei des Lichts", immateriell und in ständiger Bewegung, auf die statische, figürliche Malerei der Vergangenheit.

Die Vergangenheit, dieses Element, das immer und immer wieder bei Armleder auftaucht und das er in unterschiedlichster Weise überarbeitet, wird dem Besucher hier in moderner Form dargeboten. Aber er hat auch die Möglichkeit, das Werk zu erklimmen und die Fresken aus der Perspektive der Künstler zu sehen, die sie gemacht haben. Im Auf- und Absteigen, im Herumgehen und Verharren unter den schimmernden Lichtern, die Teil des Werks sind, findet man sich irgendwann vor den sechs Videos wieder, die an den zwei höchsten Punkten der Installation aufgestellt sind. Es sind immer drei Monitore pro Einheit, wobei wir auf dem in der Mitte einen Werbefilm der lokalen Nautic-Firma sehen, die mit Speedbooten handelt, während auf dem anderen informelle Videos laufen, die der Künstler und einige seiner Studenten im schönen Garten der Villa gedreht haben. So wird das, was draußen stattfindet, durch seine technische Reproduktion ins Innere gebracht und durch moderne Medien vermittelt, wodurch die Distanz, aber ebenso die Beziehung zwischen Realität und Fiktion verstärkt deutlich wird, die ein Charakteristikum der postmodernen Zeit ist. Realität und Fiktion, Natur und Kultur sind auch das Thema vier weiterer Videos, Sci-Fi-B-Pictures japanischer Herkunft mit prähistorischen Monstern wie Godzilla und Gorgo. Filme, in denen der Kitsch dominiert; nicht zufällig eine Ästhetik der Formexzesse, die die Kommunikation überstrahlt. Sogar in seinem Umgang mit Massenbildern und Konsumgütern, nimmt der Künstler gemeinsam mit uns auf der Schaukel der Unterschiede Platz, die zwischen hoher, mittlerer und niederer Kultur hin und her pendelt und zugleich alle diese Ebenen in der Sprache der Kunst zusammenführt. Einer Kunst, in der Godzilla und Gorgo die Menschheit zugleich zerstören und retten, in der die alltäglichen und archaischen Ängste für ein Massenpublikum aufbereitet werden. Armleder reflektiert diese strukturellen Ähnlichkeiten zwischen den Monstern und dem Kunstwerk, – einem Werk, in dem an der Kunst teilgenommen wird und wo die Rollen ständig wechseln, und der Besucher zeitgleich mit dem Künstler genießt, schafft und kommuniziert.

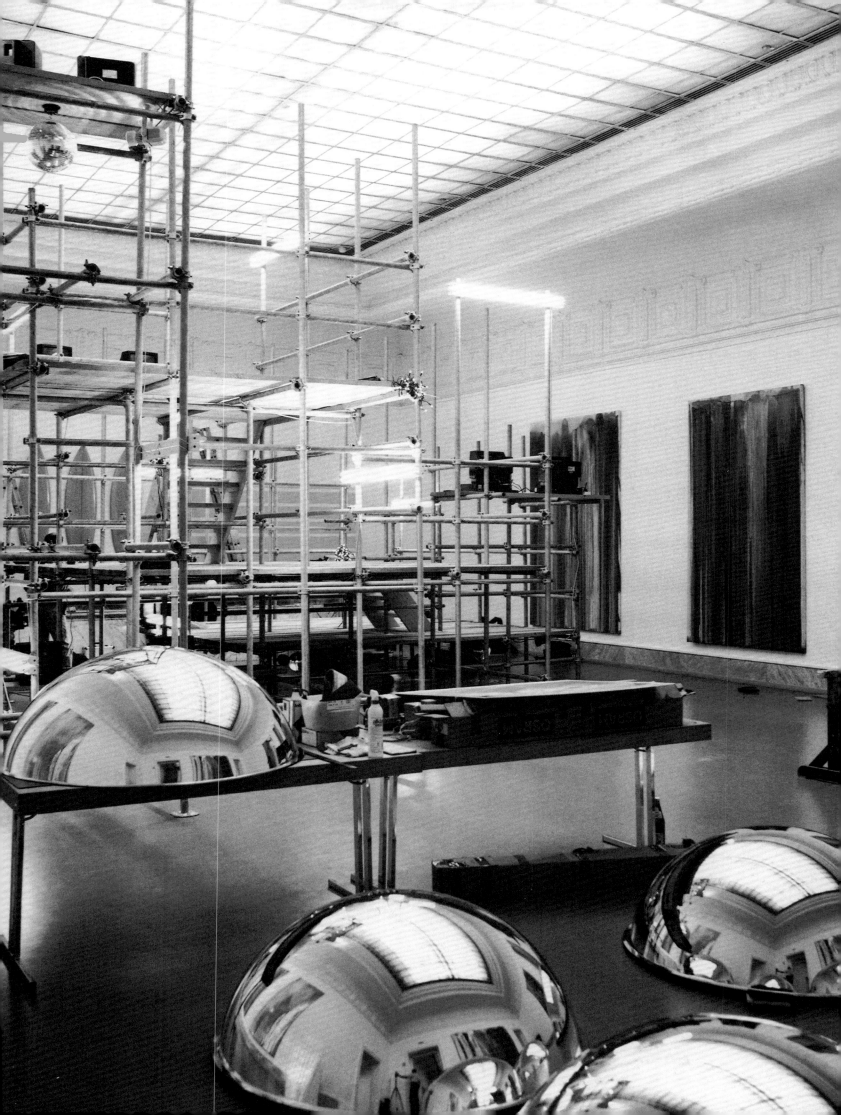

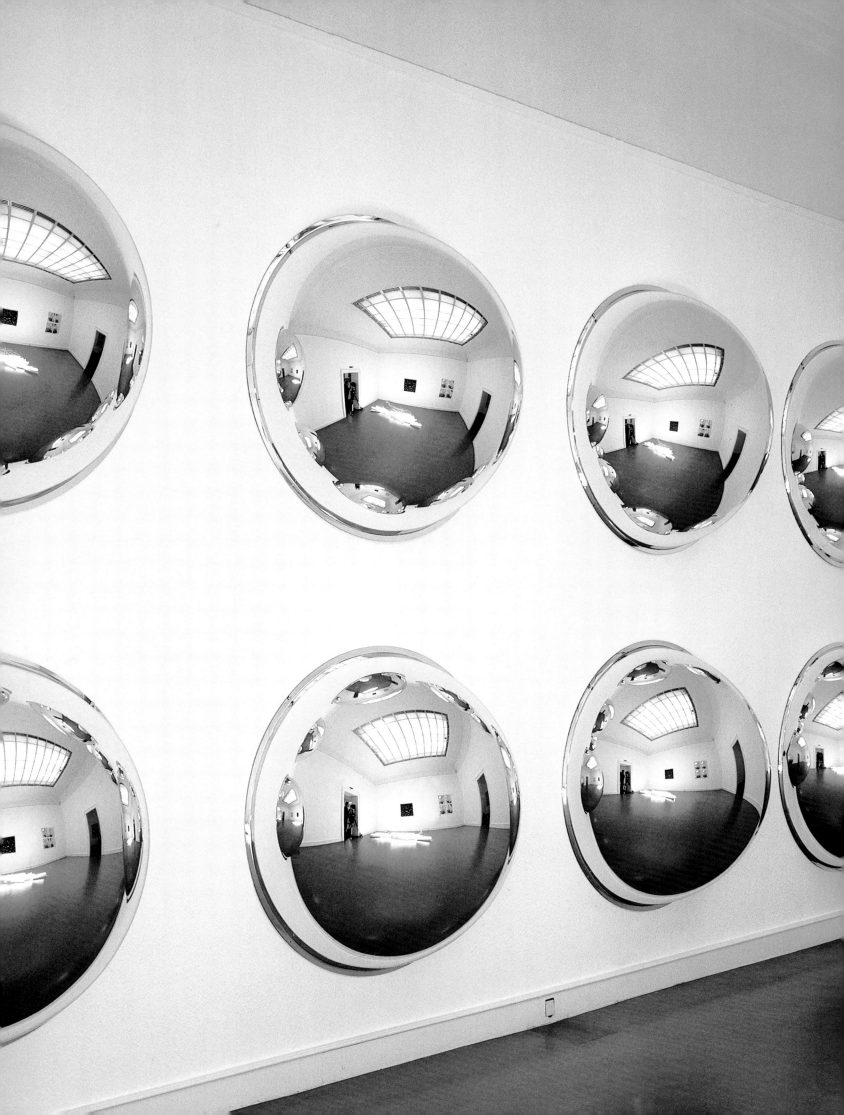

ENJOYING, CREATING, COMMUNICATING: JOHN ARMLEDER

GIACINTO DI PIETRANTONIO

THE WAY John Armleder makes of his work an expressive fluidity that dissipates between life and art illustrates a pronounced awareness of our millennium age. Indeed, if art is an opportunity, then life is the conditio sine qua non for that opportunity. This is why the works of Armleder are not so much forms to be viewed as images, places, events to participate in. At stake here is the relation between art and life: the research object of so many of this century's avant-gardes and post-avantgardes, traces of which subsist in the work of this artist. Not coincidentally, Armleder positioned himself within Fluxus where this very relation is a principal element of the poetic practice. Whereas the avantgardes, bent on experimenting with new ways of creating art and changing the world, channeled all their energies in this direction, Armleder aims to communicate the vitality of the idea itself. Thus, with communication as one of his main objectives, Armleder would set up, along with Lucchini and Rychner, the Ecart group in Geneva in 1969, the aim of which was not so much to promote its own work as that of other artists. This small but powerful group would back exhibitions, books, catalogues, records, tapes, multiples, indeed everything that could help give contemporary art a higher profile, with particular emphasis on artists hailing from or gravitating towards Fluxus. As a way of life and a way of creating art, it reflected the role of art in the age of its technical reproducibility; an age in which, as Walter Benjamin had found, the aura of the unique work of art is jeopardized by the rise of new means of communication and dissemination. These enable the reproduced product to achieve a communicative quality in that reaches the highest number of people possible outside the gallery-museum circuit, taking them unawares in the course of their day-to-day activities. This is why Armleder integrates everyday objects and rituals in his work: serving tea at the Paris Biennial in 1975, or using domestic objects such as furniture.

While we would acknowledge the fact that the object is a "material" widely used in art during our century and particularly at its end, Armleder has preserved his own approach, always utilizing anonymous, second-hand objects, never design pieces. Using something which has already been used guarantees that the object will no longer be viewed as a commodity; it also highlights the fact that not the form per se, but rather its experience – i.e. its history – is important. In his endeavor to express the relation between art and life, Armleder opts for the most direct route: superimposing abstract paintings

onto the objects or juxtaposing and combining them with abstract images. In this way, Armleder attempts to communicate his concept beyond the art world's closed circle of specialists – to a broader public. After all, everybody has a painting on the wall at home, hanging above the sofa or next to the dresser; these works are not necessarily originals, but they're not isolated from life like those consigned to museums and art galleries. Moreover, this juxtaposition can also be interpreted as a comment on the work of art in the age of its technical reproducibility, where the uniqueness (creation) of the painting and the reproducibility of the object meet in confrontation.

Yet when tracing the evolution of Armleder's work we must also consider the contribution he made within the group and the Ecart gallery space itself. There both the work of art and the concept of the exhibition space became subjects of debate. The aim was not an architectonic shell with pictures hung on its white walls; what was needed was a workshop for the production and dissemination of art – evidencing the advent of a new era in which the means and the message are of fundamental importance. In this way, Armleder raised questions regarding the paradox of the avantgardes: the desire to embrace life while maintaining one's distance. Armleder, in contrast, endeavors to come to terms with this discrepancy. Indeed, what Armleder does is to transform Duchamp's idea of the spatial context. Duchamp taught us how a "non-art" object, "readymade," can be positioned within the art system by its presentation within the exhibition context; Armleder attached a modern painting – be it abstract or informal – to an everyday object. Matching objects and paintings in this way reveals how far we are removed from the "readymade". We realize the extent to which this act is no longer a metaphor but rather reproduces a household microcosm, an everyday interior where we are no longer in the presence of an object within art space but in a small portion of space reminiscent of life and its relationships. This shift in perception is of fundamental importance if we are ever to fully appreciate the linguistic transformation that took place during the passage from modernity to postmodernity and, therefore, between the era of experimentation and that of communication, relation and participation. There is no doubt that Duchamp's gesture has experimental value and served to trailblaze new territory. Yet like all experiments, it is difficult to grasp without also understanding the theory behind it and the context it belongs to – without which the "readymade" is relegated to being mere object. On the other hand, it is obvious how Armleder transforms the gesture into compositional fact; those who see one of his works always recognize the used object as part of a known context at the same time realizing the fact that it didn't become the way it is by accident – not seldom the fate of "readymades." Certainly this is one of the paradoxes of contemporaneity which must be resolved to

prevent further accidents of the type that befell Duchamp's Door at the 1978 Venice Biennial, where the piece was repainted by unsuspecting workmen. Inserting a thing into a context involves occupying a place and establishing something. An object – a chair, a table, a musical instrument, or a Venetian blind – combined with a painting requires an immediate perception of the relation between the part and the whole, rendering it an integral component in the work. It is the work itself that interests us here, for the return to the artwork appears to be virtually characteristic of this finishing century. The way Armleder addresses the issue differs from the neo-expressionist approach: while both shift the attention away from the context to the work, they operate on completely separate levels of communication. Thus, "a work of art is a work of art" seems to be what Armleder's pieces are asserting and, in this sense, he is to the "inventor" Duchamp what the IT wizard Bill Gates is to the "scientist" Albert Einstein. Of note here are the incidents that occur along the way as everyday objects are transformed into works of art. And when recipients persist in confusing these artworks with the real things, this happens both because these works are symptomatic of the relation between reality and fiction and because they reveal today's general perception of contemporary art. As long as art remains separated from real life for most people, it can come as no surprise that an old door should find itself repainted. This is one of the gaps that artists today are trying to bridge by shifting their artistic activities from experimentation to communication, i.e. placing more emphasis on the relation that the work of art establishes with users. They ultimately see not only the artwork itself but also the public aesthetics that it communicates and produces.

Redefining the poetic practice is something every artist must do. The aim is not to find a form but rather to show perceptual possibilities and ways of implementing the form – above all in an era when the discovery of new materials for art is of little importance because the material is communication itself. Hence while Armleder moves Duchamp from the "internal" sphere of art and its attendant system into the sphere of communication, i.e. the "external" part of life, he himself is acting at the level of communication and thereby rendering contemporary art an everyday fact of life, accessible to all. I have already explained how Armleder's work encompasses both painting and objects, which he uses in two ways. In the first phase, which began in 1979, Armleder applied an abstract painting to a chair back (Furniture Sculpture 1, 1979). In the following phase the object was placed alongside a painting. In the first phase, the object also forms the backdrop, taking the place of the canvas; in the latter phase, it is an element of pictorial composition. This "modus operandi" brings together gestures from art and life that range from artistic to "domestic" painting; in other words, from Combine Paintings such

as Rauschenberg's "Pilgrim" to the incident at the Venice Biennial mentioned above. However, painting a picture on an object also marks an attempt to reconfirm the uniqueness of the creative gesture – by removing a serially-produced object from its anonymity by virtue of its being painted. It should be borne in mind that the chair is a recurring subject in Armleder's work, probably the most recurrent element in his oeuvre, which leads to certain questions and comparisons not only with visual arts but also with design. Noteworthy instances in art include Kosuth's "One and Three Chairs", which illustrates the theory of real, ironic and linguistic knowledge, or, closer to the work of Armleder, George Brecht's "Chair Event," a piece highlighting the existential aspect of the object itself. In design, a discipline born of the 20th century – not coincidentally the era of the object – the chair owns a special significance as it does in art. This is due to the fact that it is a theoretical model with which all designers and designer-architects have concerned themselves, for it constitutes a micro-habitat, a micro-environment of sorts. Le Corbusier's "Unité d'habitation" in Saint Etienne, Alvar Aalto's "Viipuri Library" and the Max Bill's university complex in Ulm (now a hospital for the mentally ill) are examples of works known mainly to students and architectural experts. In contrast, Le Corbusier's "Chaiselongue", Aalto's curved, wooden stool and Bill's "Sgabillo" have, for some time, been attracting their own brand of notoriety and use – not to mention Rietveld's "Red Blue Chair" or, more relevant still, the chairs made into objects by Alessandro Mendini. This he accomplished by applying pointillist or abstract painting to chairs (including armchairs and other furniture), making manifest what art had long propagated: namely that form no longer follows function, but rather communication.

Whereas the above artists attempted, with the aid of artistic gesture, to render theoretical fact from banal object, Armleder is well aware that the Modern mind has been shaped more by objects than by architecture. This is why he is able to clear the path from the Duchamp museum gallery, an architectonic space, to a coupling of object and painting. He defines this step as a relevant comment on realizing the modern in a postmodern age. This is an era wrongly accused of dwelling on the past, although it is the very hypermodernity of reality – as antithesis – which is guilty of generating the backward glance. During the passage, however, Armleder preserves something of the modern gesture of art: the fact that he refuses to use "valuable" designer objects, favoring instead things of anonymous design revealing traces of past use. The fact that the objects are second-hand is not only significant insofar as the object has been used but also because it resembles or is a variant of the objet d'auteur, i.e. the examples I mentioned earlier. Indeed, using an object already established in collections and museums would impose

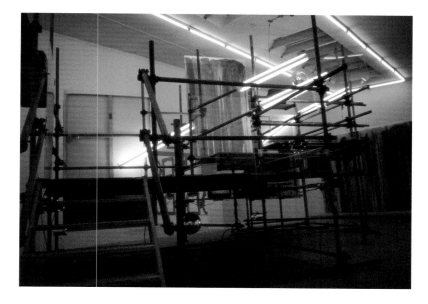

connotations that would have been too strong and would not have justified being attached to a painting. This is precisely what prevented Duchamp from using an "objet d'auteur" as a readymade: it was already a work of art per se. Thus if the artwork is to have the character and familiarity of the everyday, making it the equivalent of what in the past would have been consigned to still life, Armleder creates the contemporary still life in which objects take the place of the traditional apples and pears. Where these objects thrive on the relation between themselves and the painting (many of Armleder's works were developed in reference to a painting or a thing), his oeuvre contains other pieces whose painterly quality is achieved in the type of exhibit or in unusual combinations (see, for example, the work consisting of chenille drapes which earned Armleder the front cover of Flash Art International).

The artist leverages this approach to stress that there is in fact a connection between art and life, if only because art penetrates life through the aesthetic diffusion of its pictures and objects as well as through quite natural processes. And although Armleder's works constitute a commentary on and criticism of society as a whole, he also implements parts of nature – plants and flowers – and positions his pieces in a natural context. This is how Armleder proceeded for the project "Territorio Italiano," for which he was invited to permanently install a work at a location of his choice in Italy: the artist elected to position a crude cement disc on the banks of the River Po in Piacenza. The piece is periodically covered by water and thus modified. It is a fluid work that changes, affected by atmospheric conditions and the passing of the seasons; as such, like a plant it is dependent on meteorological conditions. This work is "relative" in the same way that "time" – the fourth dimension proposed by Einstein – is today, a phenomenon which artists have tried in various ways to introduce

and communicate in their art as a reference to life. This century's end has taken us from an experimental to a communicative approach; a journey due in part to the fact that we have left the modern age behind us – an era dominated by politics – and embraced instead its successor: a postmodernity in which aesthetics have succeeded in consolidating their influence on reality due to the presence of an overwhelming mass of aesthetically formed images and sounds. Ours is a civilization in which the synergetic experience of total art has become an everyday phenomenon, where the futuristic wish to incorporate the spectator in the painting has come true. Armleder's installations graphically illustrate this. Take, for instance the piece Armleder produced for the 1996 exhibition at the Consortium in Dijon, where pipes and wooden planks were combined to create a spiral structure inspired by Tatlin's "Monument to the Third International." The form screws itself orthogonally into the space, at the same time forming an exhibition structure predicting its versatility for future uses. This is an artwork, it constitutes an artwork and it hosts other works in much the same way as the earlier Ecart space did. Indeed, the work is more than a mere skeleton, it is also everything attached to it: videos, glittering balls, fluorescent lighting, paintings, wires. It is as if the artist's entire life and art had been synthesized in the ensemble. The synthesis is further highlighted by the installation set up in the Villa Carlotta[1], Menaggio, during the "Advanced Course in Visual Arts" held by the Antonio Ratti Foundation in July 1996. A large-scale structure made of scaffolding pipes and wooden planks, it occupies the entire length of the salon area. The form, which unwraps upwards in steps, was inspired by the platform El Lissitzky designed for Lenin. The constructivist element is not new in Armleder's work; here he has matched up his constructivist pictures with objects and things to echo the pictures' internal orientation which, as we know, is diagonal in constructivism. During the Modern era, the diagonal was synonymous with movement, signifying the beginning of the future – and at the same time an expression of the movement of things mechanical that were to abound in the new world. It is a world with its sights set firmly on the future, and set high. Armleder too sets his sights high, positioning his things close to the ceiling so that they seize control of the entire space, in much the same way as the constructivists and the suprematists did in their turn. The constructivist inspiration of the Lenin stage is also an expression of Armleder's special interest in communication. After all, the stage was to be a latter-day pulpit from which the father of the revolution addressed the masses, expounding his ideas for a new society. Although Armleder knows that our society has been moving from divine through bourgeois to a faceless society, now presenting itself as the public society in the age of the media, he exaggerates the stage / pulpit situation and makes of it a spectacle. By using materials traditionally associated

1 | This text was first published in "John M Armleder", Fondazione Ratti, Como 1997. Revised english translation.

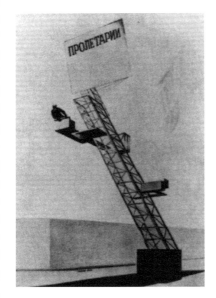

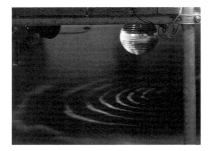

with the construction of stages (and also alluding to the work ethic and its ideology, communism), he illustrates in his art the shift from the political to the aesthetic, a main feature of our end of the century and the millennium.

It is a modification which, from a visual point of view, conjures up Boccioni's "La Città che sale" by moving the spectator from outside to inside art, hence concretizing Boccioni's call for putting the vie-wer in media res at the work's center. In fact, in a life that has now been aestheticized, the people – the viewers – are no longer on the outside but have been summoned inside where they can ascend, descend, circulate. The glittering balls mounted in the "belly"of the work paint their own bodies with reflected light, lending the entire setting with its eighteenth-century frescoes a whole new chromatic value. Here is the meeting point where the "abstract painting of the light," – immaterial and in constant motion – encounters the static, figurative art of bygone days.

The past is a perennial element in Armleder's work which the artist approaches from various perspectives; here it is offered to viewers in a modern guise. Yet the audience is free to climb onto the work, observing the frescoes from the perspective of the artist who created them. While ascending and descending, circulating and stand-ing beneath the shimmering lights (which are an integral part of the construct), viewers will at some point come to rest before the six VCR's installed at the structure's two highest points. There are three monitors at each site, the left central one projecting images from a promotional film for a local nautical company, Tullio Abbate, which deals in speedboats. On the middle monitor on the other side, a series of informal films made by the artist and even some students are dwelling at the beautiful gardens of the villa. Consequently, the outside is transported inside by a process of reproduction using modern media, reaffirming the distance as well as the proximity be-tween reality and fiction, a postmodern phenomenon. Reality versus fiction and nature versus culture are also the subjects of the four remaining videos that feature Japanese sci-fi B-movies, complete with prehistoric monsters such as Godzilla and Gorgo. These are films that share kitsch as their common denominator – not coinci-dentally an aesthetic of formal excess that dominates the communi-cation. Even when he uses mass-produced images and consumer objects, the artist joins us on the seesaw as it swings between high, medium and low-end culture, bringing all these together in the lan-guage of art. This is an art where Godzilla and Gorgo both destroy and save humanity and where long-standing, everyday fears are brought back to life for a faceless audience. Armleder reflects on these structural similarities between the beast and the work of art – in a piece in which art is participatory and where roles are continually inverted, where the spectator enjoys, creates and communicates simultaneously with the artist.

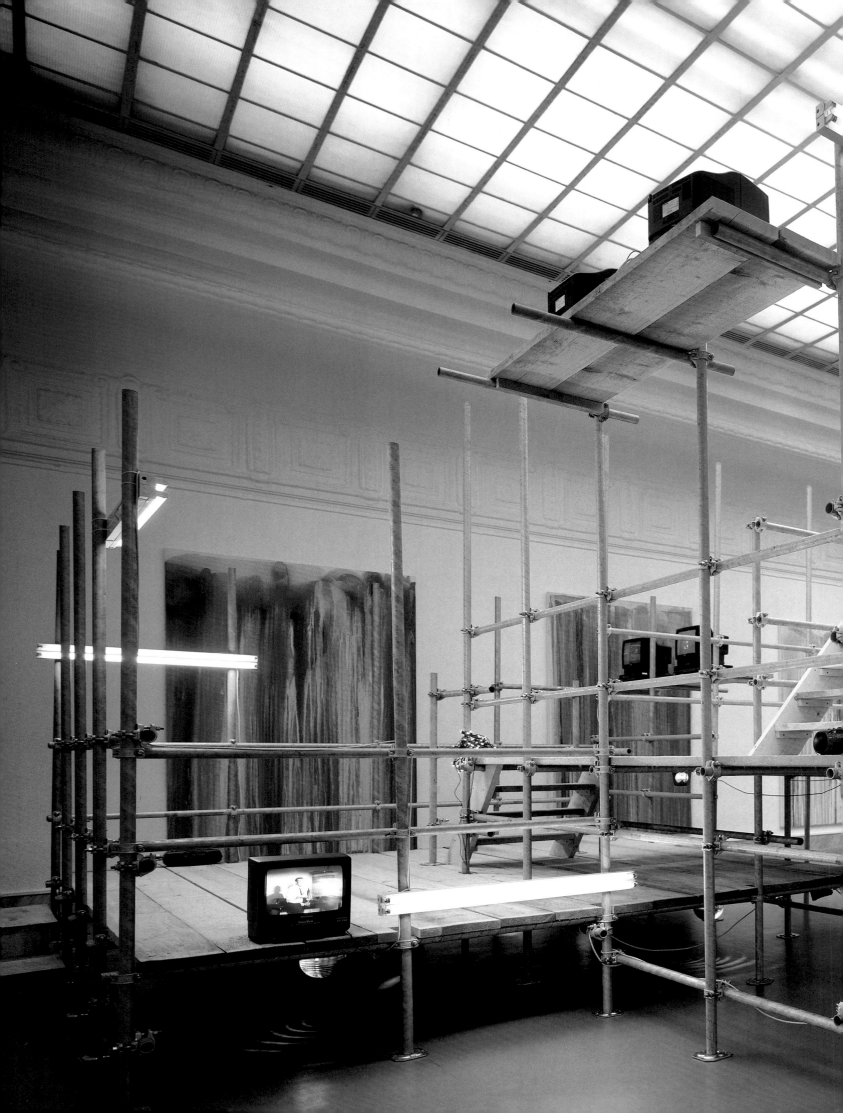

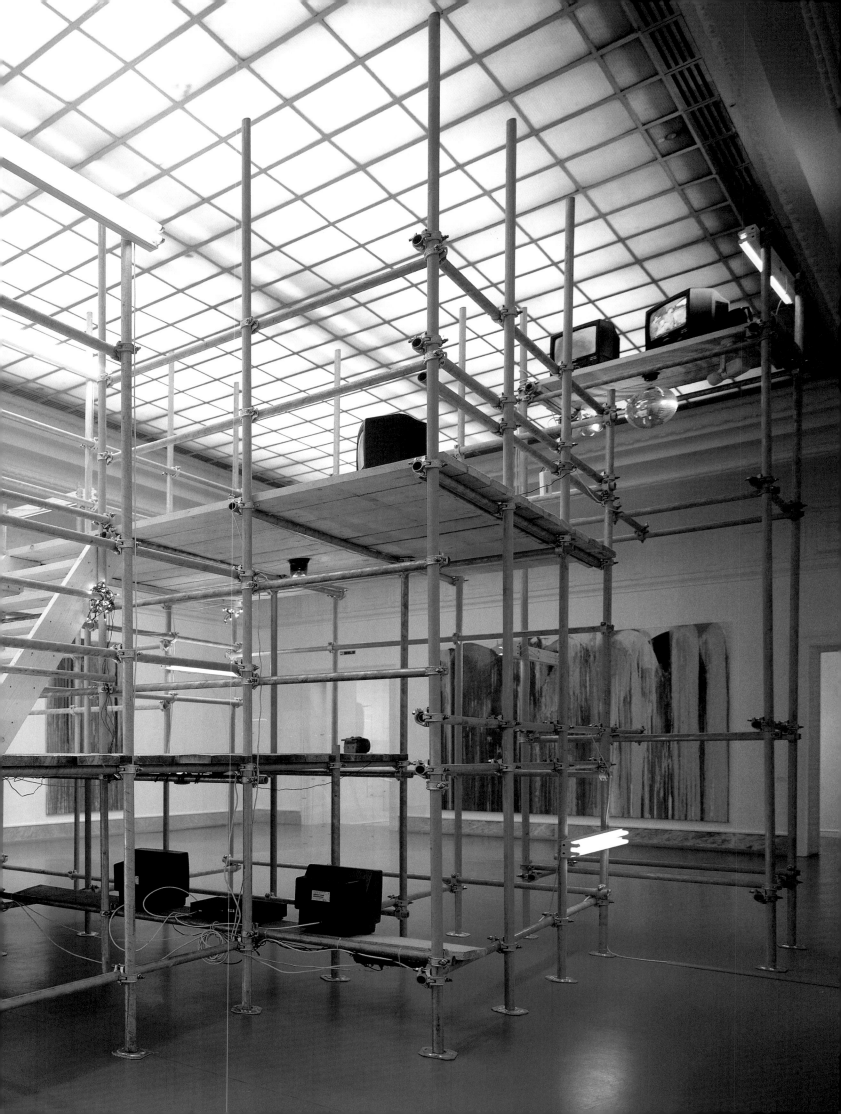

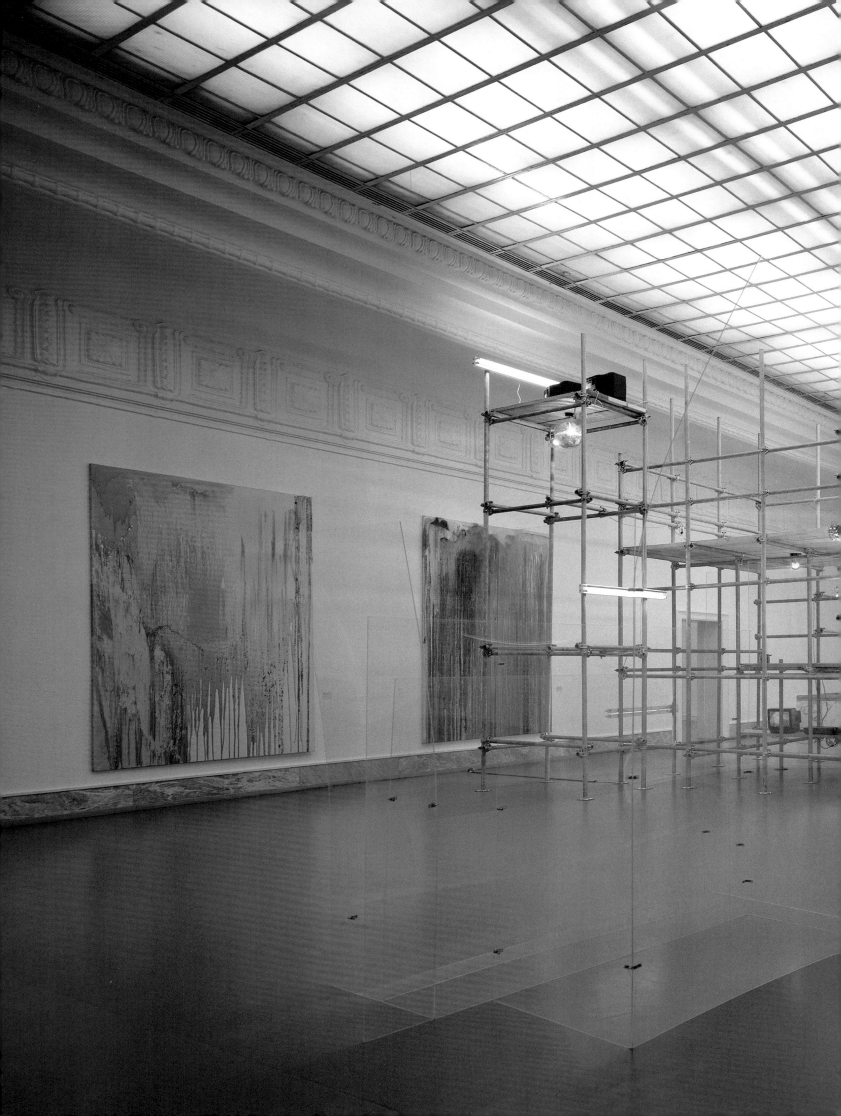

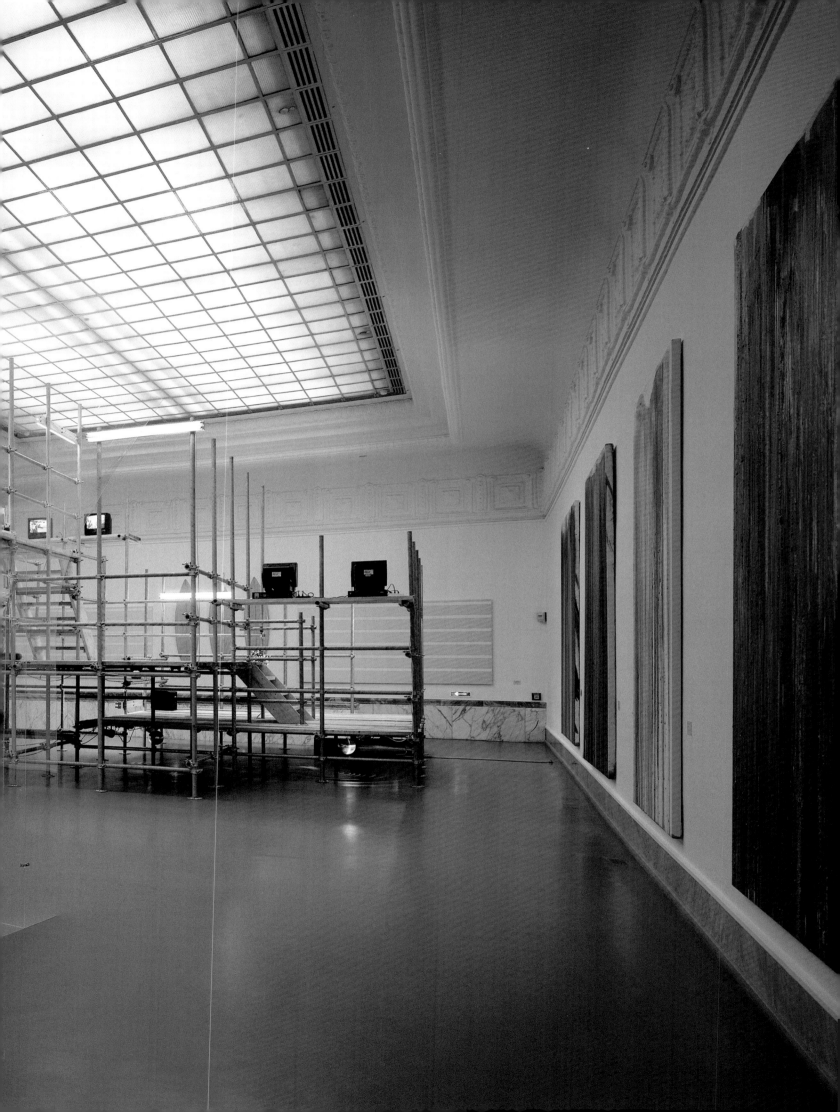

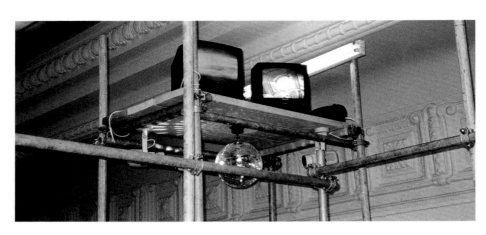

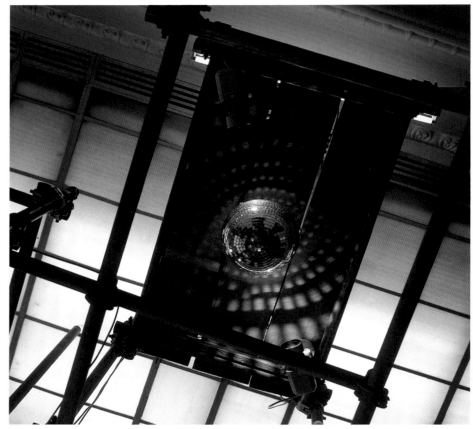

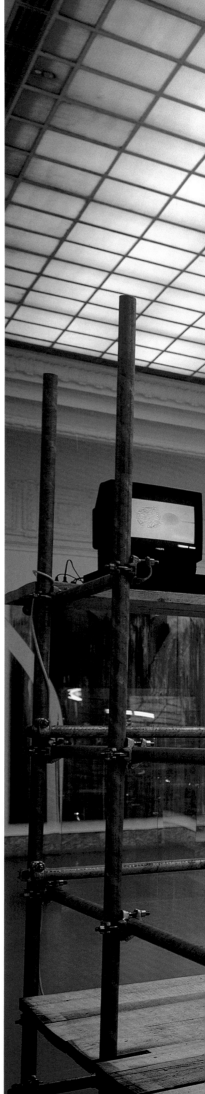

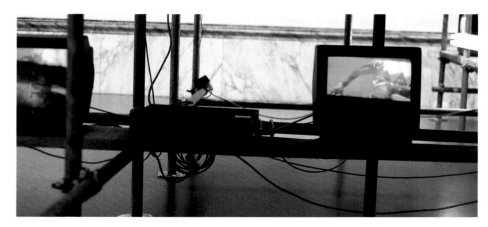

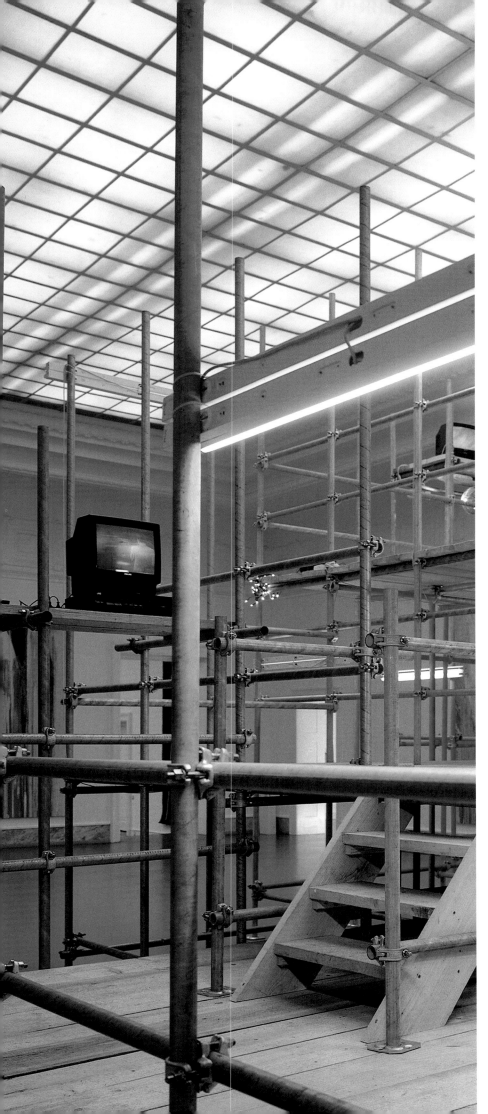
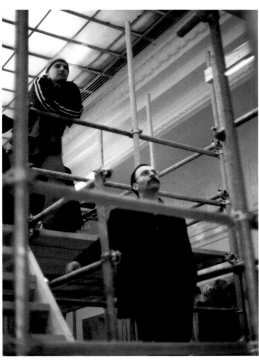
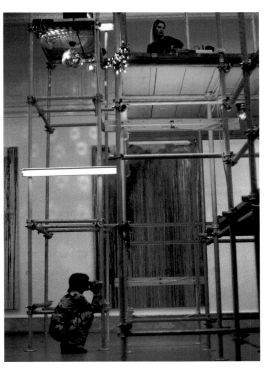

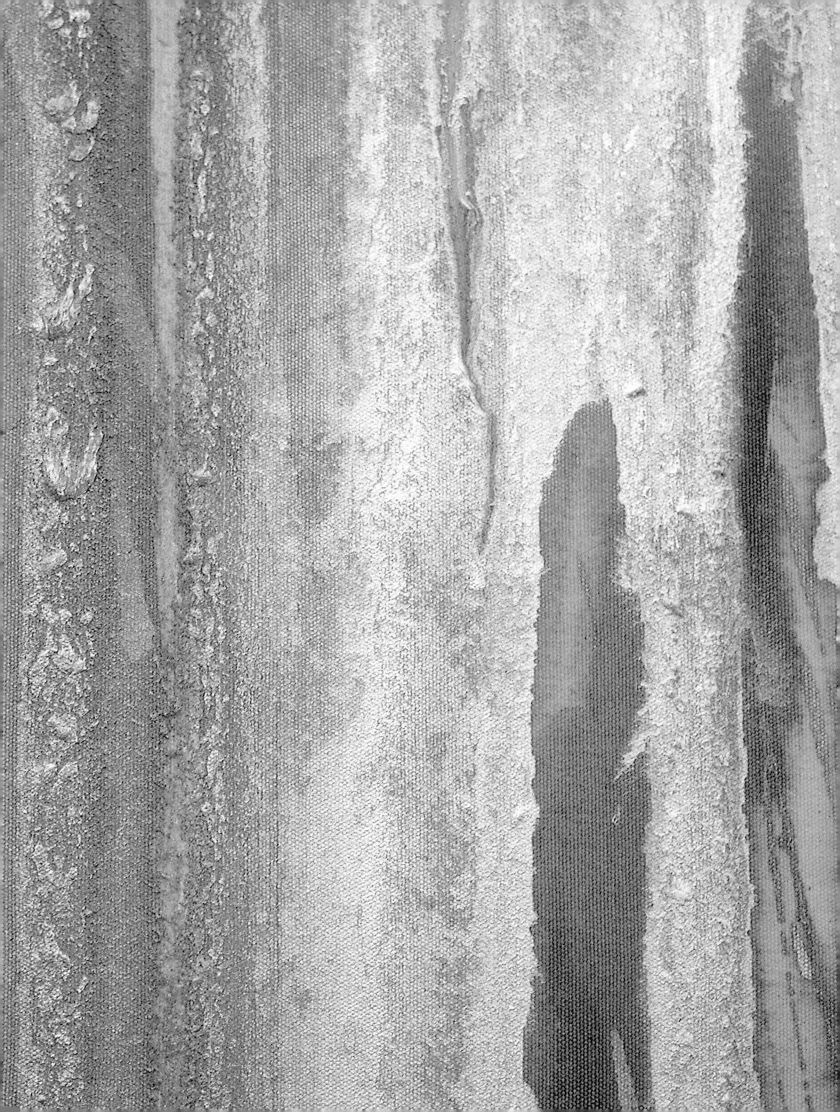

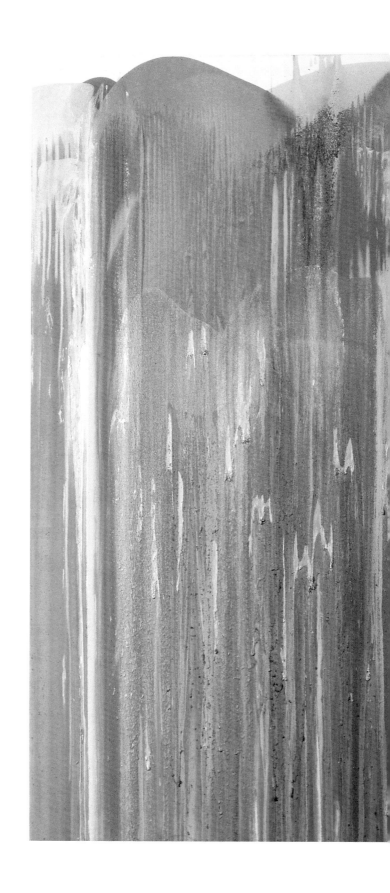

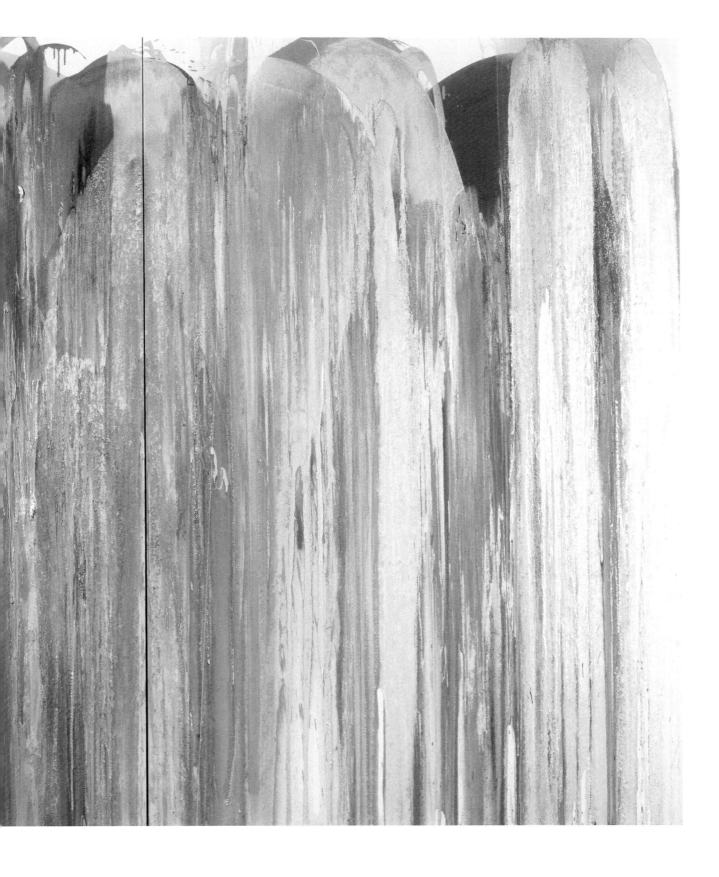

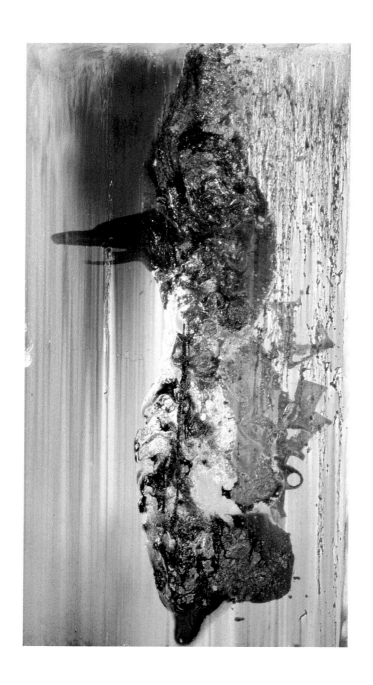

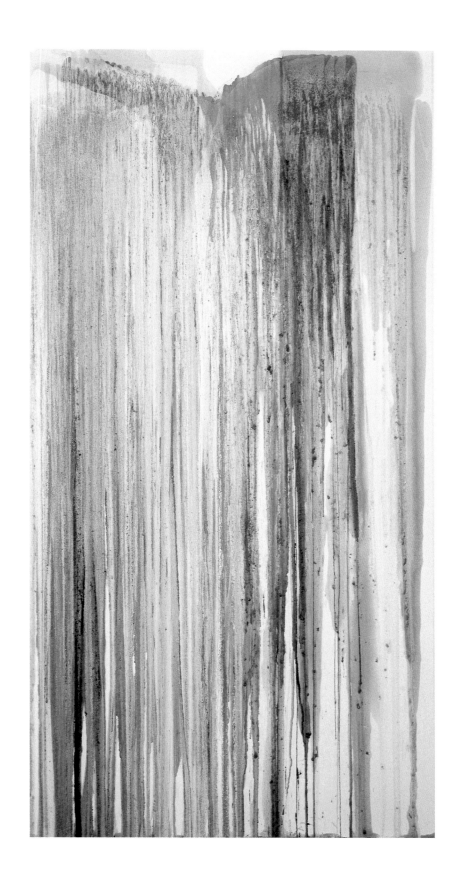

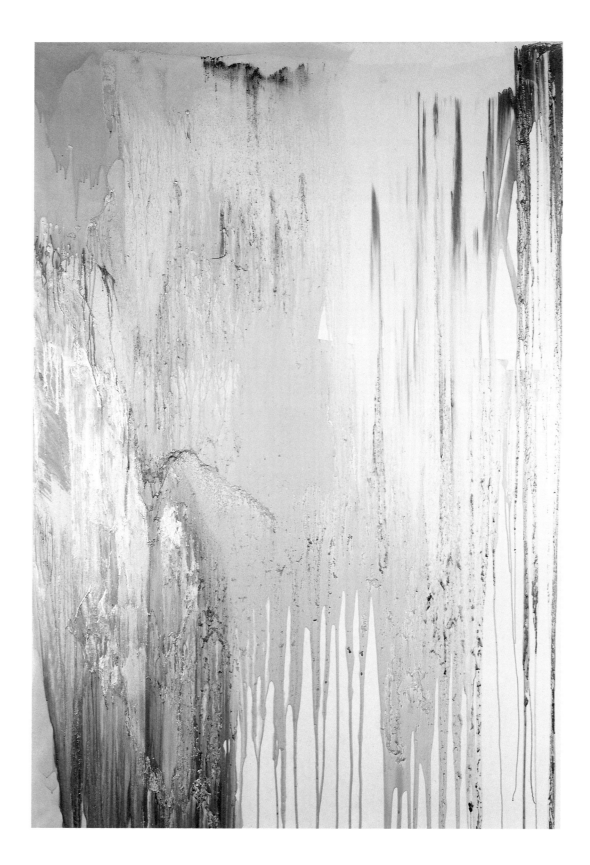

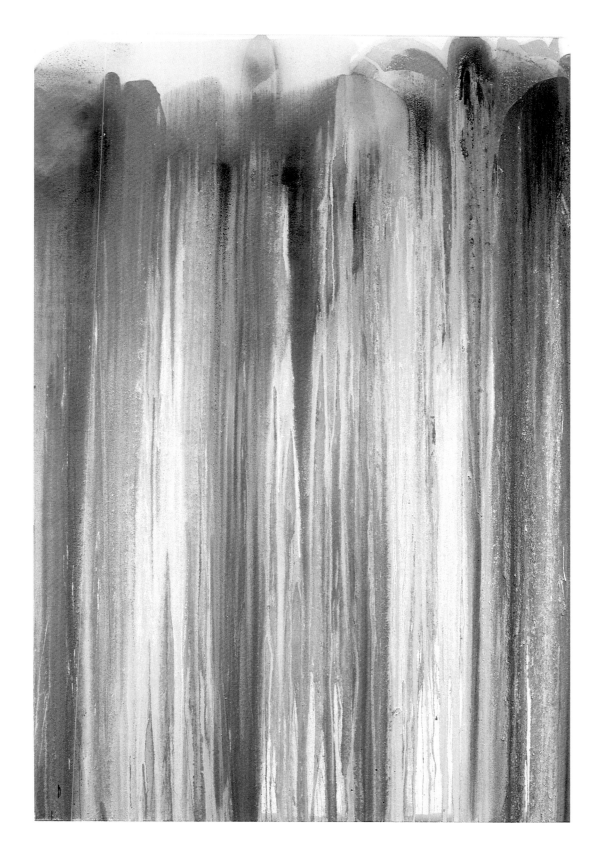

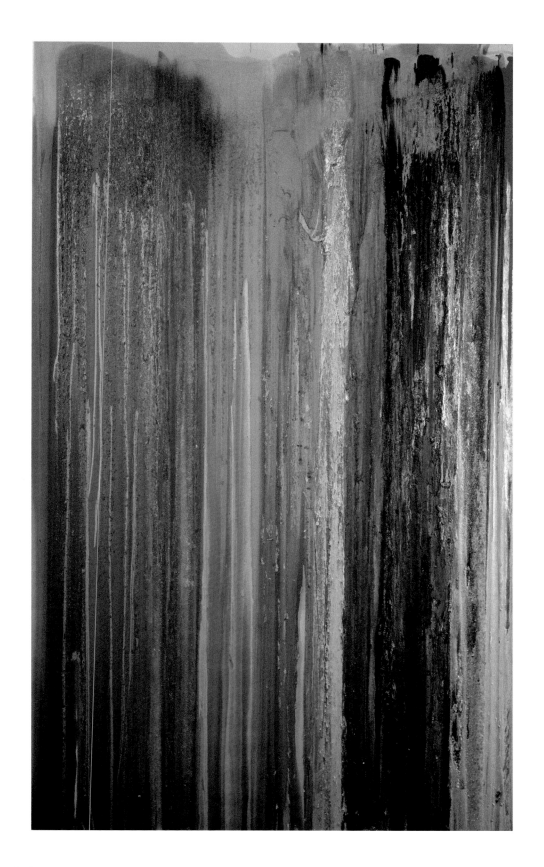

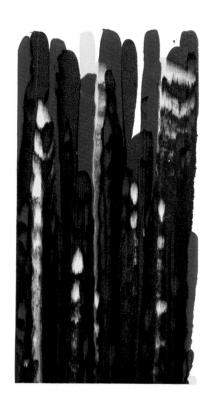

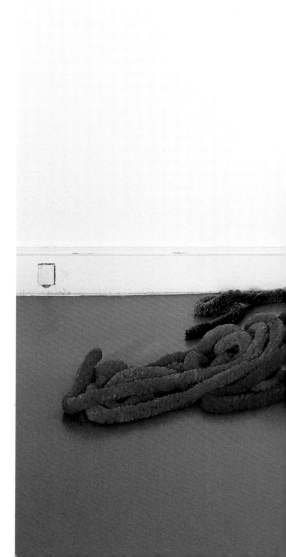

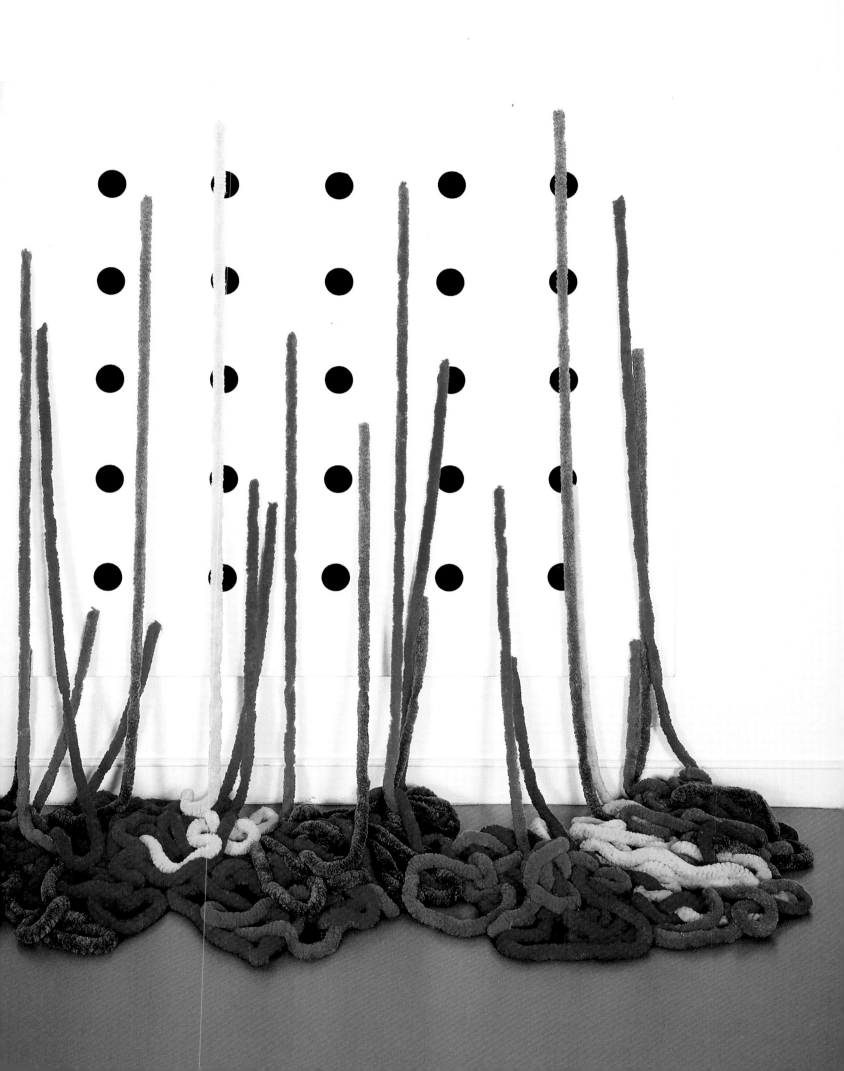

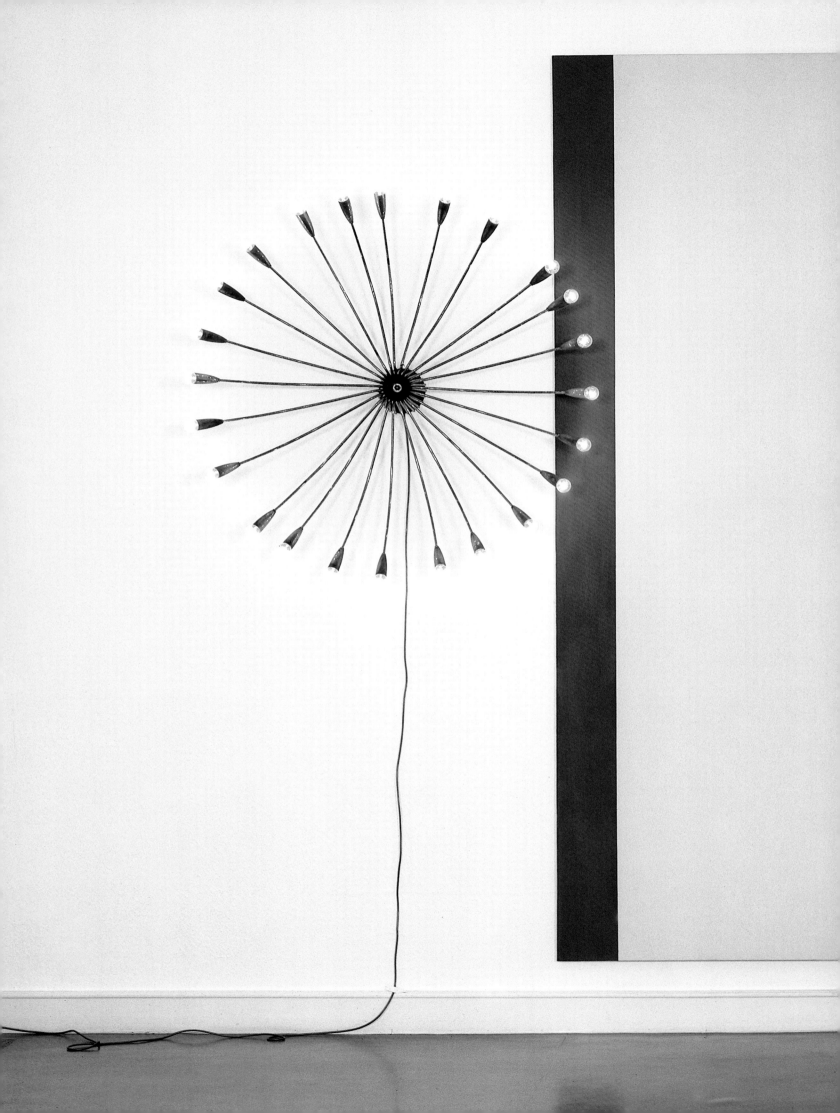

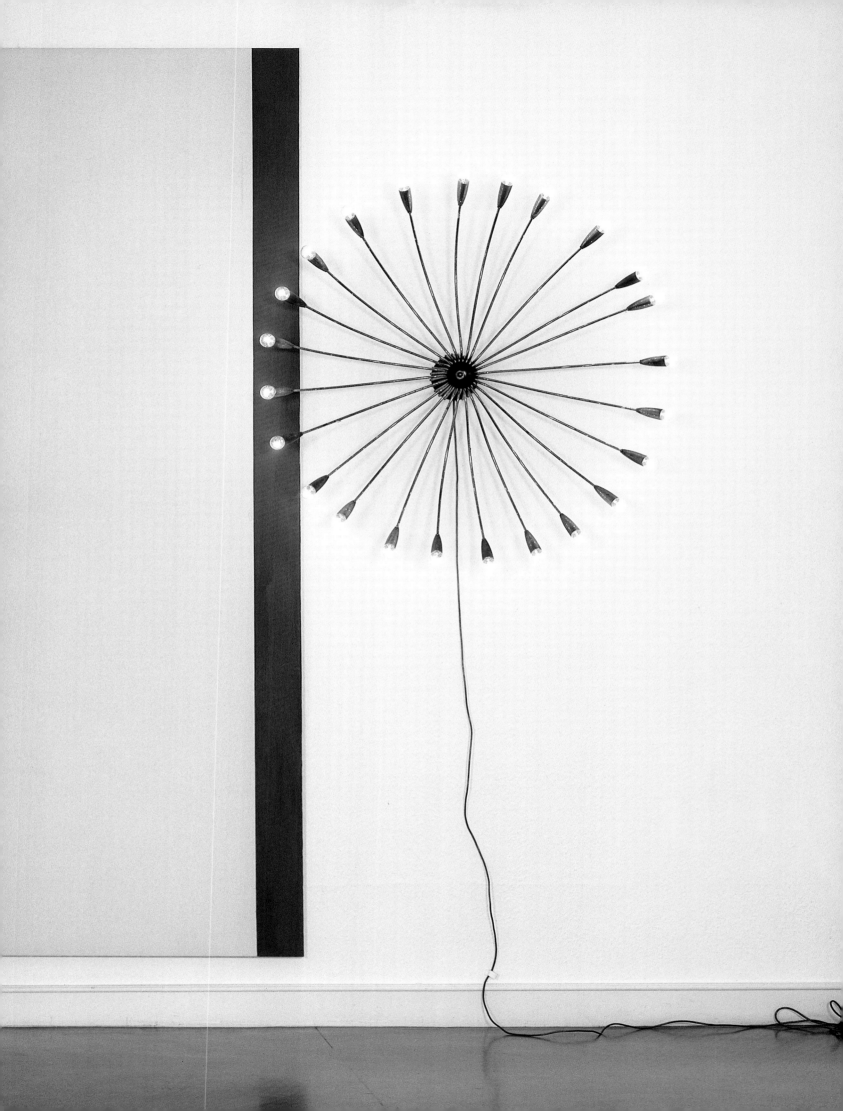

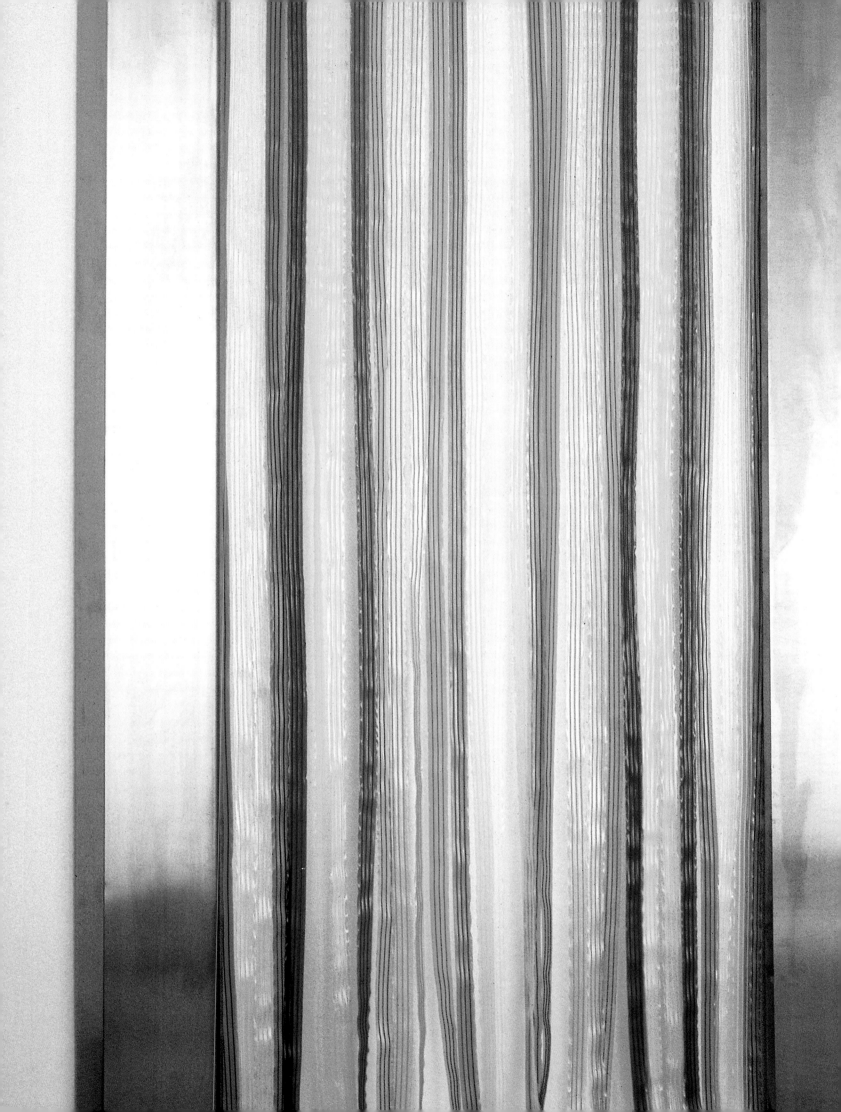

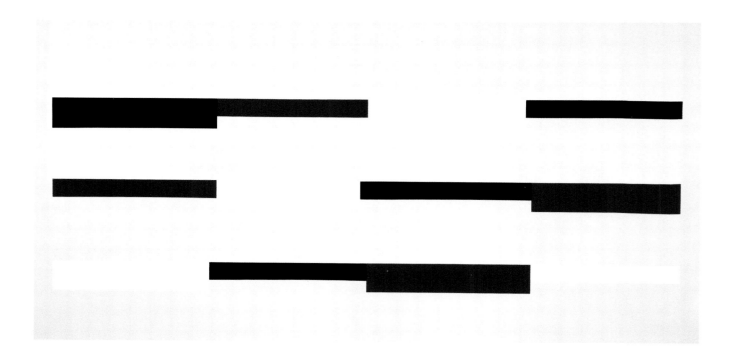

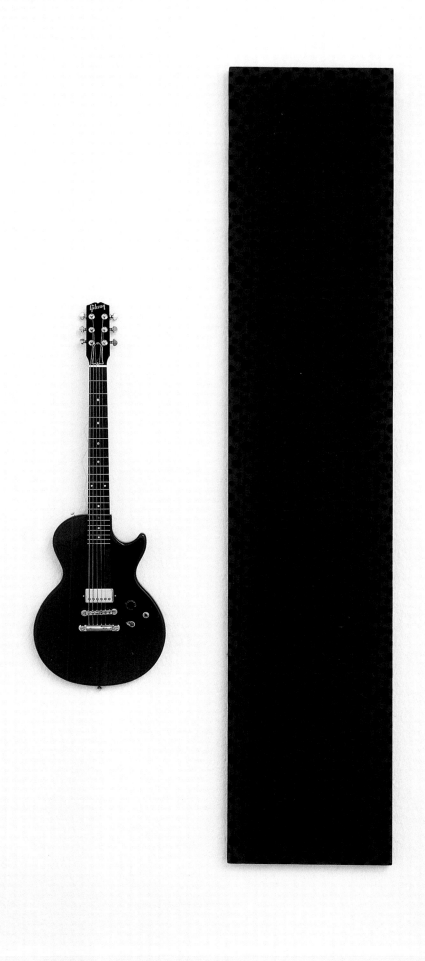

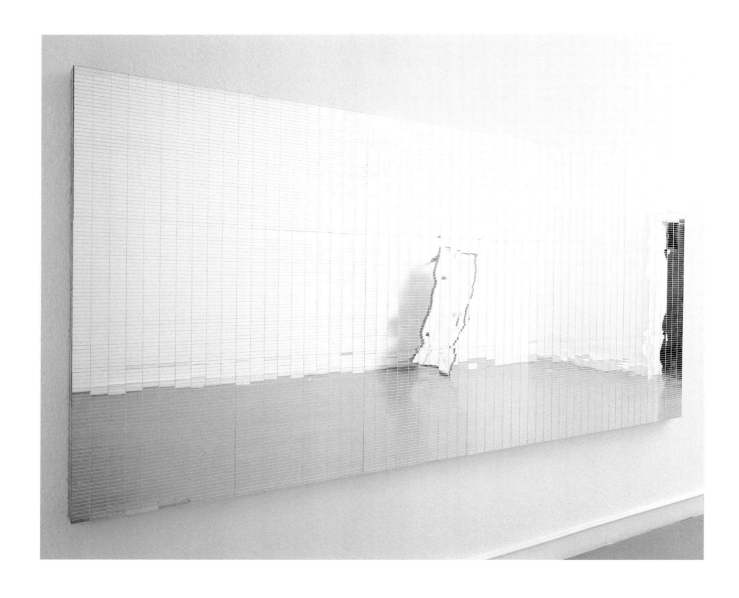

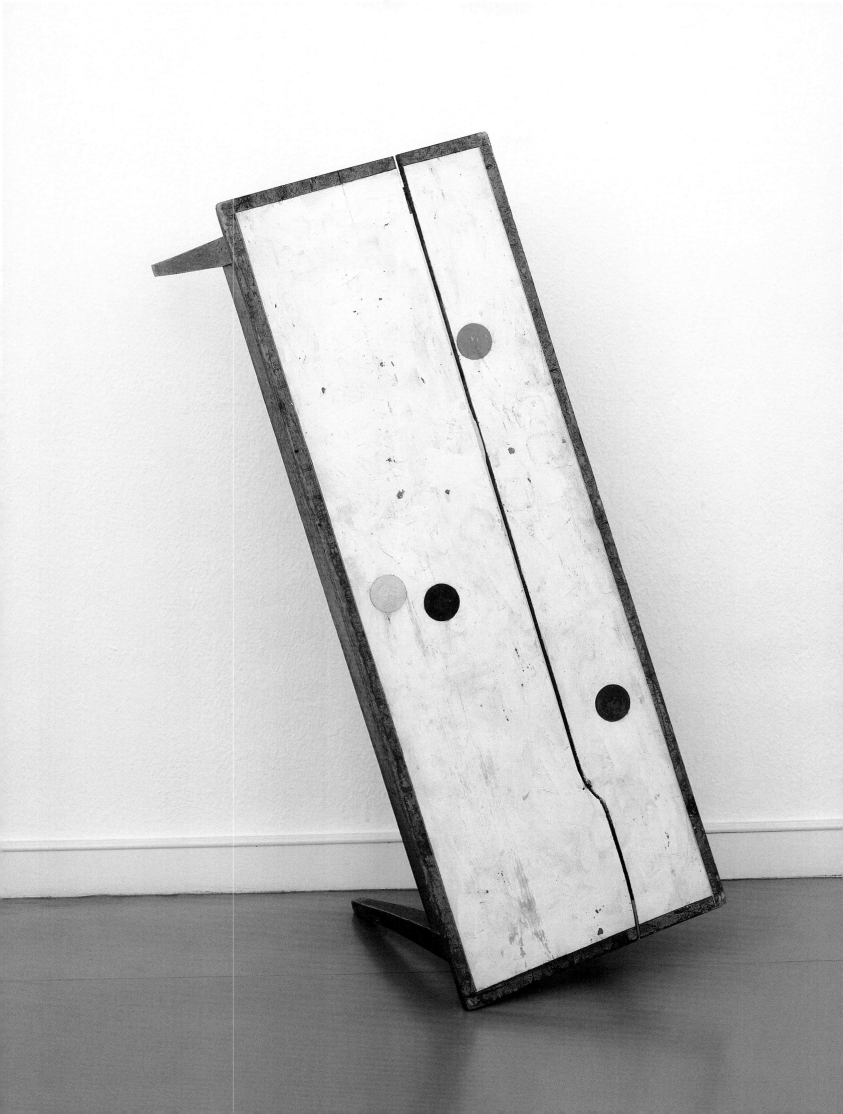

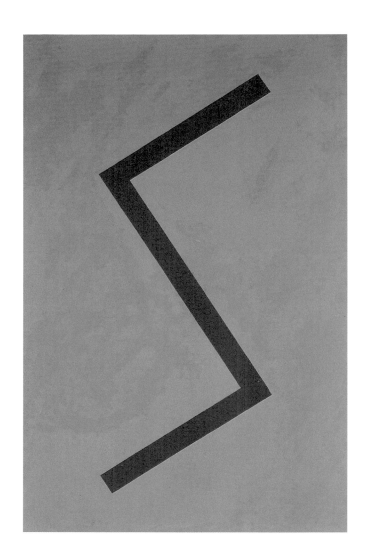

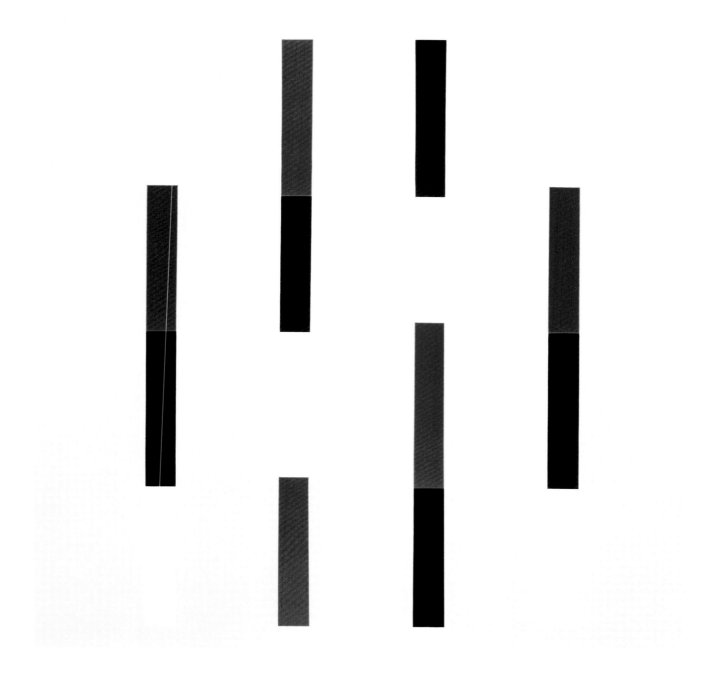

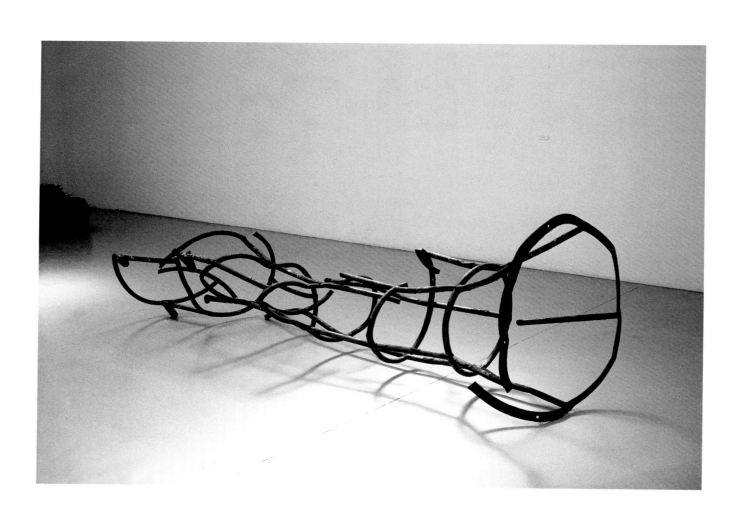

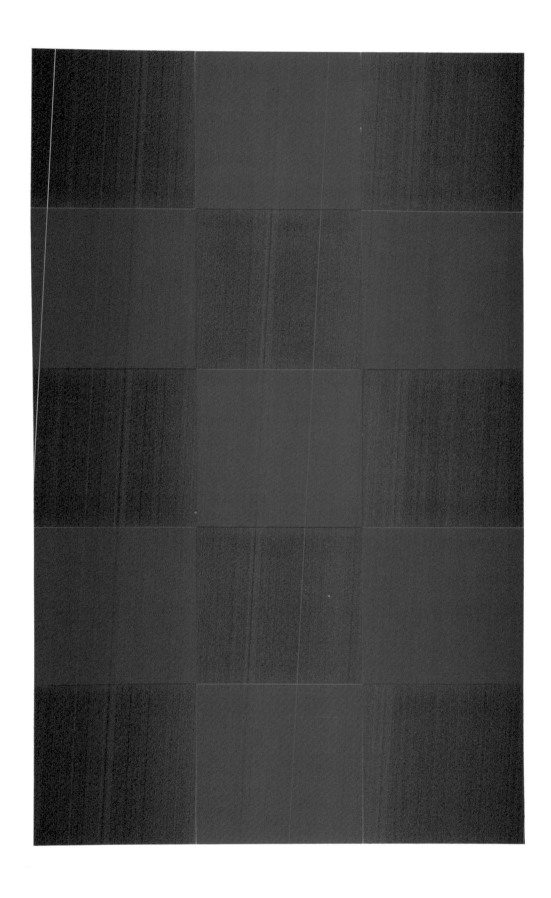

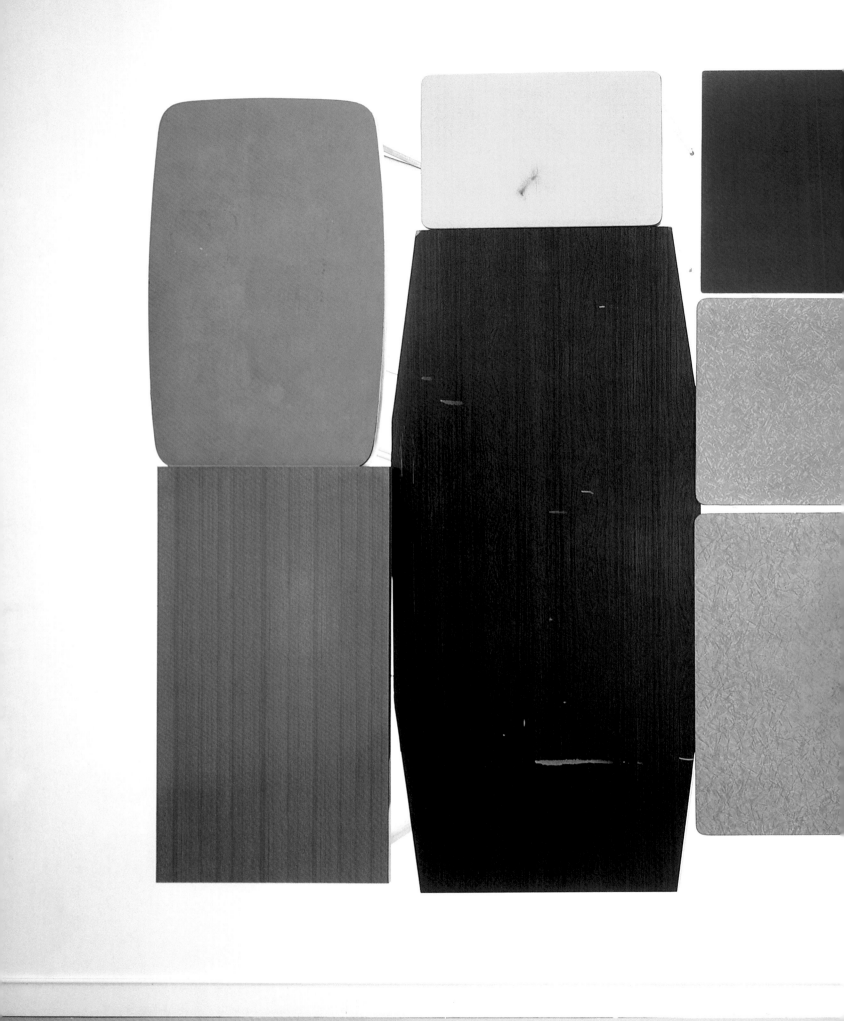

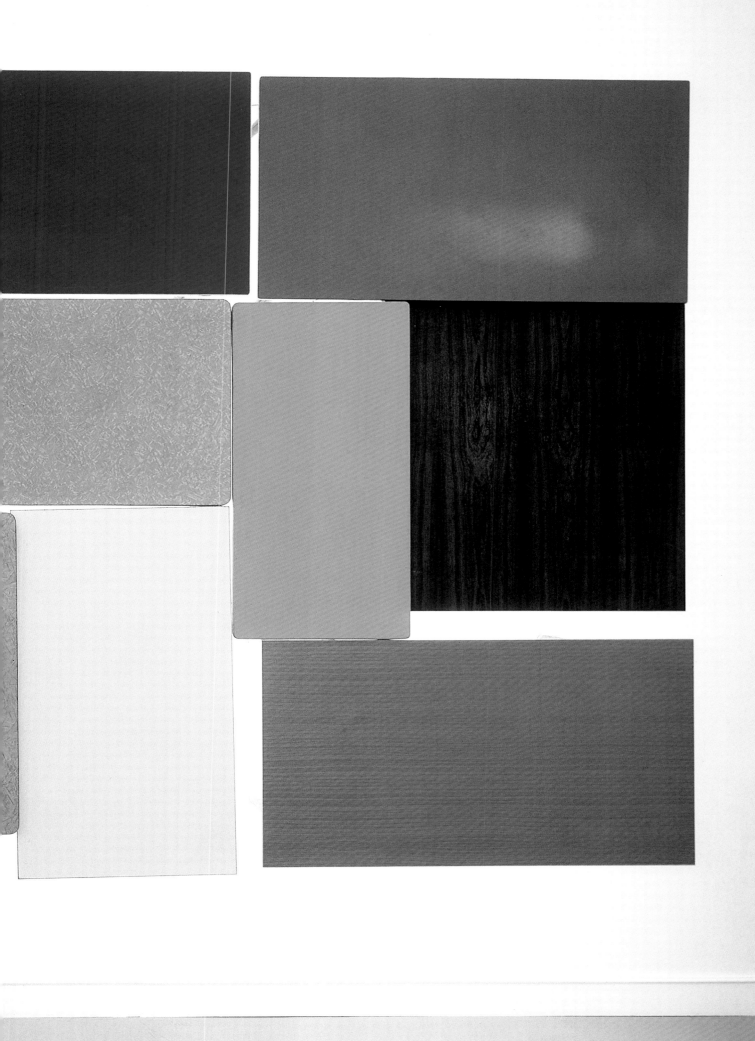

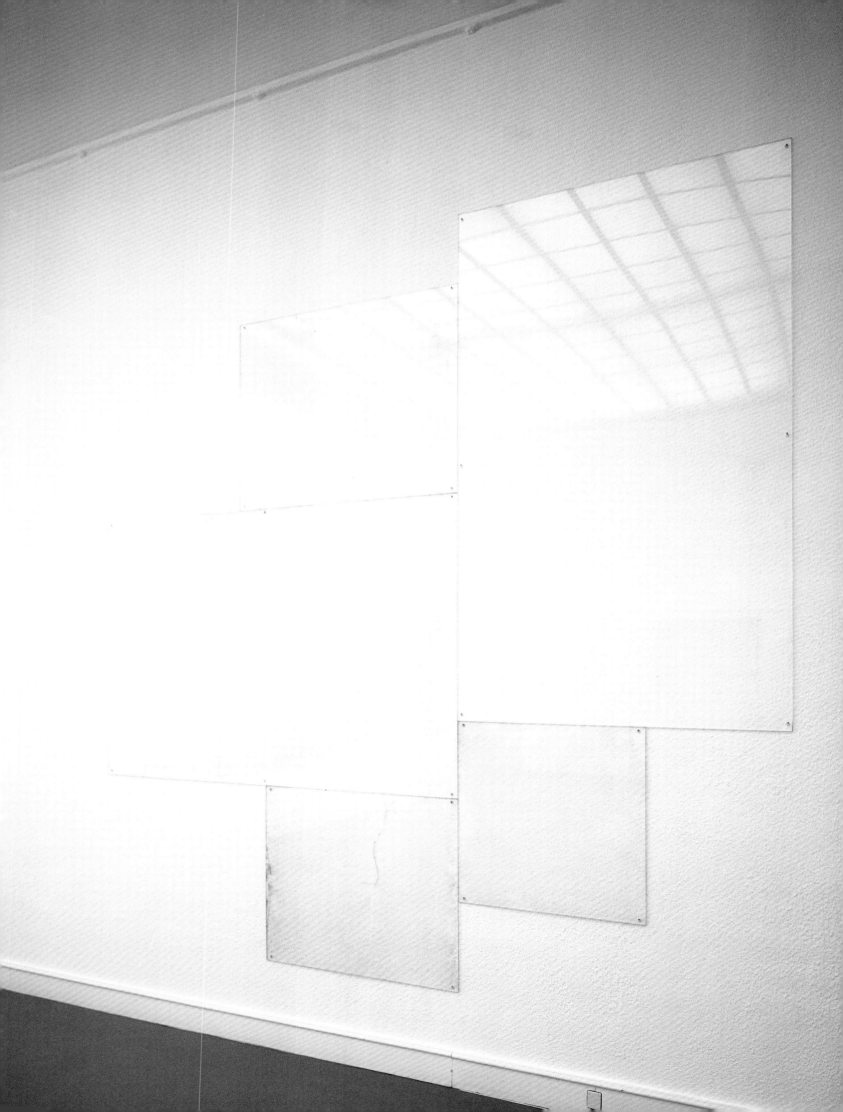

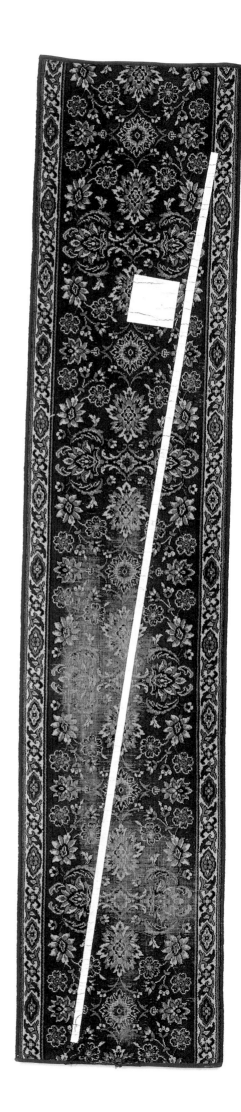

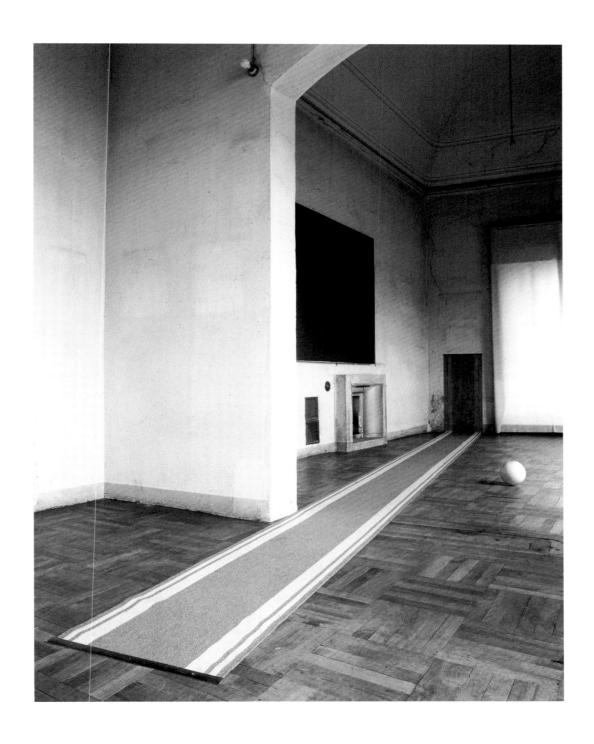

THE PUDDING OVERDOSE – JOHNNY BE GOOD

AXEL HEIL

DIE GESCHICHTE DER MODERNEN KUNST ist lange schon und nicht erst „soeben" – mutwillig – eine geradezu „klassisch" verworrene, der man auch mit viel Liebe und antrainierten Ordnungskriterien oft nur mühsam begegnen kann. Es wird auch nicht schwieriger, wenn man voreingenommen ist, oder „autodidaktisch ausgebildet", oder parteiisch. „Wir scheinen immer zu glauben, daß überall in der Kunst eine Ordnung eingerichtet werden muß. Was aber, wenn Kunst zur Unordnung anstiftet?"[1]

Nichts macht mehr Durcheinander als ein unübersichtliches Œuvre, und so beginnen wir gleich bei einem hohen Schwierigkeitsgrad, denn irgendwo muß man anfangen. Wir sehen uns dem Pudding gegenüber. Noch genauer „dem Pudding", den John Armleder uns serviert hat. – Rewind and fast forward – garantiert wird er wackeln – wie jeder gute Pudding. Daß das zuerst Angerührte, also das Unterste nach dem Stürzen automatisch oben liegt, ist selbstverständlich. Und daß er so schmackhaft ist, daß eine Überdosis leicht zuviel sein kann – auch das glauben wir gerne. Pudding kommt „privat-ethymologisch" bei Armleder aber vor allem auch von »putting (things) together«[2]. Womit nicht nur geschickt ein Arbeitsergebnis in Gerundivform beschrieben, sondern eine Methode („wie ich zu meinen Bildern komme") glücklich metonymisiert wird. Für das Zusammenfügen eigentlich als disparat empfundener und so gar nicht zusammengehöriger Teile greifen wir mit der vielfach zitierten Lautréamont-Phrase tief in die Mottenkiste: Als mit dem „Zusammentreffen einer Nähmaschine mit einem Regenschirm auf einem Seziertisch" gleichsam das erste „klassische" Furniture Sculpture der Moderne beschworen wurde, war es schon zu spät. Obwohl oben genannte Sentenz als Opener in keiner Abhandlung über den Surrealismus fehlt, handelt es sich natürlich (dem Erscheinen im Kontext nach) mindestens um das zweite oder dritte „echte" Furniture Sculpture (FS), denn Duchamp hatte selbstverständlich sowohl mit dem „roue" (Fahrradrad auf dem Hocker), als auch mit dem Flaschenständer und den Garderobenhaken (trébuchet) bereits das „Gelände" sondiert. John Armleder beschäftigte dies alles längst nicht mehr als er Ende der 70er Jahre mit dem Begriff „Furniture Sculpture" sein umherschweifendes Tun präzisierte. Bald 15 Jahre zieht sich die Diskussion um die „Zitatkunst" („Appropriation Art") nun schon hin und noch immer meinen gut informierte Kritiker es mit einer „minder wichtigen Spielart pseudo-avantgardistischer Möchtegern-Künstler zu tun zu haben". (Après nous la XXIème siècle.) Daß sich John Armleder wie wenige andere Künstler seiner Generation bereits Anfang der siebziger Jahre in der Rezeption der Moderne besser auskannte als viele sollte ja kein Nachteil sein. Sein Spiel und das haben die Ecart-Aktivitäten mehr als bewiesen[3], war stets frei und fern jeglicher methodisch oder strategisch abgeklärter Mechanik. Daß aber nicht nur der oft und zurecht zitierte Suprematismus der Russischen Avantgarde als „Reflexzone" herhalten mußte, sondern nahezu und „bei Gelegenheit"

1 | John Cage, in: Für die Vögel, John Cage im Gespräch mit Daniel Charles, Berlin 1984, S. 100.

2 | „I'm always interested in how bringing things together" J. A. im Gespräch mit A. H.

3 | Siehe hierzu die Texte von Lionel Bovier und Christophe Cherix.

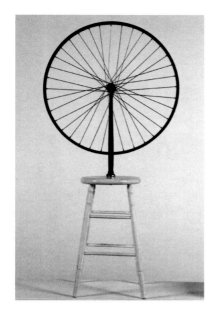

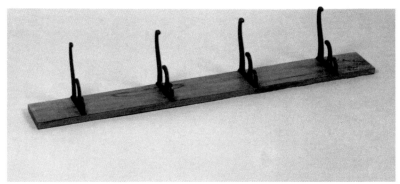

jede nur erdenkliche Strömung dieses Jahrhunderts, macht es den „Hardcore-Appropriation Art-Verteidigern" im Fall Armleder nur schwerer. –

Die „Methode" muß also woanders ihren Ursprung haben. The pudding overdose – show me your motion. Rewind. Zurück zu FS: der Begriff „Furniture Sculpture" drängt sich bei John Armleder der genaueren Untersuchung geradezu auf. Er ist, und das bleibt festzustellen, bevor wir ihn genauer abtasten, bereits so eng mit dem Künstler terminologisch verbunden, wie die Toteninsel mit Böcklin oder der Hut mit Beuys [4], womit wir schon mitten im Thema wären ... „ ... Ad Reinhardt (Beuys spricht) sagte: ,Skulptur ist, wenn man vor einem Bild zurücktritt und hinten über etwas stolpert, was im Weg steht.' " [5] Daß es irgend etwas Räumliches war, das wußte man ja, aber man hatte keinen Begriff was Skulptur ist ...

Furniture Sculpture könnte demnach ein Gattungsbegriff sein. Eine Lineage einer Unterabteilung der Gattung „Sculpture" – aber der Schein trügt. Denn in vielen Furniture Sculptures tauchen Objekte auf, die unschwer als „Gemälde" zu klassifizieren sind, und es gibt „Objektkonstellationen", die weder aus Skulpturen noch aus Möbeln oder „Möbelartigem" bestehen. – Eher aus Sperrgut – Encombrements. Sollte es auch hier nur eine Frage des „Survival of the fittest" sein? Es ist also eher eine „neue" Gattung, „die nicht mehr eine neben anderen ist, sondern eine ,gattungsumschließende' Gattung", die Friedrich Schlegel vor mehr als 150 Jahren schon mit dem Prädikat der „progressiven Universalpoesie" belegte, ohne sie zu kennen ... [6]

„Universalpoesie" ist in der bildenden Kunst bei Fluxus, Ecart und spätestens seit dem Siegeszug aller Video-Combine-Installationen auch auf dem Gesamtkunstwerkspielfeld des Jahrhunderts kennzeichnende Praxis. Diese „Umbildungen" genuin oft absichtliche Variationen „bekannter" Wiederholungen, erweisen sich aber als wenig

4 | Es war die Frage „Nepal oder Beuys" (J. A.), die sich die jungen Genfer stellen mußten und es war die Frage nach sich selbst. Es ging darum, etwas zu machen, was man selbst in jenem Moment war und nicht darum „seine Tendenzen" zu illustrieren.

5 | Joseph Beuys im Gespäch mit Martin Kunz, in: Joseph Beuys, Spuren in Italien, Luzern 1979, o. S..

6 | Siehe z. B. in: Friedrich Schlegel, Fragmente aus dem Athenaeum, hrsg. v. Ernst Behler, Bd. I, Darmstadt 1983, S. 188ff.

kompatibel und vergleichbar, will man sie mutwillig unter eine General-
oberbegrifflichkeit zusammenfassen oder gar gegeneinander aus-
spielen. Vielmehr, und das zeigt die Vermischung der Grenzen von
Künstler, Kurator[7] und DJ mehr als deutlich, haben wir es mit einem
„Kontinuum" sich ausbildender, „flüssiger" Darstellungsformen zu
tun, die sich eher vom Rand her (Ecart) als aus einer mutwillig kon-
struierten Mitte heraus ergeben[8]. (Ein „Verlust" übrigens, den wir
nicht mehr in Zweifel ziehen, sondern über den wir uns ganz offen-
sichtlich freuen – und das auf über tausend Plateaux.)

Eine Konsequenz davon (das permanente Mutieren, Expandieren
und Verwischen eingeschlossen) ist die Vermischung und Koagulation
in Phänotypen unterschiedlichster Ausprägungen. Es kommt zu völ-
lig „neuen" Werkformen – (erhalten wir uns zunächst für Momente
diesen Glauben). Der historisch so scheinbar festgefügte Bereich,
der so glanzvoll „heroisch" apostrophierten Moderne – „Füllen wir
die jungfräuliche Leinwand Mondrians – und sei es auch nur mit un-
serem Elend."[9] – erscheint so eher als ein großer Flohmarkt.

„Do (buy?) the right thing". Es ist hier die Regel, daß der Prozeß
das Resultat gebiert. – Und das Resultat ist ein Zwischenergebnis.
Mit etwas Muße kann man dann auch wieder eine Plattform bauen,
Gerüst-Erfahrungen machen, von denen aus das bis dahin „Ge-
schaffte" garantiert wieder anders aussieht – und nochmal anders
verwendet werden kann. »Wir leben in einer B-Society« (John Arm-
leder). Transästhetik[10] und Transformation definieren „Werke" und
„Begleiterscheinungen", ob als Furniture Sculptures oder als Neon
Pieces, in ihrem Erscheinungsbild gleichermaßen wie die vermeint-
lichen „Déjà-vu"-Impulse tägliche Stimulans der Betrachtung sein
können. Es geht um Initiative und Begeisterung.

BEGEISTERUNG ODER HIT THE SPOT
»The most silly things I do, I do with a lot of pleasure«. J. A.
„Es geht um die Begeisterung für das Nicht-Etwas. Eine Art Tao: Es
ist der Anfang aller Dinge und zugleich die Art auf die sich alles voll-
zieht. Es ist das Nicht-Etwas."[11]

Die Strecke, die der Betrachter zurücklegen muß, um ein Kunst-
werk zu „finden" ist genau der umgekehrte Weg der Genese eben
dieses „Werkes". Der Betrachter sieht den „letzten Touch" zuerst,
während der Künstler (schlimm genug), mit dem ersten Touch beginnt
und mit dem vermeintlich „letzten" endet, (der vielleicht sogar den er-
sten wieder unsichtbar macht). Zwischen diesen beiden Betrach-
tungsweisen gibt es keine Möglichkeiten des Austauschs (Diffusion
der Kommunikation), aber das hat nichts mit Wahrnehmung zu tun.
Man fragt nur nach dem Puddingrezept, wenn man ihn kalt stellen will.

Eine ebenso wichtige Frage für viele „pieces" von John Armleder,
ist die Frage der „Balance". – »Fixed to the wall« wäre oft zu ein-
fach.[12] Die Auswahl der Objekte, und das berichtet John Armleder

7 | „There is a strategy in looking on other peoples' work." J. A.

8 | Vergeßt Sedlmayer.

9 | Constant, in: Reflex, Amster-
dam 1948, o.S.

10 | Weinen über die Verluste und
den „degré xerox", den Reproduktions-
charakter der Kultur, z.B. bei Baudril-
lard, in: NOEMA, No. 23, 1989.

11 | Cees Nootebom, in: Rituale,
Frankfurt 1992, S. 200.

12 | Es war eine große Freude
beim Einrichten der Ausstellung in
Baden-Baden festzustellen, daß der
Tisch (FS 20) von John Armleder so
auf zwei Beine dirigiert wurde, daß er
von alleine an der Wand stehen blieb.
Lediglich zur Sicherheit der Besucher
mußte er fixiert werden.

 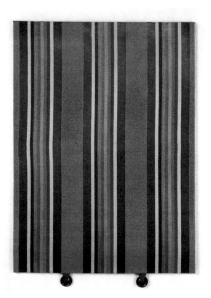

in zahlreichen Kommentaren zu seinen Furniture Sculptures [13], ist eben auch ein Spiel von Balance [14], Zufall (daß einem etwas zufällt…) und Intuition. Er verläßt sich darauf und kann sich darauf verlassen. Instinktiv so scheint es, gelingt immer wieder der glückliche und entscheidende Griff zur kleinen Verrückung, zur spielerischen Dekonstruktion, die über sich selbst in den Gang der kurzweiligen Unterhaltung hinausweist. [15]

REWIND | Zurück zur »Furniture Sculpture« [16] und hier zu einem Beispiel, das wie kein zweites im Werk von John Armleder der mediteranen Assoziation freien Lauf läßt, die da heißt: „Der Süden ist blau" [17]. FS 181 aus 1988 [18], so erzählt die „Legende" war das Ergebnis einer Ausstellung in der Galerie Tanit in München und einem „Shopping bavarois". Der Künstler berichtet von seiner nomadischen Arbeitsmethode, „unterwegs" das „Seine" zu tun, zu komponieren und das finale Setting in der Galerie oder dem Museum einzurichten. Es ist fast die Regel mit Ausnahme, daß die Werke vor Ort entstehen.

Immer weist er im Gespräch darauf hin, wie wichtig all die Anregungen und „Supports" der Menschen um ihn herum als Stimulanzen wirken. Dieses „plastic curtain piece" ist aber Resultat eines speziellen Shoppings mit Sylvie Fleury – das Erstaunliche ist die „Baumarkt"-Atmosphäre, die dieser Art von „Auswahl" anhaftet. Der Griff zu den „industriell gefertigten Farben" (die Plastikbänder) ist jedoch Programm und so erzählt John weiter, daß er mehr eine Malerei in dem Objekt sieht als eine Tür-„Füllung" oder eben umgekehrt. The doors of perception. Hier spielt der Wind.

Der „brachial coloristische Reichtum", der saturierte Oberflächenreiz der Kupferabdeckungen evozieren leicht späte Streifenbilder von Morris Louis oder Bridget Riley in den „glühenden" Siebzigern – oder ein „charge-objet" von Jean Michel Sanejouand. Morris Louis

13 | Siehe John Armleders ausführliche Beschreibungen, z. B. in: John M Armleder, Furniture Sculpture, 1980-1990, Ausst. Kat. Musée Rath, Genf, 1990.

14 | Es ist bezeichnend, daß eine der „abstraktesten" Skulpturen von Max Ernst nur noch als Abguß existiert. Nicht nur als Teil „seiner" Methode, die ursprünglichen Elemente einer „Collage" vergessen zu machen, sondern gerade eben als ironische Paraphrase dieser Methode; – denn daß es sich um einen auseinandergesägten und wieder „falsch montierten" Tisch handelt, bleibt, zumindest für den Kulturkreis der westlichen Hemisphäre sogar noch von ferne sichtbar – aber verblüffend.

15 | „Mit enorm wenig viel" war ein Slogan von Meret Oppenheim, den Bice Curiger so bezeichnend knapp in die John Armleder Debatte einwarf. (Live Galerie Susanna Kulli, St. Gallen, 1997)

16 | Die Gruppe der „charges objets" von Jean-Michel Sanejouand nehmen als „radikale" Setzung der Dekontextualisierung von Gegenständen einen unheimlichen und viel zu wenig beachteten Platz in der Geschichte der Kunst der sechziger Jahre ein.

 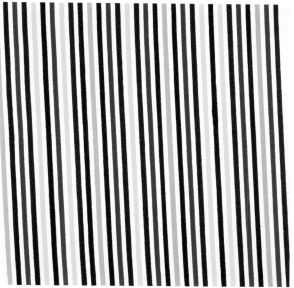

spielt aber auch bei den Pour-Paintings eine Rolle, wie wiederum der „Süden" bei „Vasarely-Flash", einem „ordentlich" gemalten Bild. (In Kollaboration mit Sylvie Fleury und sogar die „Original-Farben" des „Meisters von Gordes" benutzend.) Um noch ein weiteres, sehr spezielles Furniture-Sculpture „Forward" in Erinnerung zu rufen, sei auf FS 191 ebenfalls aus 1988 verwiesen. Die Beschreibung lautet: »Lit de chien ou chat en fourrure synthétique«. Ein Katzen- oder Hundekorb also und wer wollte bestreiten, daß es sich dabei um eine extreme Luxus-Chaiselongue für Sheba-verwöhnte Tigerchen handelt. Auch Katzen haben Möbel, und ist es wirklich Zufall oder genützte Chance, daß eben jenes Objekt seine „Uraufführung" in einer Ausstellung erfährt – anläßlich eines Festivals für „musique contemporaine – consacré à John Cage". Bleibt zu erwähnen, daß Cage seinen berühmten Aufzeichnungen den Titel „Pour les oiseaux", „Für die Vögel", gab, und das natürlich als vergnügliches Wortspiel mit seinem Nachnamen zu gelten hat.[19] Das Photo von Cage wiederum, der uns in »Conversations à dix bandes magnétiques« als einer der „Wegbereiter" von Ecart erscheint, war im Original[20] ein Schnappschuß von John, der „occassionally" schon frühzeitig Eingang ins Pantheon fand.

»I'm not interested to give the work a meaning, basically I'm not interested in meaning.«[21]

GEDULD – BUSY LIZZIES
»Jedes Kunstwerk ist in sich endgültig und kein Versprechen von etwas Besserem danach«.[22]

Das wirkliche Experiment ist stets, ob der Betrachter willens ist, anzunehmen, was sein Auge ihm übermittelt. Wir befinden uns jetzt direkt einem Dot-Painting gegenüber. Alle „Punkte" sind kreisrund.

17 | Auch von BEN aus Nizza einstmals lapidar ins Bild gesetzt.

18 | »Quand je parle de mon incapacité de préférer une de mes œuvres, en voici bien une dont l'impertinence gauche m'attendrit toujours.« J. A. in: s. Anm. 13, S. 64.

19 | Daß Haustierkäfige häufig auch in die Kategorie FS gehören scheint unzweifelhaft.

20 | Leider konnte trotz heftiger Recherche von Christophe Cherix bisher diese Originalphotographie nicht wieder aufgefunden werden. Sie wurde in der Rekonstruktion für Baden-Baden 1998 durch eine mit dem Original vergleichbare ersetzt.

21 | J. A. im Gespräch mit A. H.

22 | Man Ray 1961, zit.n. „The Age of Light" in: Man Ray Photographies, o. S.

Es sind keine Punkte. Sie, die „Dots", sind ausgemalte Flächen – sie sind schwarz und sie sind nahezu regelmäßig verteilt. Es scheint auch ein „Fehler im System" dabei zu sein. Einer hängt etwas durch.[23] Daß es extrem spannend sein kann, „Fehler im System zu entwickeln" und geradezu programmatisch „Unordnung herzustellen", war auch planvolles Unterfangen des Wahlparisers André Cadere. Seine, in den siebziger Jahren „unübersehbaren" Stäbe, die als systematisch mit sich geführte Irritationsmomente in Ausstellungen von „anderen" Künstlern (befreundet oder nicht) unvermittelt mit „ihrem Träger" (Cadere selbst) auftauchen konnten, verwundern auch heute noch durch ihre Souveränität in der Ökonomie der Mittel. Auch hier „ambulante Malerei im Einsatz" und als „retardierendes Moment".[24]

Zurück zu den Punkten…. War es noch in den späten sechziger Jahren, vielleicht angeregt durch Arnheim's „Art and Visual Perception…" üblich, über die nutzbringende Analyse von „mechanischen" und „natürlichen" Konzepten auf gemalten Bildern zu spekulieren, so reizt John Armleder heute mit »The overloaded pudding overdose« bereits in einer anderen Liga. Sehr verkürzt gesagt: Arnheim benutzte Modelle, z.B. eine schwarze Scheibe, die jenseits der Mitte in einem Quadrat plaziert war. Diese „einfache" Konstellation diente der Darstellung aktiver oder passiver Kräfte gegenüber der Scheibe (lies: „dot"). „Natürlich" wäre, so behauptete er, daß immer der Eindruck erweckt werde, als ob die Scheibe vom Quadrat und nicht das Quadrat von der Scheibe beeinflußt wäre. Diese Situation sei verantwortlich für Aussagen über die Stabilität im Bild und die Wahrnehmung der Balancen von Anziehung und Abstoßung. Dieser Ausflug zur längst vergessenen Wahrnehmungspsychologie (die heute eher Biologie der Cognition heißen darf) scheint weithergeholt, aber er verweist auch auf „traditionelle Erklärungsmodelle", die John Armleder ganz nebenbei und ohne didaktische Absicht ad absurdum führt. Es waren nämlich kleine Quadrate, die nach einem bestimmten Ablauf den genauen Platz der dots auf der Leinwand bestimmten. – Inklusive natürlich des „Ausrutschers"[25] – den nur von Langeweile geplagte Detektive wirklich dechiffrieren wollen…. Diese Methode tangiert (im ursprünglichen Sinn des Wortes) wiederum die Frage nach der Menge der Punkte auf der Größe der Leinwand und ob das immer so weitergehen könnte, ob das ein Muster sein soll oder ein Dekor. Was ist es, wenn die Punkte golden sind (Sonnen?) oder pastellfarbig und manche sogar Individualität tragen durch aufgedruckte Smileys? The pudding overdose[26] – override. Es bleibt dabei, wie das „gequälte Quadrat"[27] bleibt auch der „black spot" die Zielscheibe der Aufmerksamkeit[28] des Künstlers. Es kann keine Diskussion zwischen Betrachter und Künstler über eine einzige Pudding-Theorie geben, die dem allen zugrunde liegen soll. »There's a whole Bircher Müsli of meanings«, meint John Armleder. Und das ist gut so.

23 | Auch „Vasarely Flash", so erzählte mir John, hat ein System, aber es wäre eben ‚Archäologie' dieses „zu re-discovern".

24 | Über André Cadere ausführlicher und empfehlenswert in: Unordnung herstellen, Ausst. Kat. Salzburg/München 1998.

25 | J. A. im Gespräch mit A. H.

26 | Siehe auch die fünfteilige Edition „The Pudding Overdose" 1998.

27 | „Malewitsch – a young artist will use it without context: Male which? - Male who?", J. A. im Gespräch mit A. H.

28 | „His [Arnheim's] theories fail totally in their perception of creative activity…" „He placed the square not the disc." Asger Jorn in einem Brief an John Lefebre, nach Ausst. Kat. Lefebre-Gallery, New York 1970.

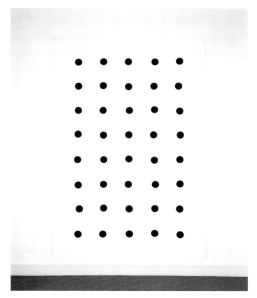

INITIATIVE – SHOW ME YOUR MOTION

„Schönheit ist ein paar Schuhe – die höllisch drücken."

„Beauty is a pair of shoes – that makes you wonna die". [29]

Mit der Sicherheit, daß etwas zutiefst Unsichtbares eine Vision sein kann und die Logik des Mißlingens ein guter Berater ist auf dem Weg „glücklichen" Scheiterns, erscheint am 12. Februar 1966 in der No. 36 des „Le journal de Genève" ein Gespräch von Guy de Belleval mit Martial Raysse. Raysse, zu dieser Zeit Vorzeigekünstler der Grande Nation und Exmitglied der Nouveaux Realistes in Nizza und Paris, macht darin folgende Aussage: „Je fais n'importe quoi avec n'importe quoi". („Ich mache Irgendetwas mit Irgendetwas.") Schon möglich, daß jene Zeile, selbst Teil eines umfangreichen, an Transversionen und Anspielungen auf „Modifikationen" reichen Artikels, Begeisterung bei den sehr jungen „peuples d'Ecart" hervorgerufen hat. Als extrem „zeitgeistiger Artist", der sich als „von der ,Assemblage-Kunst' kommend" [30] verstand, bildete er das so verzweifelt gebrauchte „missing link", den vitalen Anschluß von Europa an Amerika. [31] Ebenfalls erstaunlich, daß gerade Raysse (als Maler!) nicht nur „gebrauchte Plastikflaschen" einsetzte [32], ohne auf „Recycling" hereinzufallen oder das beliebte „primitivistische Assemblage" Glatteis zu gelangen, sondern mit gleicher Finesse auch das Neonlicht als quasi „natürliche Erscheinung" (und diese in Europa!) in gemalten Bildern einsetzte. [33] »Die Werbung ist heute so im Bewußtsein verankert, daß ein einziges Licht genügt; für mich ist das Neonlicht ein Klischee…. Anders ausgedrückt, ich wollte ein Stereotyp des westlichen Denkens festhalten….« [34] Ein Haufen Neonröhren [35], einfache weiße, blendend helle Neonröhren, wie sie auch im Eingangsbereich der Kunsthalle in Baden-Baden zu liegen kamen, sind immer noch Provokation. Und doch führt irgendwie eine Linie von

29 | „Beauty knows no pain", in: „You are what you is" Frank Zappa, Zonx, Ffm 1996, S. 234f.

30 | In: Martial Raysse, Ausst. Kat. Museum Ludwig, Wien, 1994.

31 | Martial Raysse lebte 1964/ 65 mehr als ein Jahr im Chelsea Hotel in New York (dies zur Hotelfrage).

32 | Nicht Tony Cragg als Erster.

33 | Zu einer Zeit als Dan Flavin und Keith Sonnier erst an den Grundfesten einer Definition von „neuer Skulptur" zu wackeln begannen.

34 | Martial Raysse im Interview mit Otto Hahn, in: Le Matisse des prisunix et Le Rodin de déchets, in: Art Loisirs, Paris No. 24, 9.-15. März 1966, S. 51.

35 | Untitled (Fluorescent Tube Sculpture, No.6), 1998, Courtesy Galerie Susanna Kulli, CH-St.Gallen

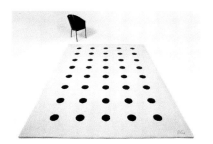

36 | Jasper Johns, „Souvenir", 1964 und „Souvenir 2", 1964.

37 | Paul Maenz, in: Die Sammlung Paul Maenz, Ausst. Kat. Weimar 1999, S. 284

38 | J. A. vgl. Ecrits et Entretiens, s. hier Anhang, S. 197.

39 | Vgl. John Armleder, FS 18, „Table haricot fixée au plafond par son plateau", in: 891 Again, 1980 – 81

40 | Robert Rauschenberg, Pilgrim, 1960, Museum Folkwang Essen.

41 | Mit Hilfe eines kleinen Klappscharniers befestigt, die Farben schmutzig, aber in „flaggenartiger" Abfolge. (s. auch Jasper Johns …).

42 | Robert Rauschenberg, in Ausst. Kat. Stedelijk Museum Amsterdam 1968.

43 | „Es gibt einen Grad der Lüge, den nur die Fälschung erreichen kann." Guy Debord.

44 | John Armleder im Gespräch mit A. H.

der Taschenlampe (die mit der Aufgabe betraut war, ein serigraphiertes Selbstportrait von Jasper Johns auf einem Teller auf einem Bild über einen Spiegel zu beleuchten)[36] bis zu den Neons, die von John Armleder „abused", um durch ihre penetrante „farbenfrohe" Anwesenheit eine ganze Ausstellung in ein anderes Licht stellen. „Die Hinterlassenschaft der Fortschrittsmoderne, ihr Credo der Stile, erscheint bei Armleder noch einmal gespiegelt – und zugleich erlöst von der elementaren Pflicht zur Kritik am Bisher"[37]. Und wer wird dem FS aus der Galerie Vera Munro (s. S. 87) seine „unvorhersehbare Eleganz" absprechen wollen; ob Barnett Newman „army olivgrün" als Farbe nun mochte, humorvoll war oder nicht. »Wenn ich eine Form, die von einem Werk des Konstruktivismus abgeleitet ist, und ein objet trouvé im Geiste des Fluxus gegenüberstelle, dann deshalb, weil ich an ihren Gegensatz nicht glaube, vielleicht ist doch das Gemälde Fluxus und das Objekt kontruktivistisch?«[38]

HÖFLICHKEIT

FAST FORWARD | Long long ago there was a man who tried to make his skill ultimate. Because of his bloody life it was no accident that he was involved in the troubles of NEO GEO.

REWIND | Unvermeidlich noch einmal in die fünfziger Jahre zurückzugehen – nicht nur wegen eines gelegentlich an der Decke montierten Nierentischs[39], sondern vor allem wegen Robert Rauschenberg, dem „living in the gap" Giganten der zweiten Jahrhunderthälfte. Er hatte nicht nur seine Bettdecke (als eine aufgespannte Version über Keilrahmen) ins Spiel gebracht, sondern mit „Pilgrim"[40] auch einen bemalten Stuhl vor die Leinwand gehängt.[41] Nebenbei „erfand" er auch den Terminus „Combine Painting", der als älterer Cousin von FS gelten darf. Armleder hängt anläßlich der Ausstellung „Promenade" im Parc Lullin in Genthod 1985 einen Stuhl in den Baum, FS 87 – ein Hochsitz ohne Jäger – „Pilgrim", der Wanderer, er kommt vorbei oder ist eben nicht da. Das „gejagt sein", oder die allzu verräterische „silent hectic" wird zum unausgesprochenen Thema. „I'm trying to

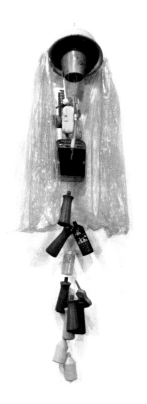

check my habits of seeing, to counter them for the sake of greater freshness. I'm trying to be unfamiliar with what I'm doing."[42] Ist es das noch immer bemühte „Prädikat" der Rauschenberg-Ära, die Objekte der Wirklichkeit gegen die überlieferten Habits des Abstrakten Expressionismus einzusetzen oder das „Ne dites pas non" der 90er Jahre? — Hatte man schon Rauschenberg durch das „Erased De Kooning Drawing" im Ansatz falsch eingeschätzt (Die Geste des Auslöschens eines arrivierten Meisters war eine mindestens ebenso deutliche Hommage, wie ein Zeichen durch ein „Nicht-Zeichen"), so hat auch John Armleder nie „einfach" mit einem Stil „konkurriert". — Auch sein Werk kennt keine Agressivität — weder im Angriff noch in der Verteidigung. Beider Diktion der „reality of the fake" („Die Realität der Täuschung") ist elementar verblüffend und subtil. Sie nutzt sogar die Einwände der Kritik als mögliche Voraussetzungen.[43] »Everyone works with a broad range... if someone tells me ›You are a damn heavy weight expressionist‹, I say ›That's not totally wrong.‹«[44] So sind die Schüttbilder („Pour-Paintings") auch keine oberflächlich verspielten Avancen an Pollock, und seine Drippings alles andere als „Expressionism re-defined". Sie sind „overloaded"[45] was ihre Geschichte angeht, aber nicht ihre Erscheinung. Sie behaupten ihre „Individualität" gerade ob ihrer vermeintlichen Nähe zur historisch folgenden Generation; zu Larry Poons[46] zum Beispiel, der bekannterweise ja auch Punkte gemalt hat... . Und da war ja noch die Rewind-Frage mit der „endlosen Leinwand", und die letzte futuristische Gruppenausstellung 0.10 mit Malewitsch in Petrograd 1915 (auf dem bekannten Photo sieht man unter der „Black Square"-Ikone, leicht aus der Ecke gerückt einen Bugholzstuhl...) und so bleibt als Antwort nur die Frage: „Würden Sie nicht auch lieber mitmachen bei einer Serie von interessanten zeitverschwendenden Trends?"[47] »Anyway, I like to look behind paintings!«[48]

FAST FORWARD |

»Wenn ich meine großen Punkte mache, male ich sie peinlich genau; im Vergleich zu Niele Toronis stempelartiger Arbeit ist das eine archaische Malweise.«[49] Anhaltspunkte sind Schlußpunkte. **FIN** | »Nein, ein Werk auszuführen ist unvermeidlich. Noch dazu, weil es kein Scheitern gibt. Ein Pudding kann zwar zusammenfallen oder steif werden, statt wackelig; dennoch es war einmal ein Pudding, wenn auch nur ein gedachter oder beabsichtigter. Voilà!«[50]

45 | „I try to get it all (i. e. all colour values). Dark, light. To put as much on to my painting as I possibly can. I'd like to really do an overloaded painting. Not just a little overloaded, really overloaded." Larry Poons, Interview by Phylis Tuchman, Artforum IX, 1970, No. 4, S. 45

46 | „Er ist ein Maler, den ich schon bewundert habe, als ich noch ziemlich jung war, obwohl ich mich für den ‚Op-Art'-Aspekt in seinen Bildern nie wirklich interessiert habe. Seine Arbeitsweise ist von meiner völlig verschieden. Er schafft seine Bilder nach persönlicher, visueller Einschätzung und beurteilt daraufhin das Endergebnis. Beurteilt den Zustand des Bildes als fertig oder wie dieser Tage schneidet nur Teile davon heraus. Ich dagegen entscheide mich vor dem Malen und habe ich mich einmal entschieden, ist es nur noch die Ausführung die übrig bleibt. Aber es gibt natürlich Parallelen zwischen der „klumpigen" Farbmaterie und den dicken Tropfspuren in seinem Werk und meiner Arbeit mit Kreisen und ineinanderlaufenden Farbqualitäten verschiedener Lacke. Es ist stets eine Überaschung für diejenigen, die mich wegen „Polke-Mißbrauch" kritisieren, wenn sie feststellen müssen, daß es Poons ist, dessen Werk ich plündere." J. A. in: Interview mit Suzanne Pagé, in: John M Armleder, Ausst. Kat. Kunstmuseum Winterthur u.a., Winterthur 1986, S. 61, übersetzt v. A. H.

47 | Frank Zappa, s. Anm. 29.

48 | J. A. im Gespräch mit A. H. auf der Berlin Art Fair 1998.

49 | J. A. in: Interview mit Suzanne Pagé, vgl. Anm 46, S. 61. Vgl. auch Niele Toronis „Stempel" in der Galerie Ecart in diesem Katalog, S. 176.

50 | J. A. in: Che fare? 1996, S. 2.

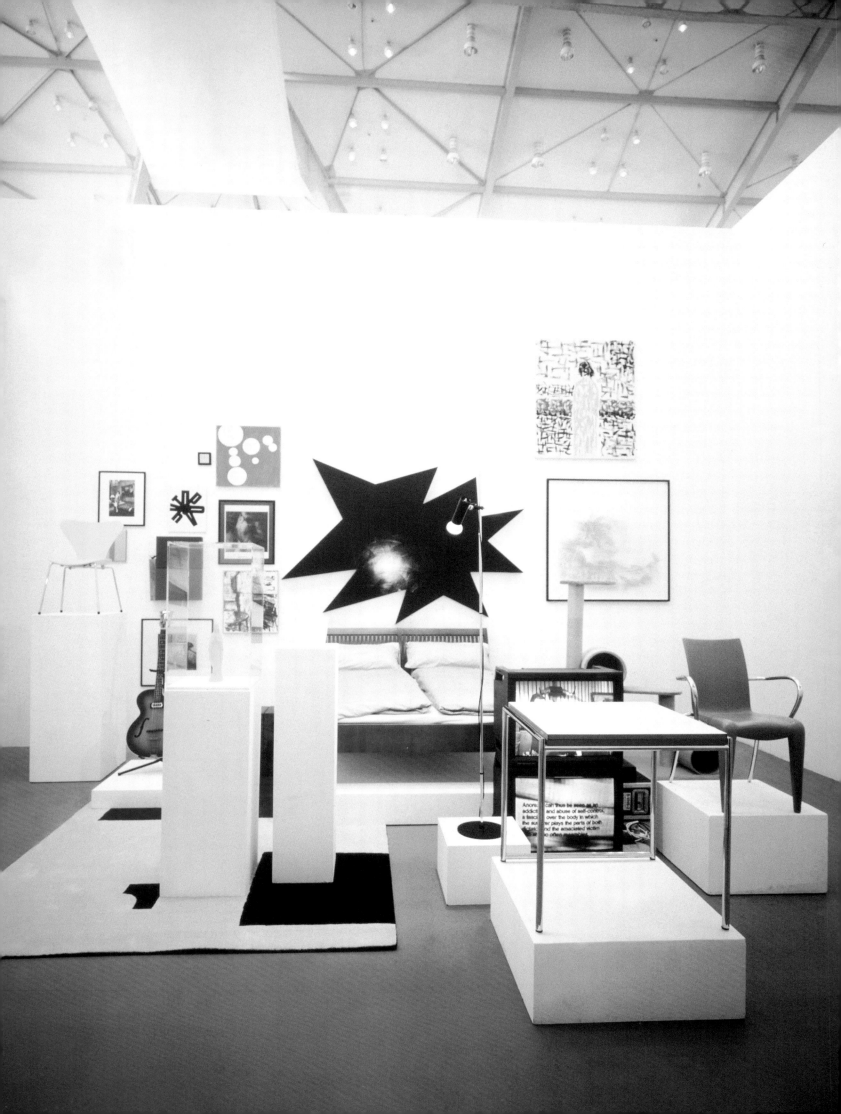

THE PUDDING OVERDOSE – JOHNNY BE GOOD

AXEL HEIL

"I love you like a pudding, if you were a cake, I would eat you." Man Ray

The history of modern art has long been and not just "of late," an entanglement of "classic" proportions, that even with much love and cultivated powers of discrimination, is a challenge to defy. It becomes even more difficult if one is biased, or even self-taught, or partisan. "It seems we have a necessity to put order into art. But what if art incites disorder?"[1]

Nothing is more confusing than a work lacking in rules. Let us begin at a high level of difficulty, since we have to start somewhere. We find ourselves facing a pudding. Specifically, "The Pudding" that John Armleder has served us. – Rewind and fast forward – it's guaranteed to jiggle – like every good pudding should. Of course we know that unmolding brings that which was undermost to the top. And, it being so tasty, that an overdose would be easy – and could just tip the balance – well we know that too. Pudding in John Armleder's "private etymology" has to do with »putting (things) together.«[2] This is not only a clever way to describe the fruits of one's toil in gerund form, but also a method ("how I arrive at my pictures") successfully metonymised. For the juxtaposition of disparate and thereby totally unrelated parts we reach deep down in the mothballs to the oft-cited Lautréamont phrase: By the time the meeting of the sewing machine and the umbrella on an operating table could be seen as the inauguration of the first modern Furniture Sculpture, it was already after fact. Though the above mentioned sentence is included in every treatise on surrealism, it describes only the second or third FS, since Duchamp had of course with his "roue" (bicycle wheel on a stool), and also with the bottle dryer and the coat rack ("trébuchet") already staked out the territory. None of this bothers Armleder anymore. The discourse on "Zitat-Kunst" (art by appropriation) has been going on for nearly 15 years, and still well-informed critics consider it "a mode of expression of minor importance, used by pseudo-avantgarde would-be artists." Après nous la XXIème siècle. It is certainly to no disadvantage that John Armleder like few other artists of his generation understood this reception of the Modern as early as the '70s. His multifarious non-style, as well-proven by the Ecart-activities[3], has always been free and unencumbered by any methodically or strategically determined machinations. However, that not only the often and rightly cited supremacy of the Russian avantgarde, but, by the way, also nearly every other conceivable trend of this century should be held up as "buffer zones" only makes it grimmer for defenders of hardcore Appropriation Art. The "method" must therefore have its origins somewhere else. Enter the

1 | From a conversation between John Cage and Daniel Charles in Für die Vögel (Berlin, 1984) p. 100.

2 | "I'm always interested in how to bring things together." J. A. to A. H.

3 | See apropos also the texts of Lionel Bovier and Christophe Cherix.

 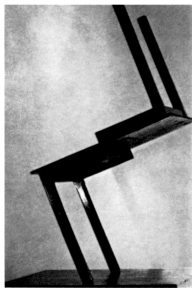

pudding overdose – show me your motion. Rewind. Back to FS – the concept of Furniture Sculpture and John Armleder demands closer inspection: It is, and this must be established, before we inspect any further, terminologically bound to the artist, like Böcklin and the Toteninsel, or Beuys[4] and the hat, which brings us straight to the point..."...Ad Reinhardt (Beuys speaks) said: 'Sculpture is, when one steps back from a picture and trips over something in the way behind him.'"[5] We knew that it was something three-dimensional, but we had no idea what sculpture was...

In this light, "Furniture Scuplture" could denote a species, a sub-group of the genus "Sculpture," but looks deceive. Furniture sculpture includes many objects which could easily be classified as "paintings," and other "object constellations" that qualify neither as sculptures nor as furniture nor furniture-like. One could as easily refer to them as bulky objects – encombrements. It is a question of survival of the fittest – vive qui vit. Let us consider therefore, a new species "no longer one among others, but a 'species-encompassing' species,"[6] designated with the name "progressive universal poetry" by Frie-drich Schlegel more than 150 years ago.

In representational art in general, most recently since the triumph of video-multimedia-installations, and also as regards the collective field of 20th century artworks, this is a benchmark characteristic. The recastings of genuine, often varied repetitions of "known" material, prove incompatible and difficult to compare when lumped together in one general category. Rather, and this clearly shows the blurring of distinctions between artist, curator[7] and DJ, we are dealing with a continuum of evolving, "fluid" representational forms that develop more away from the edge (Ecart) than outward

4 | It was the question »Nepal or Beuys« that the young Genevans had to ask, and it was a question of each to himself. It was about making some-thing that was oneself at the moment and not about illustrating one's own tendencies.

5 | From a conversation between Joseph Beuys and Martin Kunz in Joseph Beuys, Spuren in Italien (Luzern, 1979).

6 | See e. g. in Friedrich Schlegel, Fragmente aus dem Athenaeum, edited by Ernst Behler, Vol. 1 (Darmstadt, 1983) p. 188 f.

7 | "There is a strategy in looking at other people's work." J. A.

 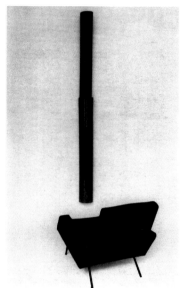

from a deliberately constructed center.[8] (A loss, by the way which we no longer regret, over which instead we now quite openly rejoice.)

One consequence of this (constant mutation, expansion and cancellation included) is the mixing and coagulation of the most varied phenotypes. Entirely "new" workforms evolve (let us for a moment believe this). The realm we thought to be historically so strongly welded, the brilliant heroic Modern ("Let us fill Mondrian's maidenly canvas, albeit only with our own misery."[9]) – appears to us now more like a huge flea market. "Do (buy?) the right thing." Here the rule is that the process bears the result. The result is temporary, but if necessary one could build another platform, experiment with different scaffolding, and from there what we had already accomplished would surely look different – and could be used again in a different way ... »We live in a B-Society.« (John Armleder) Transaesthetic[10] and transformation define "works" and their "accompanying manifestations" whether as furniture sculptures or as neon pieces, in their outward appearance similar to the alleged "déjà-vu" impulses prompted by the stimulation of daily viewing. It is all about initiative and enthusiasm.

ENTHUSIASM OR HIT THE SPOT
»The most silly things I do, I do with a lot of pleasure.«

"It is about enthusiasm for the non-something. A kind of Tao: It is the beginning of all things and at the same time the way in which all things are accomplished. It is the non-something."[11]

The path that the viewer must travel in order to "find" a work of art is precisely contrary to the way in which this "work" was created. The observer sees the "final touch" first, while the artist traditionally

8 | Forget about Sedlmayer!

9 | Constant in Reflex (Amsterdam, 1948).

10 | See e.g. Baudrillard in NOEMA No. 23, 1989.

11 | Cees Nootebom in Rituale, (Frankfurt, 1992) p. 200.

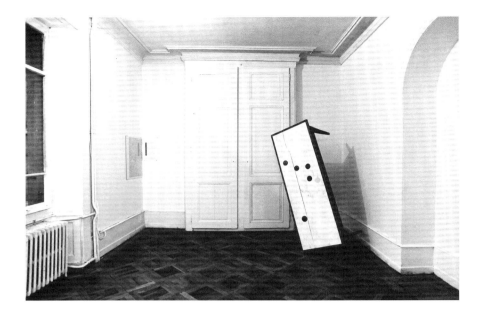

(bad enough) begins with the first touch and finishes with the last (that maybe even renders the first invisible again). There exists no possibilty for interaction between these two modes of perception (diffusion of communication), but the reason for it has nothing to do with perception. One only asks for the pudding recipe when one wants to serve it chilled.

An equally important question for many of John Armleder's "pieces" is the question of "balance." Fixing them to the wall would often be too simple.[12] The choice of objects, says John Armleder in the many comments to his Furniture Sculptures[13], is also a game of balance[14], chance (of having an idea...) and intuition. He depends on it. Instinctively, it seems, he continues to find the lucky and deciding moves — little shifts toward playful deconstruction, finally leading the way to entertainment.[15]

REWIND | Back to "Furniture Sculpture"[16] and here to an example that unlike any other of John Armleder's work leaves free rein to Mediterranean correlations: "The south is blue."[17] FS 181 from 1988[18], according to the "legend" was the result of an exhibition in the Galerie Tanit in Munich and a "bavarian shopping spree." John Armleder tells of his nomadic working habits, doing his work and composing "on the road" , and then doing the final setting in the gallery or museum. It is almost a rule, though with exceptions, that the works prolong the gallery. In conversations he often points out how importantly all the encouragement and support of the people surrounding him serve as stimulants. This "plastic curtain piece" is the result of a special shopping trip, with Sylvie Fleury, and the astonishing hardware-store atmosphere that this type of "choice" of material brings with it. The idea of using industrial paints (the plastic

12 | During the installation of the exhibition in Baden-Baden we discovered with great pleasure that John Armleder's table (FS 20) was directed on two legs in such a way that it stood against the wall by itself. Later, naturally, for the safety of the visitors it became necessary to fix it to the wall.

13 | See e.g. the catalog from the Rath Museum (Geneva 1990).

14 | It is significant that one of Max Ernst's most abstract sculptures exists today only as a cast. Not only as a part of his method, to make one forget the original elements of his collage, but also as ironic paraphrase of this method — because anyone at least in the cultural circle of the western hemisphere, can see that it's about a table sawed in half and then falsely reassembled.

15 | "With enormously little" was a slogan of Meret Oppenheim, that Bice Curiger so poignantly thrust into the John Armleder debate (Live from Galerie Susanna Kulli, St. Gallen, 1997).

16 | The group of "charges objets" of Jean-Michel Sanejouand as "radical" setting of the decontextualization of objects occupies a much too insignificant place in the history of the 60's.

17 | See also BEN from Nizza.

18 | »Quand je parle de mon incapacité de préférer une de mes œuvres, en voici bien une dont l'impertinence gauche m'attendrit toujours.« See note 13, p. 64.

bands) is part of the program and so John continues, he sees more a painting in the object than a "door", or perhaps the other way around. The doors of perception. The wind is blowing here.

A "fallow coloristic realm," the alluringly saturated surface of the copper facings somewhat evoke the late stripe compositions of Morris Louis or Bridget Riley in the "glowing" seventies – or a J. M. Sanejouand "charge objets." Morris Louis also influenced the pour-paintings, as for instance with the painting "Vasarely-Flash" (in collaboration with Sylvie Fleury even using the the Gordian master's "original colors"). Also from the year 1988, let us refer to FS 191, for another very particular furniture-sculpture-forward worthy of recall. The description reads: »Lit de chien ou chat en fourrure synthétique.« In other words, a dog/cat-basket-cum-luxury-chaiselongue for Mommy's little "tiger" that eats only Sheba. Yes, cats have furniture, too and is it by chance or opportunism that such an object should have its début at a festival of contemporary music, in an exhibition dedicated to John Cage? Cage entitled his famous sketches, "For the Birds," a tongue in cheek reference to his surname. [19] On the other hand, the photo of Cage that appears to us in »Conversations à dix bandes magnétiques,« presents him as a forerunner to Ecart, and was in the original [20] a snapshot of John which"occasionally" found acceptance in the pantheon already early on.
»I'm not interested in giving the work a meaning. Basically, I'm not interested in meaning.« [21]

GEDULD – BUSY LIZZIES
»Every artwork is an end in itself and does not promise anything better to follow.« [22]

The test of a true experiment is whether the observer is willing to accept what his eyes convey. We find ourselves directly in front of a dot-painting. All the dots are perfectly round – they are actually not dots, they are painted-in areas. All are black and nearly evenly spaced. There seems to be a "error in the system" – one of the dots kind of sags a bit. [23] That it can be exciting to create "system errors" and flat out deliberately "create chaos" was also a daring venture of adoptive Parisian André Cadere. In the seventies, his immense rods, with their systematically orchestrated moments of irritation, that would pop up unnanounced in exhibitions of "other" artists (befriended or not) with their porter (André Cadere himself), made an impression that endures to this day through their sovereignty in economy of means. Here, too, "painting" implements the process of a "moment of retardation." [24]

But back to the dots… Though until the late seventies, prompted perhaps by Arnheim's "Art and Visual Perception" it was common to

19 | It goes without saying that cages often figure in the FS category.

20 | Unfortunately even avid research by Christophe Cherix has not yet turned up the original photograph. A similar photograph was substituted in the installation for Baden-Baden.

21 | J. A. in conversation with A. H.

22 | Man Ray 1961 in The Age of Light, Man Ray Photographs, no page number.

23 | According to John "Vasarely-Flash" has a system, too, but »to rediscover it would be archaeology.«

24 | André Cadere, see exhibition catalog, Unordnung herstellen (Salzburg /Munich, 1998).

speculate on the practical analysis of mechanical and "natural" concepts in paintings, today John Armleder with his »overloaded pudding overdose« is playing in another league entirely. In short: Arnheim used models, e. g. a black disk placed somewhere beyond the center of the painting inside a square. This simple constellation served to bring forth active or passive energy with respect to the disk (read: dot). "Naturally" he maintained, it always seems that the disk is influenced by the square and not the square by the disk. This situation was responsible for statements regarding stability in the picture and the perception of balance between the forces of attraction and repulsion. This may seem far-fetched, but it points to the "traditional illustrative models" that John Armleder carries incidentally, without any didactic intent, ad absurdum. There was namely no grid used to determine the exact, ordered placement of the dots on the canvas – including of course, the single intentional flub[25] – whose meaning only a detective would want to encode. This method touches again upon the question of the number of dots for the size of the canvas and whether it could go on like this – if it constitutes design or decoration? What if the dots are yellow (suns?) or pastel colored

and what if some are individualized with smiley-face stickers? The pudding overdose-override.[26] It, like the "tortured square"[27] remains the black dot on the target of his awareness.[28] There can be no discussion between the viewer and the artist over a single theory that is supposed to be the basis of everything. »There's a whole Bircher Müsli of meanings,« says John Armleder. And that is the way it should be.

INITIATIVE – SHOW ME YOUR MOTION

"Beauty is a pair of shoes
– that makes you wanna die."[29]

With the confidence that something absolutely invisible can be a vision, and that the logic of failure is a good indicator on the way to a "successful" failure, a conversation between Guy de Belleval and Martial Raysse appeared in "Le Journal de Genève," no. 36, on February 12, 1966. Raysse, at the time an exhibition artist (vorzeigekünstler) of the Grande Nation and former member of the Nouveaux Realistes in Nizza and Paris, made the following statement: "Je fais n'importe

25 | J. A. in conversation with A. H.

26 | See edition "The Pudding Overdose", 1998.

27 | »Malewitsch – a young artist will use it out of context (Male which? Male who?)« J. A. in conversation with A. H.

28 | "His [Arnheim's] theories fail totally in their perception of creative activity…" "He placed the square not the disc." Asger Jorn in a letter to John Lefebre, see exhibit cat. Lefebre Gallery (New York 1970)

29 | "Beauty knows no pain," in You are what you is, Frank Zappa, Zonx (Frankfurt 1996) p.234 f.

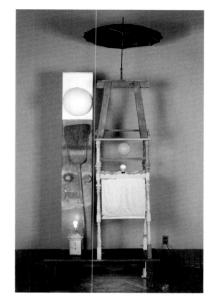 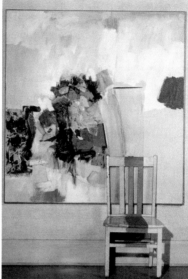 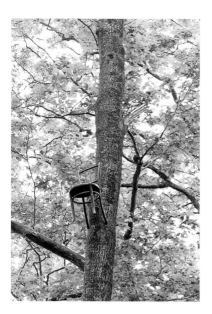

quoi avec n'importe quoi (I do whatever with whatever)." It is possible that this one line, part of an extensive article about cross relations and rich with references to "modification," triggered enthusiasm in the very young "peuple d'Ecart (Ecart people)". An extremely "contemporary" artist that understands himself as coming from assemblage art [30], he provided the controversial "missing link," the connection between Europe and America. [31] Equally surprising is, that Raysse (the painter!) of all people should incorporate not only used plastic bottles, [32] without any recycling message or that weary primitivistic assemblage hype, but also set fluorescent tubes into his pictures as quasi "natural occurences" in Europe. [33] "Today's advertising is so strongly anchored in our consciousness that a single light suffices ... for me fluorescent light is a cliché ... In other words, I wanted to hang on to a sterotype of western thought." [34] A bunch of fluorescent tubes, [35] just bright white fluorescent tubes like the ones that ended up lying in the entrance of the Kunsthalle in Baden-Baden, is definitely a provocation. And yet somehow a line connects the flashlight (meant to illuminate a selfportrait of Jasper Johns on a plate in a picture above a mirror) [36] to John Armleder's fluorescent tubes whose penetratingly "colorful" presence bestows a different light on an entire exhibition. "The legacy of the progressive modern, its credo of style, appears in Armleder's work yet again refracted – and at the same time relieved of its burden of homage to critics of the past." [37] And who would want to discuss the "unforseeable elegance" of the FS from the gallery Vera Munro, whether Barnett Newman likes army olive drab as a color, or not ...?

»If I juxtapose a form that is borrowed from a constructivist piece and an objet trouvé in the spirit of flux, it is because I do not believe in their opposition – what if the painting is flux, and the object constructivist?« [38]

30 | See Martial Raysse exhibition catalog, Museum Ludwig (Vienna, 1994).

31 | Martial Raysse lived for more than a year in the Hotel Chelsea in New York City (everyone asks).

32 | Tony Cragg was not the first.

33 | At the same time Flavin and Keith Sonnier were taking the first shaky steps toward a definition of "new sculpture".

34 | Martial Raysse in an interview with Otto Hahn, Le Matisse des prisunix et Le Rodin de déchets," Art et Loisirs (Paris, No. 24, 9-15 March, 1966) p. 51.

35 | Untitled (Fluorescent Tube Sculpture, No. 6), 1998, Courtesy of Galerie Susanna Kulli, CH-St. Gallen.

36 | Jasper Johns, Souvenir, 1964 and Souvenir 2, 1964.

37 | Paul Maenz, in catalog of The Paul Maenz Collection (Weimar, 1999) p. 284.

38 | See "Ecrits et Entretiens." listed in the appendix of this catalog.

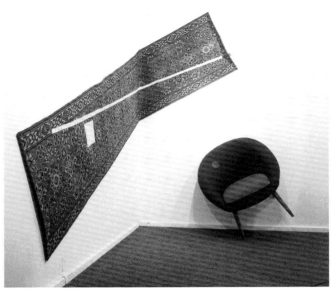 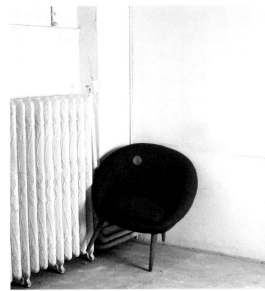

39 | See John Armleder, FS 18, »Table haricot fixée au plafond par son plateau,« in 891 again, 1980/81

40 | Robert Rauschenberg, Pilgrim, 1960, 203 x 137 x 47,3 cm, Museum Folkwang Essen.

41 | Attached with the aid of a hinge, the colors smudged but so painted as to resemble the American flag.

42 | Robert Rauschenberg in Stedelijk Museum catalog, Amsterdam 1968.

43 | "There is a level of lie that only a fake can reach!", Guy Debord.

44 | J. A. in conversation with A. H.

45 | "I try to get it all (i. e. all color values). Dark, light. To put as much onto my paintings as I possibly can. I'd like to really do an overloaded painting. Not just a little overloaded, really overloaded." Larry Poons in an interview with Phylis Tuchman, Artforum IX, 1970, No. 4, p. 45.

COURTESY

FAST FORWARD | Long long ago there was a man who tried to perfect his skill to the ultimate. Because of his bloody life it was no accident that he was involved in the troubles of NEO GEO.

REWIND | A return to the 50's is unavoidable – not only because of the occasional kidney shaped table[39] mounted on the ceiling but most of all because of Robert Rauschenberg, the "living in the gap" giant of the second half of our century. He not only brought his bedsheets (a version mounted on stretchers) into play, but with "Pilgrim"[40] he also hangs a painted chair in front of the canvas.[41] He "found" the term "combined paintings," which could be considered a cousin to FS. For an exhibition in Parc Lullin in Genthod 1985, Armleder hanged a chair in a tree, FS No. 87 – a hunter's blind without a hunter, "Pilgrim," the wanderer, he passes by or he is not there. The "hunted," the "silent hectic" becomes an unspoken theme. "I'm trying to check my seeing habits, to counter them for the sake of greater freshness. I'm trying to be unfamiliar with what I'm doing."[42] Is it the endlessly belabored "judgement" of the Rauschenberg era to pit objects of reality against handed down Abstract Expressionist habits or the "Ne dites pas non" of the 90's? In the same way that Rauschenberg's "Erased De Kooning Drawing" was misunderstood from the start (the gesture of erasing a recognized master's work is an homage at least as powerful as the comparison of a pencil stroke vs. its absence), John Armleder never "simply concurred" with a style. His work too is without aggression, neither in offense nor in defense. Both treat the elemental "reality of the fake" with startling subtelty, using even critic's objections as possible prerequisites.[43] »Everyone works within a broad range ... if someone

tells me ›You are a damned heavyweight expressionist,‹ I say, ›That's not totally wrong.‹ « [44] As such, the poured works are not just superficially played advances on Pollock, and the drippings are anything but "Expressionism redefined." They are "overloaded" [45] with historical meaning, but not so their appearance. They maintain their individuality despite a historical proximity to their supposed counterparts in the following generation (e.g. Larry Poons, [46] who as we know, also painted dots)... Oh, and then there was also the rewind-question with the "endless canvas" – Malewitsch in the last futurist group exhibition – Petrograd, 1915 (in the well-known photo a slightly out of place boxwood chair can be seen under the "Black Square" icon). So the answer remains a question: "Wouldn't you like to participate in some interesting time-wasting trends? [47]

»Anyway, I like to look behind paintings!« [48]

FAST FORWARD | »When I make my big dots, I paint them painfully exactly. Compared to Niele Toronis stamp like work this is an archaic way of painting.« [49] Places to pause are places to stop.

THE END | »No, finishing a piece is unavoidable. Also because, there can be no failure. A pudding can collapse or become stiff instead of jiggly, but still it was once a pudding, even though only imagined or seen. Voilà!« [50]

Translated from the German by Fumiko Wellington.

46 | "He is an artist who I have admired since I was young, also I was never really interested in the 'op art' aspect of his work. His method of work is totally different from mine. He creates his images from a personal visual inside and then judges the result accordingly, makes some choices, or, these days, cutting out extracts. I make the choices before painting and having made the choices all that's left is the execution. Yet there is a parallel between the coarse-grained paint and the thick droplets of color in his work and my work with circles and with dripping colors of different gloss paints running into each other. It's quite a surprise for those who criticize me for misusing Polke when they realize that it's Poons whose work I am plundering..." J. A. in an Interview with Suzanne Pagé exhibition cat. (Winterthur, 1987) p. 61.

47 | Frank Zappa, see note 29.

48 | J. A. in conversation with A. H., Berlin Art Fair, 1997.

49 | J. A. in an interview with Suzanne Pagé, see note 46, p. 61.

50 | J. A. in "Che fare?" 1996, p. 2.

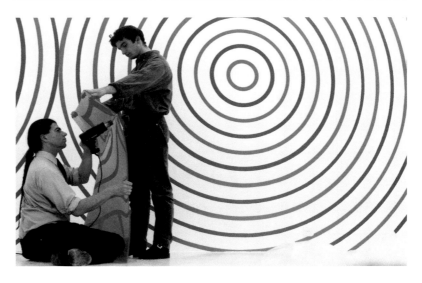

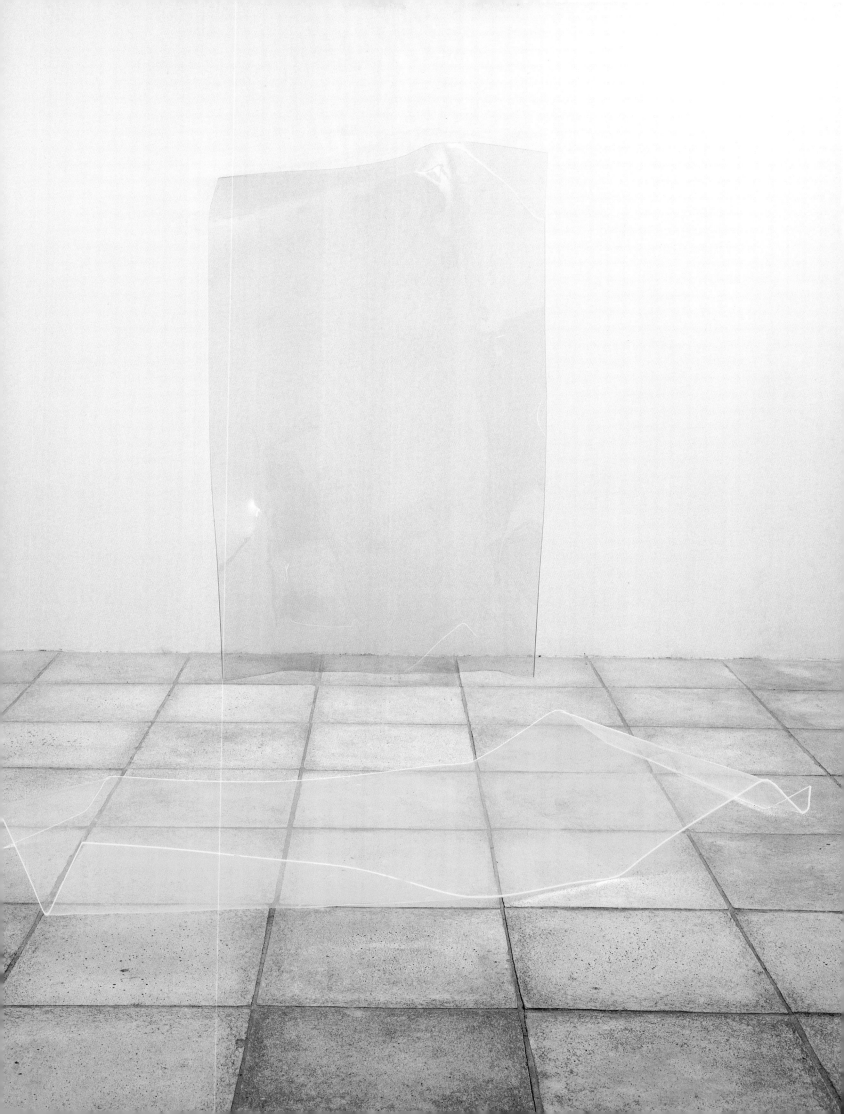

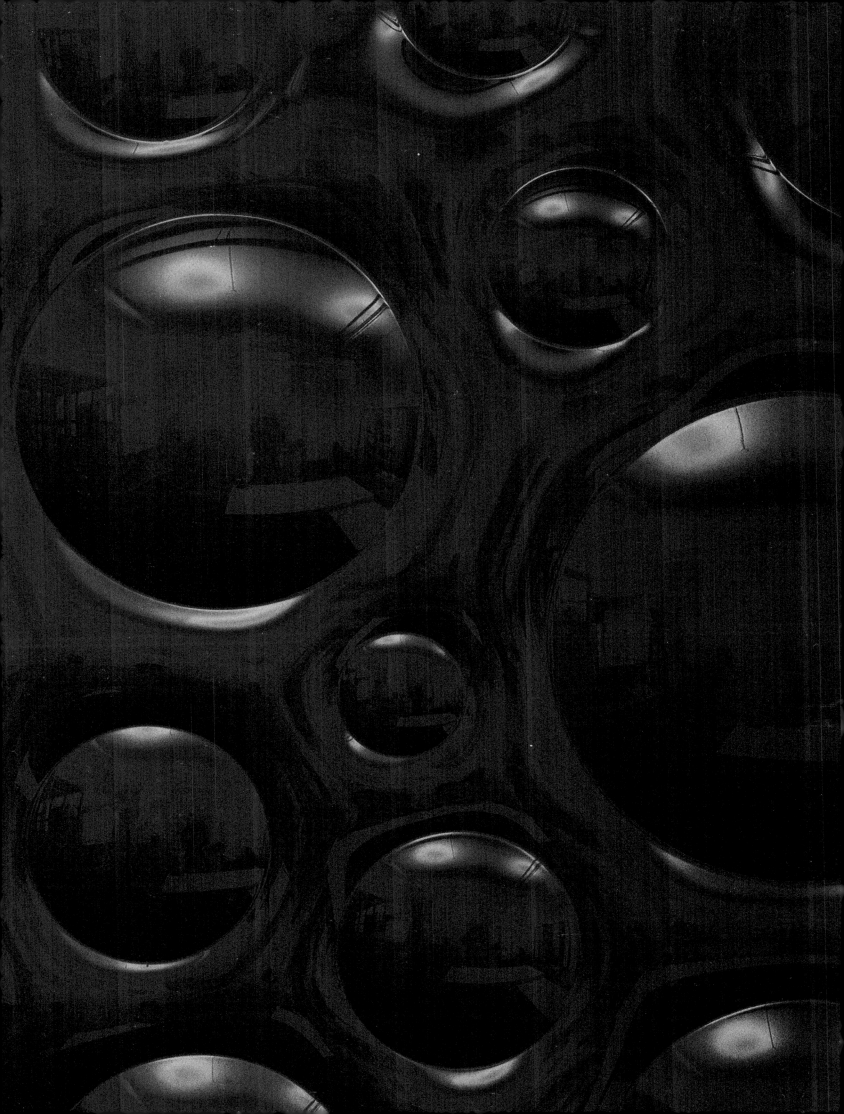

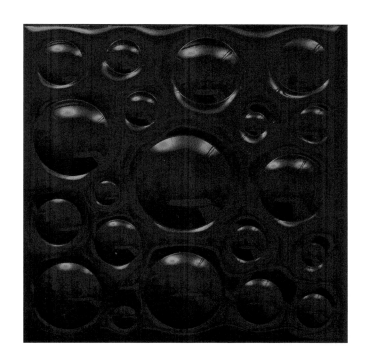

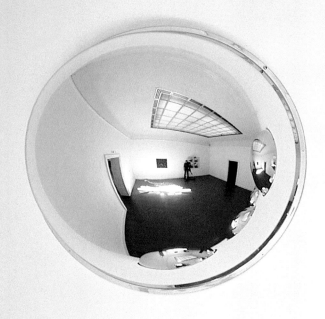

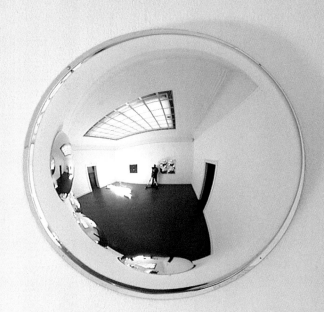
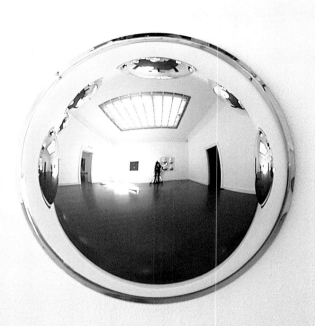
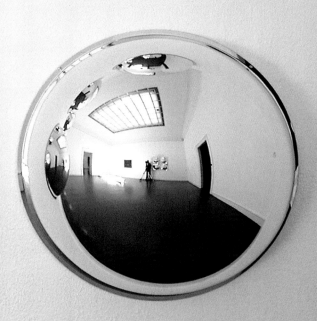

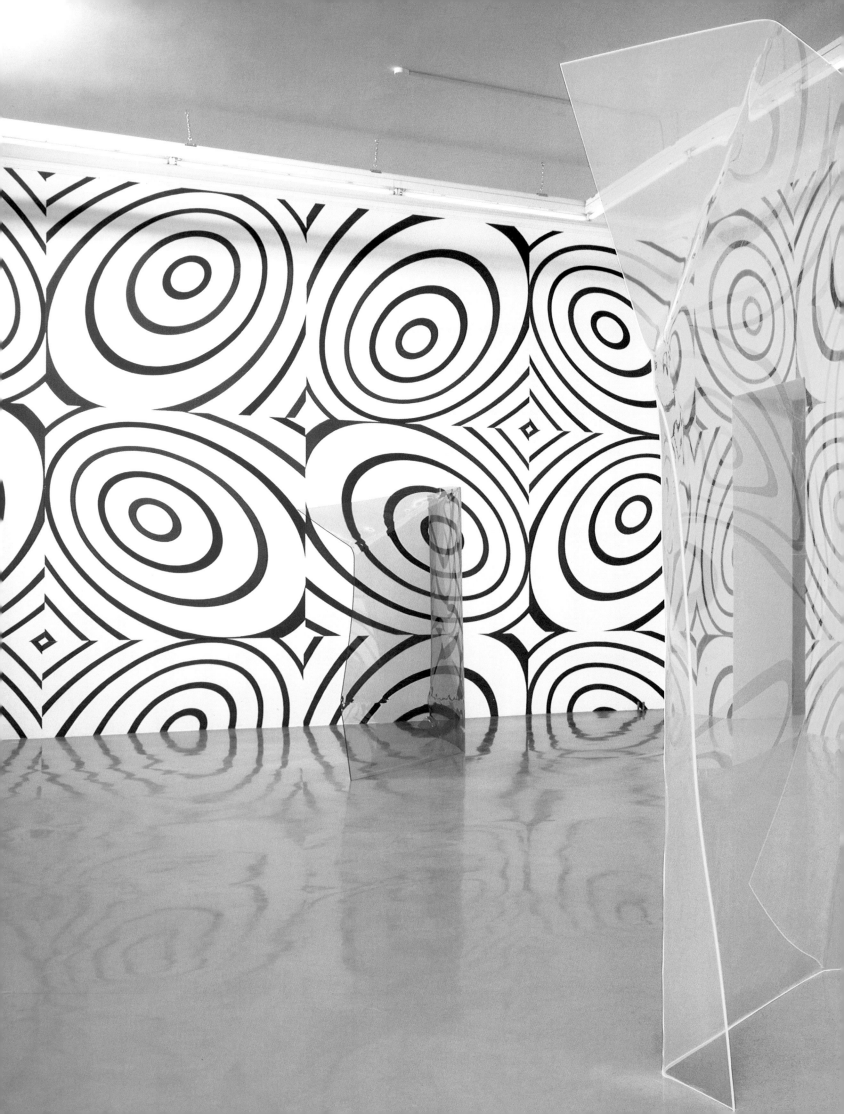

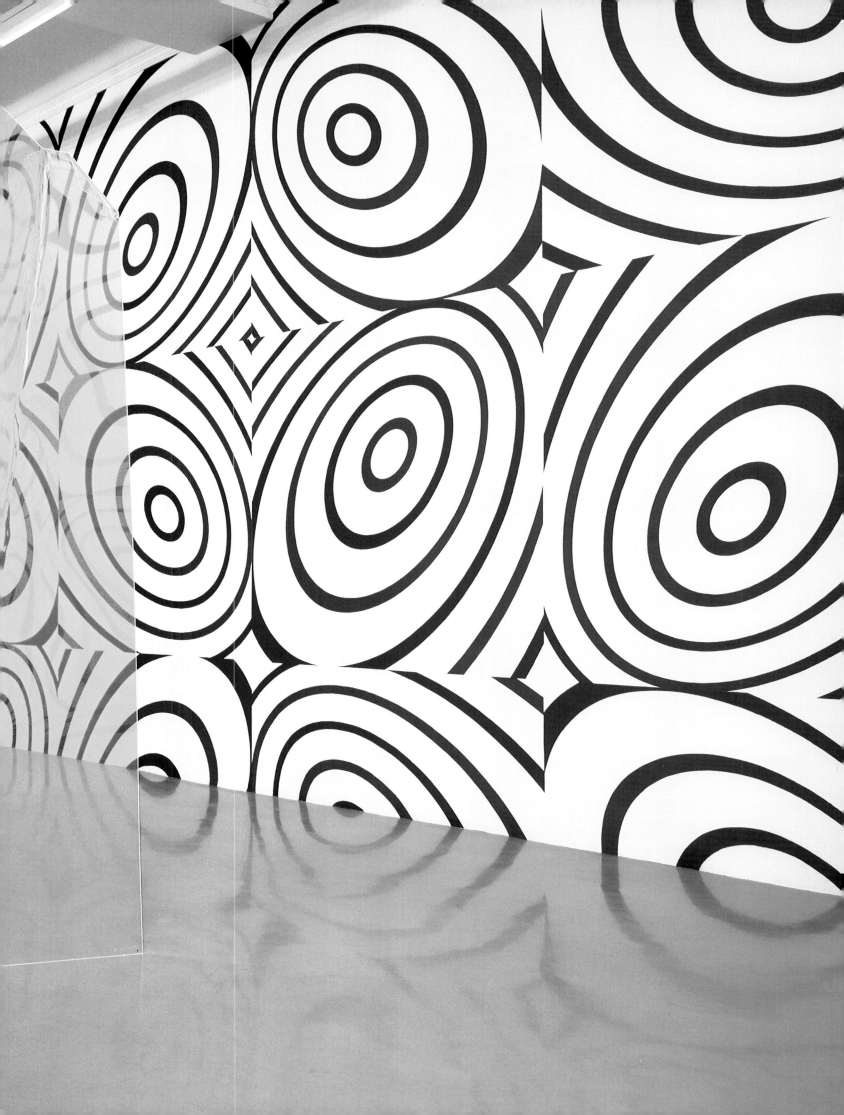

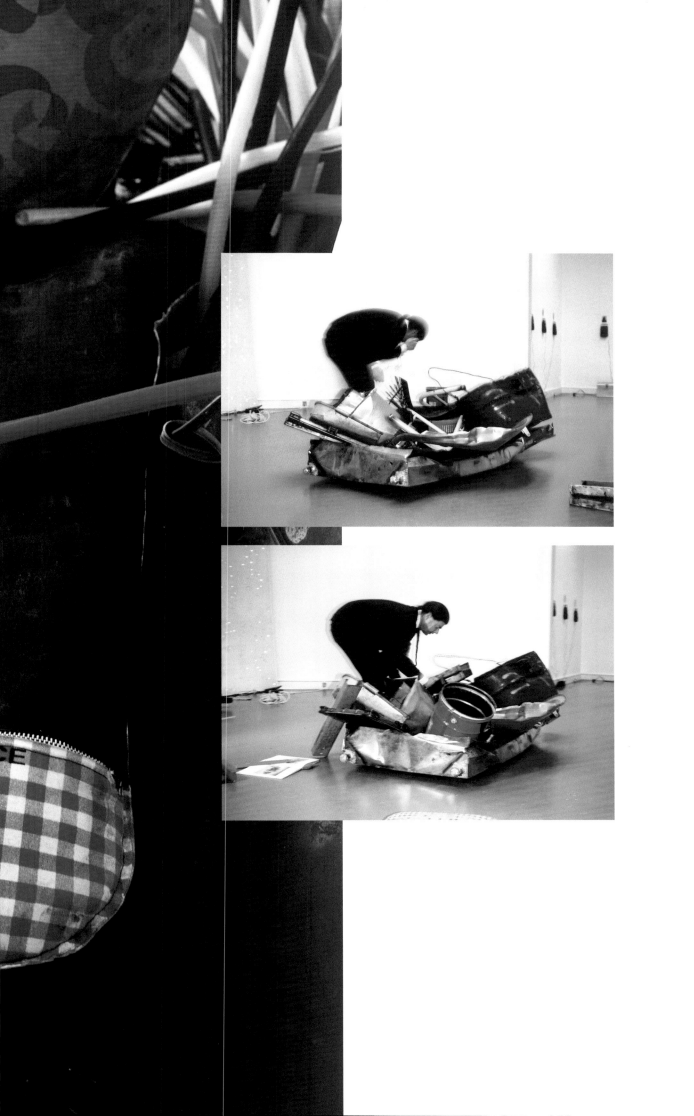

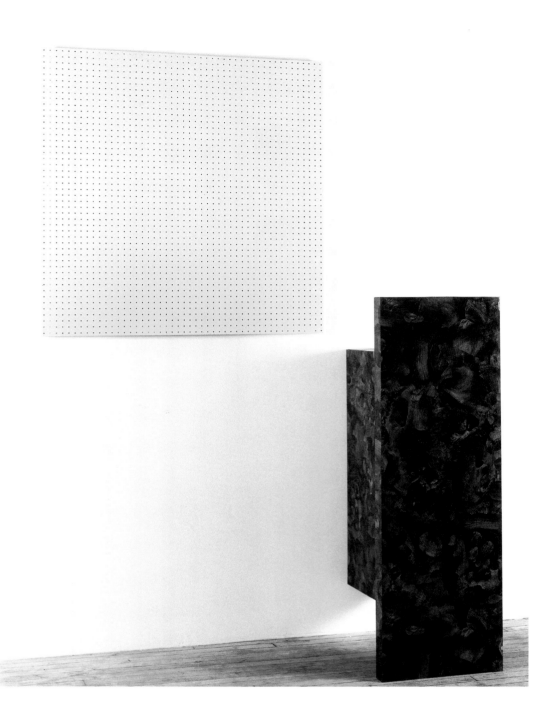

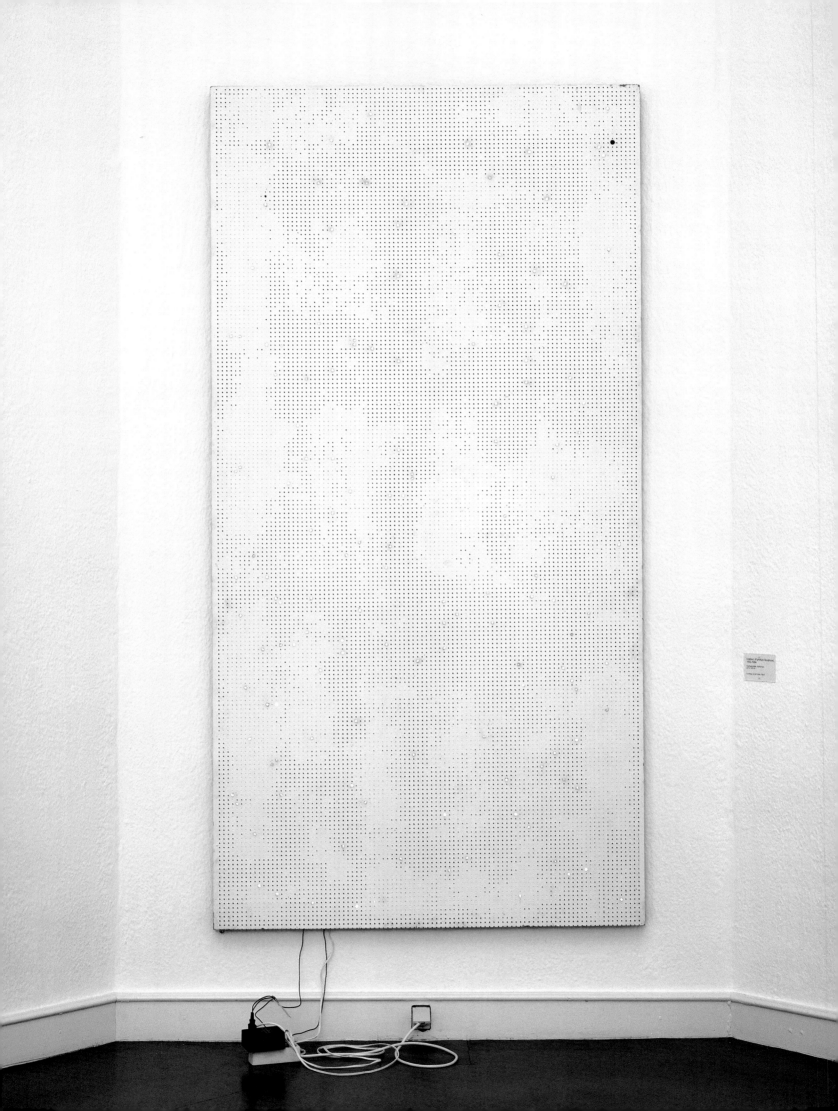

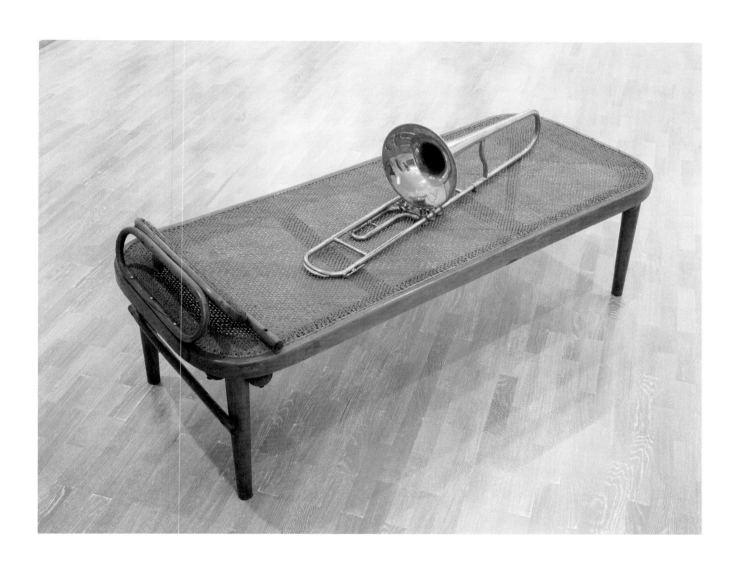

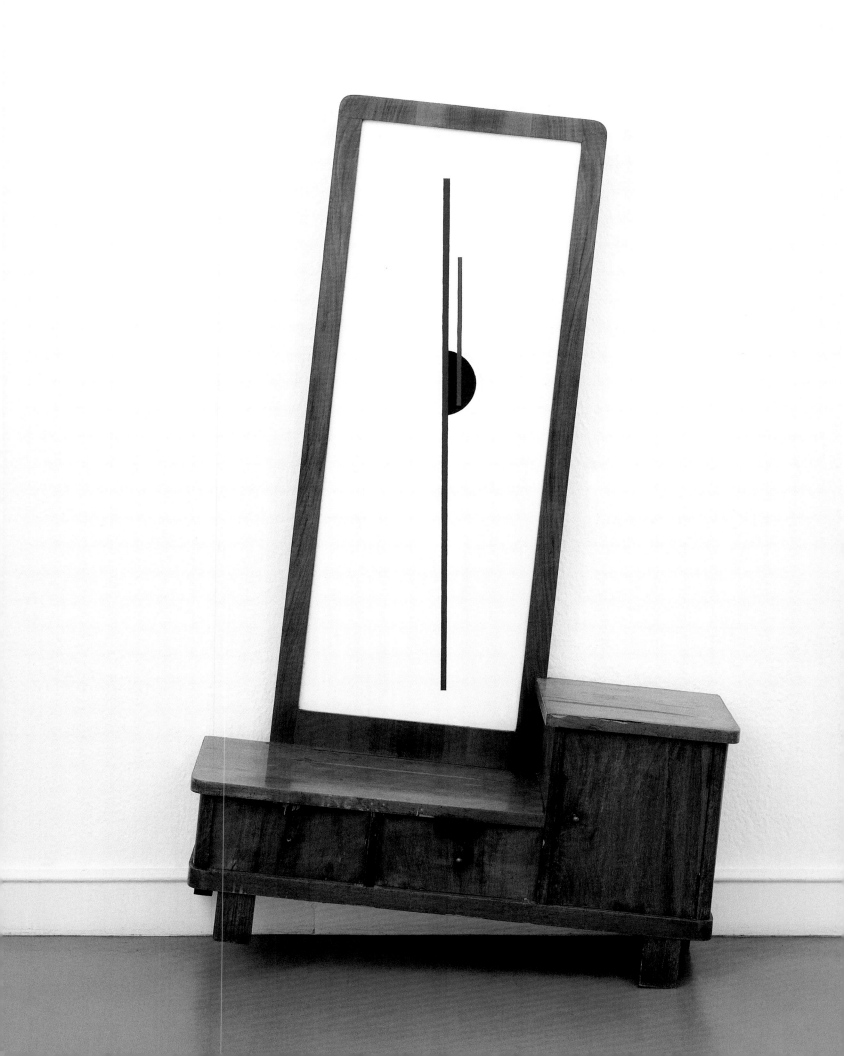

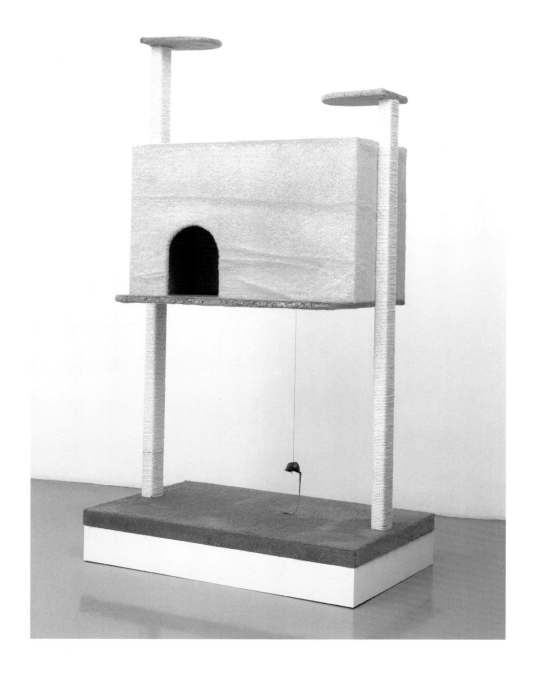

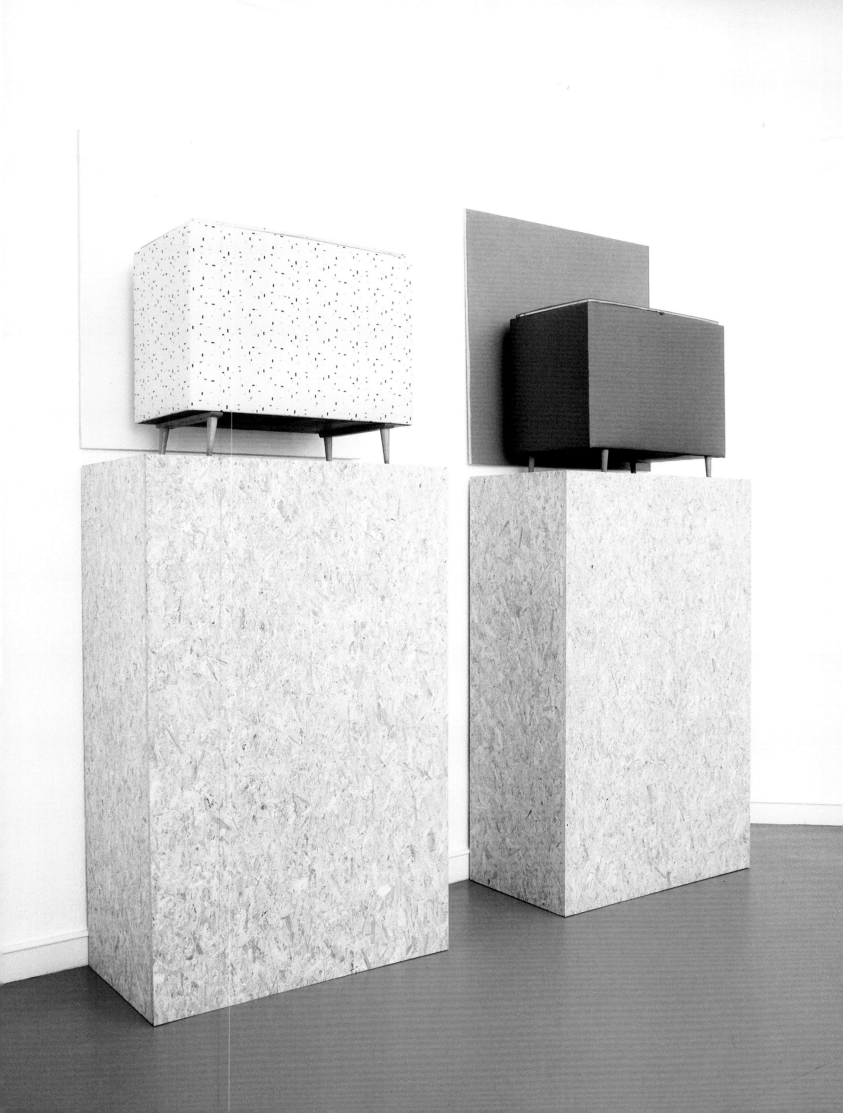

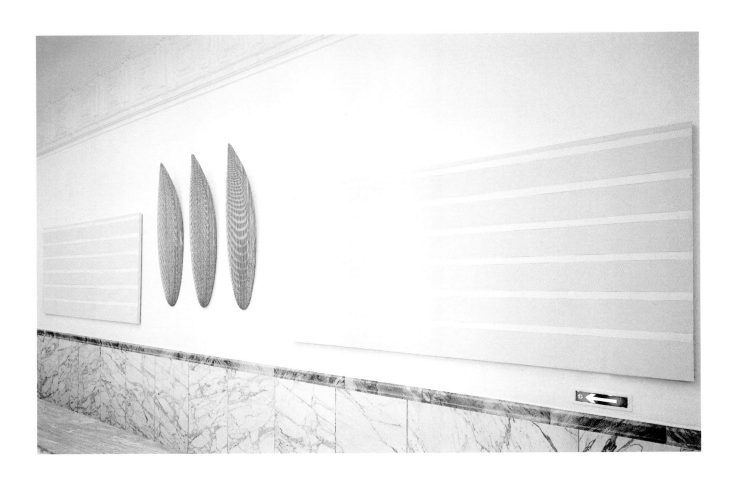

»That's what I love about those happenings:
on one hand they were puritan, and on the other it seemed as if their end product
was wildly making fun of the whole operation.«

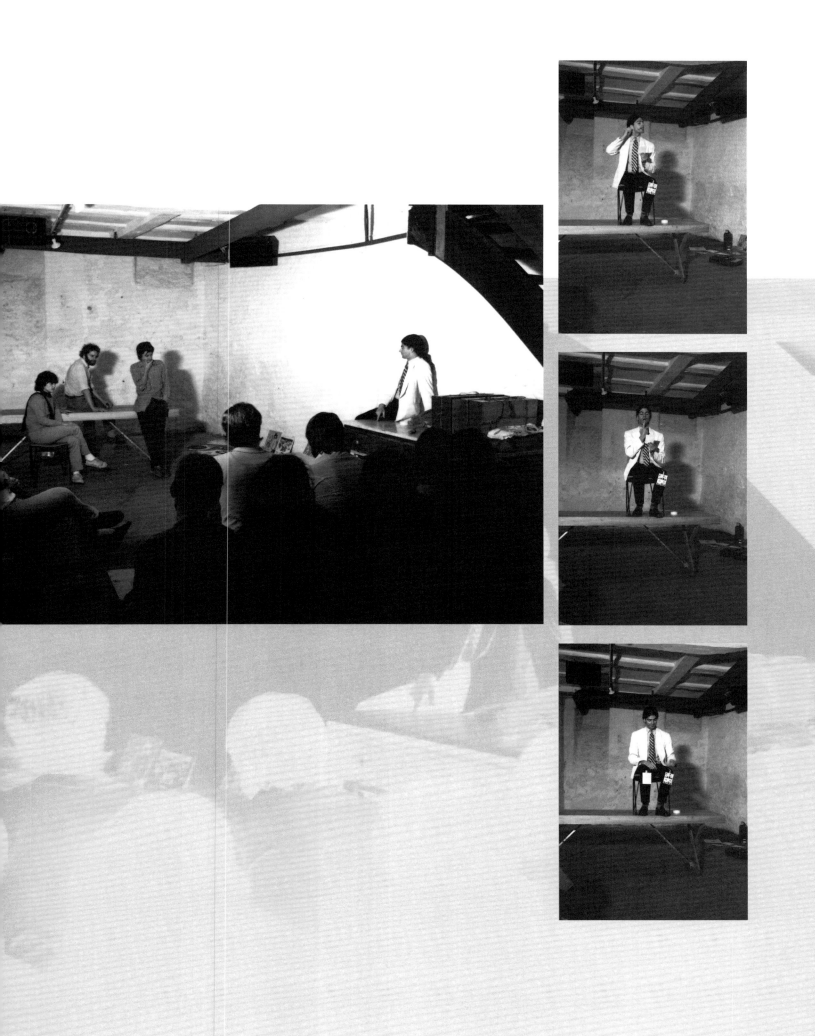

JOHN M ARMLEDER UND ECART

LIONEL BOVIER &
CHRISTOPHE CHERIX

WÄHREND DER EINFLUSS VON FLUXUS, minimalistischer und konzeptueller Kunst oder „Body Art" am Ende der sechziger Jahre omnipräsent ist, wird das darauffolgende Jahrzehnt durch einen ganz eigenständigen Umgang mit diesem Erbe charakterisiert: durch alternative Modelle, dem Arbeiten in Netzwerken oder durch gemeinschaftliches und politisches Handeln. Wie Pilze schießen in Europa und Nordamerika Künstlergruppen, alternative Ausstellungsräume und Orte des Austausch aus dem Boden. Dabei zeichnen sich zunehmend Strukturen ab, in denen das Objekt selbst weniger zählt als die Information – hier verstanden als eine Arbeitsweise, wie sie zum Beispiel die 1970 von Kynaston Mc Shine im New Yorker MoMA organisierte Ausstellung „Information" aufzeigte. Inmitten all dessen erscheint Ecart, von John Armleder, Patrick Lucchini und Claude Rychner gegründet und mit Genf als Basis zwischen 1969 und 1982 aktiv, – erscheint Ecart für eine solche Umwertung verschiedener Parameter künstlerischer Aktivität heute emblematisch. Ecart, von »vielen als wichtigster alternativer Ausstellungsraum im Europa der siebziger Jahre betrachtet, (…) und dabei das amerikanische Verständnis von Alternativem weit überschreitend«[1], war offiziell 1969 anläßlich eines Performancefestivals gegründet worden. Ab 1972 etabliert Ecart seine Aktivitäten in Form einer Buchhandlung wie auch als Galerie, in einem Raum, der an der Rue Plantamour Nr. 6 in Genf gelegen war. Zwischen 1973 und 1982 waren es Giuseppe Chiari, Braco Dimitrijevic, Dick Higgins, Olivier Mosset, Anette Messager, Daniel Spoerri, Ben, Manon und viele weitere in den siebziger Jahren aktuelle Künstler, die zunächst in diesen Räumlichkeiten und später in der Rue d'Italie Nr. 14 ausstellten[2]. Parallel dazu starteten Armleder, Lucchini und Rychner verlegerische Aktivitäten, publizierten, druckten und verbreiteten Künstlerprojekte in Form von Büchern oder Multiples. Peter Downsborough, Robert Filliou, Genesis P-Orridge, Sarkis, Endre Tót, Dan Graham, Maurizio Nannucci und Lawrence Weiner haben so eine oder mehrere Veröffentlichungen realisieren können. Wenn man hier noch die Gründung der „Ecart Performance Group" von 1974 anhängt, die bis 1981 mit Performances aufgetreten ist, so vermag man den Umfang einer überbordenden und vielgestaltigen Produktion in etwa zu erfassen. Den ersten Versuch einer Bestandsaufnahme haben vor kurzem[3] das Cabinet des estampes und das Mamco in Genf mit einer Doppelausstellung unternommen.

Christian Besson zufolge, der die Reihe der »Luftikusse, Wortakrobaten und anderen schrägen Vögel, der Was-auch-immer-Kunst,« zurück zu denen »zwischen den Stühlen zu Dada und Fluxus« dekliniert, »war das, was die Gruppe Ecart werden sollte, zunächst eine Gruppe Freunde, die gerne Rudern (row) gingen und deren erste Auftritte ohne Publikum stattfanden – aber genauso könnte man sie mit Jules Romain auch als Truppe von ›Kumpels‹ beschreiben, die Spaß daran hatten, Unruhe zu stiften (row)«[4]. Tatsächlich haben

1 | Ken Friedman, „Young Fluxus: Some Definitions", in: Young Fluxus, Ausstellungskatalog, New York 1982, Artists Space, S. 25.

2 | Jedesmal in unmittelbarer Nähe zum Centre d'Art Contemporain, unter der Leitung von Adelina von Fürstenberg, mit der Ecart wiederholt zusammengearbeitet hat.

3 | ECART, Genève 1969 – 1982 ou l'irrésolution commune d'un engagement équivoque, MAMCO und Cabinet des estampes des Musée d'art et d'histoire, Genf, organisiert von den Autoren, 28. Oktober bis 21. Dezember 1997; Katalog: L'irrésolution commune d'un engagement équivoque. Ecart, Genève 1969 – 1982, MAMCO und Cabinet des estampes des Musée d'art et d'histoire, Genf 1997, Herausgeber: Lionel Bovier und Christophe Cherix. Nachfolgende Texte sind Auszüge dieser Publikation und sind stellenweise überarbeitet worden.

4 | Christian Besson zitiert Jules Romain im Text »De quelques figures du désœuvrement dans l'œuvre de John M Armleder«, in: John M Armleder, Ausstellungskatalog Fréjus 1994, Le Capitou (herausgegeben von Electa, Mailand), S. 154 ff.

sich fast alle Mitglieder der ursprünglichen Gruppe (Armleder, Rych-
ner, Wachsmuth, Dufour, Faigaux, Gottraux) im Alter von 12 bis 15 im
Umfeld ihrer Zeichenlehrers Luc Bois und ihres Rudertrainers Pierre
Laurent (genannt „La Méduse", was im Französischen die Doppelbe-
deutung von „Medusa" und „Qualle" hat) kennengelernt. Zum Zeit-
vertreib widmete man sich bald „künstlerischer" Produktionen, die
aus Variationen, aus „écarts" (französisch für Abweichungen) des
alltäglich Vertrauten entsprangen: es wurde der Max-Bolli-Preis ge-
schaffen, Trophäen für Gekenterte oder bei den offiziellen Ruder-
regatten als Letzte-ins-Ziel-Gekommene, anlässlich verschiedener
„Forschungscamps" wurden „beiläufige" Installationen oder städti-
sche Verschiebungen während der „zweiwöchentlichen Ateliers" ge-
macht. Die Besonderheit der Gruppe, zunächst Bois oder Bolli ge-
nannt, dann Ecart, im Vergleich zu anderen Künstlergruppen wird
hier schon deutlich: Ihr Bestehen gründet sich weder auf ein Mani-
fest oder eine wie auch immer geartete theoretische Position, noch
auf politische Solidarität – nicht einmal auf ein ernsthaftes Enga-
gement in der Kunstszene der Zeit. Es genügte, daß die Mitglieder
zusammen Tee tranken, eine Wanderung machten oder irgendeinen
der Anlässe feierten, der ihre persönlichen Kalender bestimmte, um
damit gleichzeitig die kollektive Identität zu bekräftigen und eine
künstlerische Praxis der Gruppe zu ermöglichen. Außerdem ist der
Zeitbegriff, in dem sich diese Formen von Identität und Praxis situ-
ieren, nicht der des traditionellen Kunstkontextes mit seinen Be-
schleunigungen oder seinen „Verspätungen", seiner Linearität und
seinen Verschiebungen, sondern es ist die Zeit des Lebens, der
Freundschaften aus Kindertagen bis hin zum Erwachsenenleben, des
Spiels, der zen-buddhistischen Philosophie, kurz: ein Rhythmus, den
die Gruppe so ganz nach ihrem eigenen Geschmack erfindet, durch-
zogen von Geschichten, Pausen, Büchern oder „five-o'clock-teas".
Ganz selbstverständlich bezieht sich das Kollektiv auf das Fluxus-
prinzip der „Gleichung von Kunst und Leben", wie es Robert Fillious
„création permanente" anwendet. Etwas allgemeiner ausgedrückt,
entstand Ecart auf dem Hintergrund einer immer deutlicheren Ab-
kehr vom traditionellen Feld der Kunst hin zu Verfahrensweisen, die
den Zufall oder das Alltägliche, sowie kritische und politische Inter-
essen wie auch partizipatorische Strukturen verbinden. Wenn sich
die Gruppe im Zuge der Zeitumstände eine Praxis aneignet, in der
die kommerzielle Dimension der Kunst, die Kategorien des „Schö-
nen", der Originalität und der Authentizität sich auflösen, geschieht
dies zugunsten einer gemeinschaftlichen Vorgehensweise, deren Be-
sonderheit sich trotzdem nicht auf ihren Kontext reduzieren läßt.
Ecart unterscheidet grundsätzlich nicht zwischen einer kollektiven
künstlerischen Praxis, der Organisation einer Ausstellung oder der
Veröffentlichung eines Künstlerbuches. Im Gegenteil: wiederholt
stellte man sich mit „mail art", dem Tausch von Publikationen oder
bei Performancefestivals anderen europäischen und amerikanischen

Künstlerszenen, und dies wurde wichtiger als die punktuellen Bei-
träge internationaler Gastkünstler. Am bedeutsamsten erscheint
aber die Mischung der verschiedenen „Szenen", die Tatsache, daß Al
Souza mit Olivier Mosset in Kontakt kam oder daß Robin Crozier am
selben Horizont auftaucht wie Lawrence Weiner. Das Spiel der Ein-
flüsse und Komplementaritäten wird komplexer und könnte uns dazu
führen, jene Epoche neu zu überdenken.

Die erste öffentliche Ausstellung der Gruppe „Linéaments 1"
1967 stand unter dem Motto „ce qui dessine" (des zu Zeichnenden),
der Skizze, dem Entwurf einer zukünftigen Arbeit. Das Plakat stellte
der Veranstaltung ein Textfragment von Victor Hugo voran, welches
die Aktivitäten der späteren Gruppe Ecart, damals noch unter Bois /
Bolli firmierend, zu kommentieren schien: » ... langsam begannen
sich in seiner Meditation Liniengespinste abzuzeichnen und zu kon-
kretisieren, und mit der Genauigkeit der Realität konnte er zwar
nicht das Ganze der Situation, wohl aber einige Details voraus-
ahnen.« Das Informationsblatt der Veranstaltung benennt daneben:
»Der Wille zu verstehen hat den Willen teilzunehmen getötet.
Während eines Monats sind Besucher von jungen Künstlern
aufgefordert, an ihrer Seite zu stehen. Ihre experimentelle Ausstel-
lung ist eine Einladung an das Publikum, wirklich teilzunehmen. Es
geht darum, Kontakt herzustellen. Die Ausstellung ist in zwei Teile
unterschieden. Der erste Teil entspricht der Konvention. Der Raum
dient im Wesentlichen dazu, dem Publikum autonome Arbeiten zu
zeigen. Alles ist hier den intellektuellen schöpferischen Fähigkeiten
der Besucher in die Hände gelegt. Der zweite Teil besteht aus einer
Komposition auf der Grundlage des Ausstellungsraumes selbst. Die
eintretenden Besucher konstituieren die konkreten Zufallselemen-
te.« Dem Zeitzeugen Arnold Koller zufolge zeigte der erste Teil von
„Linéaments 1" »sieben modellierte, ziemlich merkwürdige kleine
Köpfe [von André Tièche]«; »Beunruhigende Formen [von John
Armleder], von denen die einen pflanzenähnlich, die anderen tekto-
nischer Natur zu sein schienen«; »Eine Art Monster mit besessenen
Augen [von Joseph Forte] aus organischen Assemblagen«; »Bildob-
jekte aus Resten banaler Gegenstände [von Floydene Coleman]
komponiert – Puppenhände, Gürtelschnalle, Eierkartons, intakte und
eingedrückte Ping-Pongbälle, usw., usw. ...« [5] Besonders auffällig
aber war eine Installation, an der Armleder, Bois, Rychner, Tièche
und Wachsmuth gearbeitet hatten. Dieses Ensemble wurde von den
Mitwirkenden als „Komposition", als „Variationen ohne verbindli-
ches Thema in einem begrenzten Raum" bezeichnet, während Ar-
nold Koller die Elemente so aufzählte: »erst einmal wird der Raum
von Gerüststangen strukturiert; darin sind Aluminiumplatten aufge-
hängt, die bei jedem Luftzug vibrieren; auf dem Boden zwei feste
Projektoren, die auf zwei reflektierende Mobiles strahlen, so daß die
Strahlen regelmäßig den Raum durchstreifen. Auf eine der Wände
sind zerrissene Plakate geklebt. Ein Tonband spielt Geräusche von

5 | In: „Vive l'impertinence!",
Tribune de Genève, Genf, 16. Juni 1967,
S. XXI.

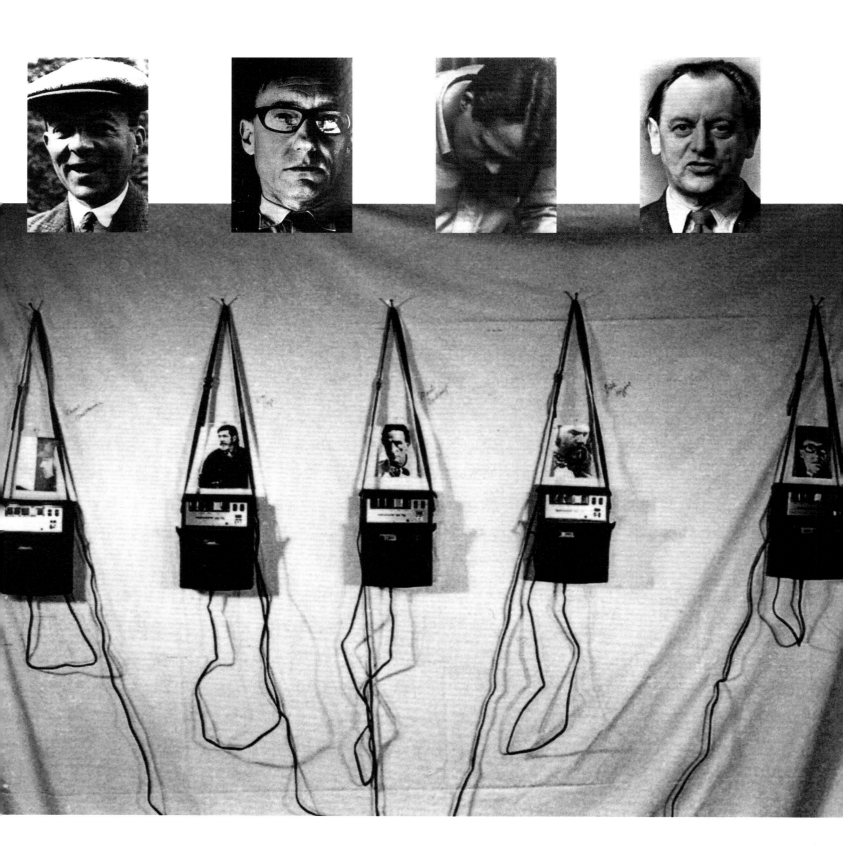

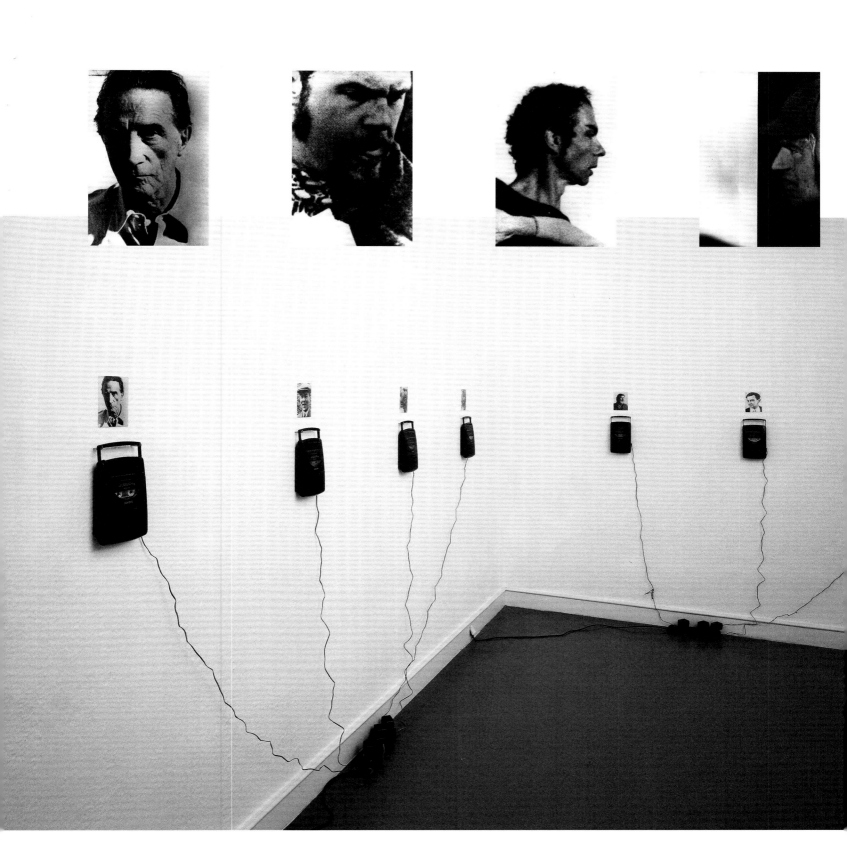

Schlaginstrumenten ab.«[6] Tatsächlich war der größte Teil des Raumes von einem Gerüst aus Metallstangen verstellt. Die Stangen verkeilten sich völlig irrational, dennoch bewahrte die Struktur eine größtmögliche Einfachheit, und darin hingen dann die Aluminium- und Acetatstreifen. Der Raum blieb im Halbdunkeln, abgesehen von einigen hellen Zonen: diese wurden durch punktuell (auf dem Boden oder an unter der Decke verlaufenden Brettern) installierte Spots erzeugt. Auf dem Boden stand ein Plattenspieler, dessen Plattenteller einem Stück Kupfer als sich im Licht drehender Sockel diente. Dies ergab die Lichtreflexionen im ganzen Raum. Gleichzeitig spielten zwei Klangquellen Tonaufnahmen von Armleder ab: die erste gab in falscher Geschwindigkeit Vogelstimmen wieder; die zweite eine Folge von repetitiven Klängen, die mit Hilfe einer Metallfeder erzeugt worden waren. Dem zugefügt waren eine ins metallische Gestänge eingefädelte Plexiglasplatte, ein Ventilator, eine an die Wand genagelte tote Taube in Fetzen und eine Plastikfolie auf einer weiteren Wand. Diese Inszenierung zielt also darauf ab, den Betrachter in eine „Totalinstallation" hineinzuziehen, in der Klang, Bewegung, Licht, Metallstreben, Effekte von Transparenz und Opazität gemeinsam wirken. Sicherlich evoziert diese Arbeit einige der damals zeitgenössischen Realisierungen kinetischer und optischer Kunst, wie sie beispielsweise Julio Le Parc im GRAV schuf. Dennoch ist hier die rotierende Bewegung durch ein Gerät aus dem musikalischen Umfeld erzeugt, und nicht durch einen bloßen Motor. Was auf die akustische Dimension der Installation verweist. Ebenso handelt es sich bei den einzelnen Elementen Stahl, Metall und Licht hier um „gefundene" Materialien, um Resteverwertung. Schließlich verkörperte das Ensemble schon eine Reihe der Arbeitsprinzipien der Gruppe Ecart: das Verschwinden einer individuellen Signatur zugunsten einer Gruppenidentität, ein aktives Verhältnis zum Betrachter (das Plakat kündigte an »der Wunsch des Publikums teilzunehmen wird ‚Linéaments 2' hervorbringen«) und eine sehr geschickte Handhabung der Informationsverbreitung in der damals zeitgenössischen Szene.

Das „Ecart Happening Festival" (1969) war der zweite öffentliche Auftritt der Gruppe und sollte grundlegend für die Aktivitäten der drei Hauptprotagonisten im folgenden Jahrzehnt sein. Die zwei Plakate mit Texten von John Armleder präsentierten die Veranstaltung als »Abweichung [französisch: ECART] ... eine blinde Abweichung, die gemeinsame Aussichten in Richtung eines äußerst armseligen Feldes lenkt, welche die vielen Ergebnisse einer überholten Aufgabenstellung durch eine bedeutungslose Realisation auflöst, und der zufälligen Veränderung einer dem Ereignis nachfolgenden Beobachtung, die die fortgesetzte Leere des Objektes zur Abweichung Abweichung Abweichung dehnt [französisch: s'étirant à l'ECART ECART ECART]. Diese im Rückschritt verstrickte Bewegung entfernt sich weiter und immer weiter von dem Anlaß, wo Bilder eines vermuteten ersten Auftauchens zusammentreffen, während sich Begriffe einer

6 | ibid.

gemeinschaftlichen Unentschlossenheit als mißverständliches Engagement in die verschiedensten Richtungen verstreuen, – und das wäre Abweichung…«. Dieses Anti-Manifest formuliert bei allem Paradox das Verständnis der Veranstaltungen, der Absichten der Organisatoren und der zukünftigen gemeinschaftlichen Praxis, die ab 1972 die Gruppe Ecart verkörpert. „The White Flights of the Imagination and Other Pieces" ist ihre erste Abendveranstaltung und eine der wenigen, die wie eine Theateraufführung präsentiert wurde. In einem rechteckigen Saal mit zwei Eingängen sind die Besucher aufgefordert, verschiedene Aktionen durch eine milchige Plastikfolie hindurch zu verfolgen, die von der Decke bis zum Boden verspannt war. Die weißgekleideten und gepuderten Schauspieler wiederholten den ganzen Abend lang die gleichen Gesten. Nur Bibollet und Armleder, die Regie führten, agierten in wechselnden Rollen. Dufour knetete, vor einem Eimer kniend, einen Wasser-Papierbrei. Bibollet zeichnete weiße Streifen auf die weißen Wände; Wachsmuth fing mit Hilfe einer Pipette aus einem Rohr sickerndes Wasser auf, um es in einen Ausguß zu tropfen. Ein anonym gebliebener Amerikaner auf der Durchreise zerriß weiße Papierbögen; Rychner serigraphierte sein Selbstporträt auf Papier; Bois stieg mit einem Eimer voller Kies auf einen Hocker und versuchte ihn in ein anderes Gefäß auf dem Boden zu schütten. Armleder durchstreifte den Saal mit einer weißen Kugel und bepuderte die Akteure daraus mit Mehl. Später ergriff Bibollet eine weiße Spraydose und zog weiße Streifen auf die Plastikfolie, die die Betrachter von der Szene trennte, worauf Armleder eine weiße Rauchbombe zündet und den Abend so beendete. Dieses Programm erinnert an die „18 Happenings in Six Parts", welche Allan Kaprow 1959 in der New Yorker Reuben Gallery organisierte. Kaprows Notizen dazu vermerken die Rollen der einzelnen „Performer" und des Publikums, dessen Teilnahme in dieser Zeit noch gelenkt war. Für dieses 90 minütige Stück hatte Kaprow die Galerie mittels durchsichtiger Plastikfolie in drei Zonen unterteilt. Die „Performer", darunter Kaprow selbst, Robert Whitman, Sam Francis, George Segal, Dick Higgins und Lucas Samaras, führten auf Anweisung verschiedene Aktivitäten aus (etwa mit den Armen wie mit Flügeln wedeln, einen Ballon schlagen, Plakate lesen, Platten auflegen, ein Instrument spielen, malen) und das in Abstimmung mit programmierten Sequenzen von Diaprojektionen und Lichtspielen. Der erste Abend des Ecart Festivals bezog sich also auf das Ereignis, welches den Begriff „Happening" eingeführt hat. Die Themen der weiteren Abende bestimmten sich von heute auf morgen auf der Basis öffentlich angekündigter Vorschläge gemeinschaftlich mit dem Publikum. Diese Vorgaben beinhalteten z. B. Musikstücke, bei denen die Aktionen der Musiker von ihrer Position im Raum und einer Tonbandaufzeichnung bestimmt wurden, oder es wurde ein Raster, eine Art Choreographie auf den Boden gezeichnet und das Publikum war eingeladen, sich in „ausgewürfelten" Konstellationen darüber

hinwegzubewegen. Das Programm des „Ecart Happening Festivals" weist darüber hinaus auch „improvisierte Lesungen", eine „Lightshow", ein „Gedicht-Essen" und eine über vier Tage sich erstreckende Akkumulation aus. „Accumulations 4 jours" war eine Installation aus gefundenen Materialien, die zwischen dem Abend des 27. und dem 30. November zusammengetragen wurden. Die Objekte wurden in einer Kiste gesammelt, die in verschiedene Kompartimente für Karton, Holz, Plastik, Baguettes und andere Materialien unterteilt war.

7 | In: Rainer Michael Mason, »Faire de l'autre un artiste«, Tribune de Genève, Genf, 28. Februar 1972.

Ecart wird von Dezember 1972 bis März 1979 ein Ladenlokal in der Rue Plantamour bespielen. Armleder, Lucchini und Rychner waren aufgrund ihrer Aktivitäten als Herausgeber- und Ausstellungsmacher, ebenso wie durch ihre kollektiven Werke die zentralen Akteure. Zunächst ist das Hauptaugenmerk der Gruppenmitglieder von Ecart darauf ausgerichtet, ihre Praxis auf diese Produzentengalerie zu konzentrieren und sich dem lokalen Publikum zu präsentieren, bevor dann später ein Programm mit den Einladungen anderer Künstler entsteht. Wie Rainer Michael Mason schreibt, » ...möchte John Armleder, der, wenn ich mich nicht irre, der erste war, der um 1967 herum Aktionen und Happenings in Genf zeigte, aus dieser Galerie keinen Ausstellungsraum traditioneller oder gekaufter Werke machen, sondern einen kreativen Ort, einen Ort der Teilnahme und der Experimente.«[7] Zur Einweihung der Räumlichkeiten am 10. und 11. Februar 1972 realisiert Armleder eine Arbeit für zehn Tonspuren mit dem Titel „Conversation. Etude pour John Cage". Es ist eine Installation aus zehn Kassettenrecordern, die Klangwerke ausgewählter Künstler endlos abspielen, über jedem Gerät ist ein Porträtphoto des Sprechenden angebracht, – es sind die Leitfiguren der Gruppe (George Brecht, William Burroughs, John Cage, Merce Cunningham, Marcel Duchamp, Naum Gabo, Raoul Hausmann, Dick Higgins, Richard Huelsenbeck und Kurt Schwitters). Die verschiedenen Stimmen vermischen sich zu einem „Klang-Magma", das in gewisser Weise von der Freiheit zeugt, mit der Ecart Beziehungen zur Geschichte, insbesondere zu Dada und Fluxus pflegte. Und so gibt dieses Ereignis den „Ton" an, die „Stimmung" nachfolgender Veranstaltungen in der Galerie, so wie sie John Armleders Arbeitsweise jener Zeit ebenfalls aufweist, die zwischen gemeinschaftlicher Praxis und persönlichen Bezügen und Elementen hin und her pendelt.

Das mit „Trois à quatre pièces" betitelte Werk ist ein weiteres Beispiel dafür. Es besteht aus vier mit Tesa aneinandergeklebten Bögen, und fächert Elemente unterschiedlicher Provenienz auf, wie es die mit Bleistift links unten vermerkte Legende notiert: »a) die Vampirfotos / b) Daniel Spoerris Porträt / c) der Konfettiregen / d) putting them together«. Drei „Vampirfotos", die aus dem „Bilder-Fundus" des Künstlers zum Motiv des Vampirs stammen, sind mit Tesa mittig auf der Arbeit fixiert. Gemacht hatte er die Fotos 1968 –

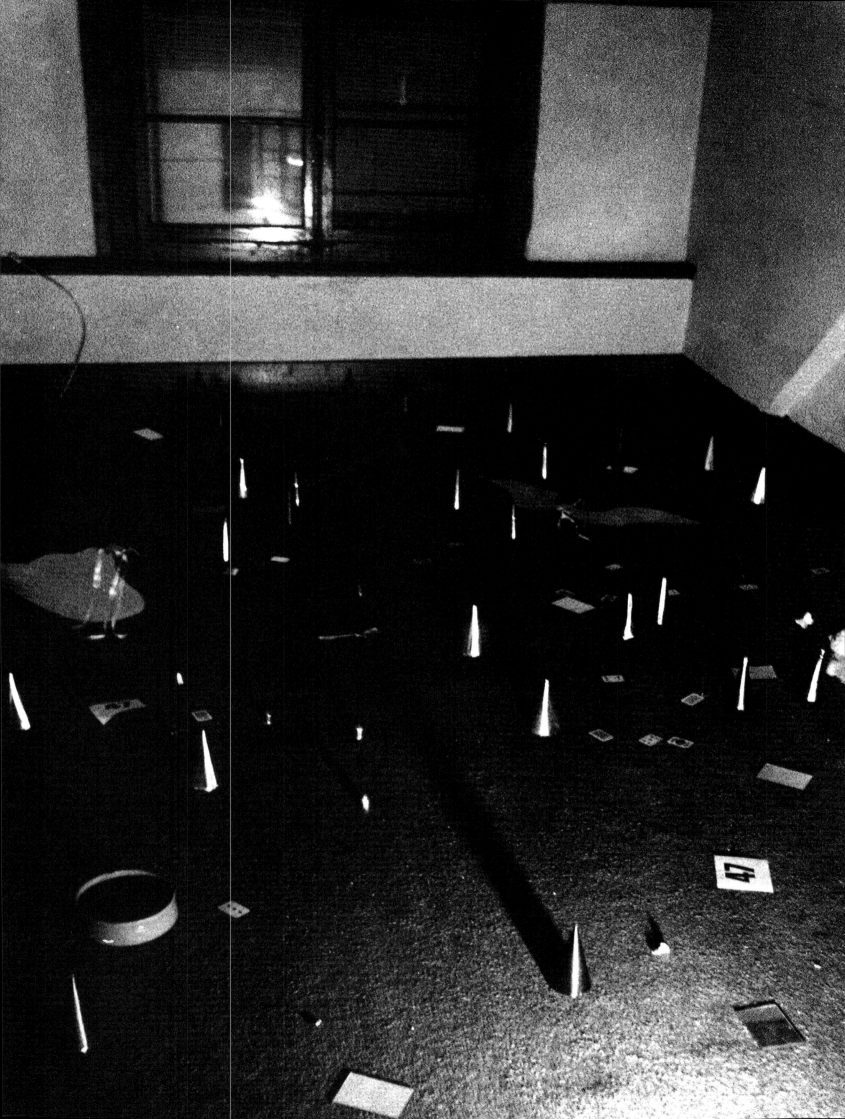

mysteriöse Schatten auf dem Fenster des Künstlers oder das Innere eines Grammophonschalltrichters. Das „Porträt Daniel Spoerri" geht auf die Weiterverwendung von zwei Siebdrucksieben zurück, die zum Druck des Ausstellungsplakates „Daniel Spoerri" bei Ecart gemacht worden waren. Das eine, mit dem Plakattext und einem Negativ eines Porträts des Künstlers, wurde zweifach in Weiß gedruckt. Dann war ein für den Katalog der Sammlung Ludwig in Köln auf Acetatfolie gedrucktes Motiv – Spoerri mit Kochmütze – für die Neubelichtung aufs Sieb umfunktioniert und in drei Farbgängen – einem violetten Rot, in Grün und dann Gold – zweimal seitenrichtig und einmal seitenverkehrt gedruckt worden. In einem weiteren Durchgang wurde dies dann mit einem so gut wie leeren Sieb – lediglich Spuren von Konfetti sind zu erkennen – in Weiß überdruckt. Als „Konfettiregen" hat Armleder kurz vor dem Druckvorgang eine Handvoll runde und sternförmige Konfettis auf den Bogen geworfen. Teilweise blieben sie auf dem bedruckten Blatt selbst haften und verklebten punktuell das Sieb, wodurch bestimmte Bildpartien beim Druck schließlich hervorgehoben erscheinen. Die Formulierung „putting them together" benennt die Geste von 1976, also die „Zusammenstellung" der heterogenen Arbeitsgänge und Bilder. Die drei Momente dieser Arbeit sind im übrigen auch mit Bleistift unten rechts auf dem Bogen angegeben: „1968 / 1973 / 1976". Neben der Armleder-Signatur dieser Arbeit finden wir dann auch den Hinweis, daß der Siebdruck – und die technische Realisation wird als vollwertiger Teil des kreativen Prozesses verstanden – gemeinsam „mit Claude Rychner" ausgeführt wurde. Was „Trois à quatre pièces" über die Schichtung der Motive hinaus ausweist (Bilder am Rand der Lesbarkeit), ist die Verknüpfung jener Vorgehensweisen, die der Künstler ebenso wie die anderen Mitglieder von Ecart nutzt. Dieser Arbeit wurde ein individueller Status zugeschrieben, sie ist aber gemeinschaftlich erstellt; sie verbindet Vorgefundenes (die Sammlung), „ephemera" (das Plakat) und Geste (der Konfettiregen); sie emblematisiert die Wiederverwertung, einen der Ecart prägenden Mechanismen, und läßt so ein spielerisches Objekt entstehen, welches fern von formalen Fragen ein gefühlsmäßiges Aufgreifen alltäglicher Vorkommnisse bezeugt. Vergleichbares wird auch am „Ecart Year Book" von 1973 sichtbar: aus Andruckbögen der Drucksachen eines Jahres wird ein Büchlein, beschnitten aufs Format eines Mini-Kalenders (zu Ehren Dieter Roths, der bereits früher Bücher in diesem Verfahren hergestellt hatte). „Trois à quatre pièces" wie auch das „Ecart Year Book" sind symptomatisch für die paradoxe Spannung der von Ecart gemachten Arbeiten: einen Abschluß zu markieren, sich auf sich selbst zurückzuziehen, auf die eigene Geschichte, der so die Möglichkeiten zur Interpretation entzogen werden, aber gleichzeitig auch als Zeichen für eine Offenheit zu stehen, nämlich den Sinn immer wieder dann in Bewegung zu versetzen, wenn eine Arbeit ihn zu fixieren schien.

Im Rückblick sieht John Armleder in den Aktivitäten der Gruppe »einen Hang für die Verwendung des Einen, um auf ein anderes zu verweisen, aber nicht im surrealistischen Sinne einer Enthüllung, sondern einem Prinzip der Gleichwertigkeit aller möglicher Wissensformen folgend. Und dies im Hinblick darauf, Zweifel einzubringen. Gibt man eine Erklärung, so greift diese auf ein Vorverständnis zurück, eine Übereinkunft zu dieser Erklärung und der Art und Weise, in der man sie gegeben hat. Oder aber: man weiß, daß dieses alles doch nicht so klar ist. Die Definition von Kunst basiert auf der Tatsache, daß es zwischen allen Wahrnehmenden keine klare Übereinkunft über ein und dasselbe Objekt gibt. Es kann eine Übereinkunft geben, einen Diskurs der Übereinkunft, der aber nicht präziser ist oder stichhaltiger als ein anderer. Indem uns als Ausgangspunkt eine Übereinkunft innerhalb der Gruppe diente, ein von allen geteiltes Wissen, eine Anekdote, die uns betraf, ging es darum, ein für „richtig" befundenes Wissen durch ein x-beliebiges Wissen zu ersetzen, welches ebenso gut funktionierte wie irgendein anderes. Innerhalb der Gruppenaktivitäten „machten" bestimmte Mechanismen für uns Sinn und wir betrachteten diese folglich als allgemeingültig. Es genügte, diese in ein System einzubringen, um einen wirklichen Mechanismus in Gang zu setzen. Als Produkt dieses Mechanismus waren die Objekte nun nicht mehr völlig „unschuldig", auch wenn die beigegebenen Bezüge von außen unlesbar waren.«[8] Zweifellos sind es diese Aspekte bei Ecart, die am faszinierendsten, gleichwohl auch am schwierigsten zu vermitteln sind. Denn wie soll man die zwei Versionen des „Livre de la Méduse" verstehen, ohne zur Kenntnis zu nehmen, daß die Wiederholung des gleichen Bildes auf allen Seiten – ein Porträt von Pierre Laurent, genannt „la Méduse" (dem ersten Rudertrainer der Gruppe) – ebenso auf Laurent's besondere Stellung in der kollektiven Mythologie der Gruppe beruht, wie auf der ästhetischen Methode, auf die sie bezogen werden kann. Auch bei den meisten Beiträgen der Gruppe zu anderen Ausstellungen gilt: die innere Logik ihrer Vorgehensweise schließt formale Entscheidungen mit ein, die für die Betrachter unerklärte Setzungen sind. Dennoch sind Betrachter immer wieder zur Teilnahme an einem Ereignis („Ecart Happening Festival", 1969), an seiner Vorbereitung („Troc de boîtes", 1975) oder an seiner Fortführung („CV Nut Art Show", 1974) eingeladen worden. Daraus wird ersichtlich, daß Ecart sich nicht in einer hermetischen Position einrichten wollte. Nur – dort im Hybriden zwischen Kunstdiskurs und dem Diskurs des Intimen, der Referenzen und der Anekdote, sitzt gerade jene kollektive Identität und die Herausforderungen an ein solches Unternehmen. Die Folge von Zeichnungen „3x(2x1)", die 1977 anläßlich einer Ausstellung der Gruppe in der Luzerner Galerie Apropos entstanden, mag dies noch einmal belegen. Armleder, Rychner und Lucchini zeigen jeder 14 Blätter in Abfolge, drei Versionen „einer Ausstellung, die der andere hätte machen können". Die Methode

8 | John Armleder, Tonbandaufzeichnung eines Gespräches mit Lionel Bovier, Juni 1995, unveröffentlicht, Archiv Ecart.

scheint durchschaubarer Logik zu folgen: drei Künstler, verschiedene Handlungsanweisungen ("kopieren", "ähnlich wie" und "aus der Erinnerung") sowie eine Kombinatorik der Elemente ahmen hier eine Mechanik des Arbeitens nach, in der das Werk das Ergebnis einer mathematischen Funktion ist. Im Unterschied aber zur Ausstellung von BMPT in der Galerie J (Paris 1967), in der jeder Künstler ein eigenhändiges Werk neben seinen Versionen der anderen zeigte, ist die Austauschbarkeit der Werke der Gruppe Ecart kein Grundsatzprogramm oder eine politische Geste zur Auflösung der persönlichen Handschrift: ihre Austauschbarkeit entsprang fast selbstverständlich dem Wunsch, alles persönlich in die Gruppe Hineingetragene miteinander zu teilen.

Im gegenwärtigen Werk John Armleders lassen sich vielfältige Spuren dieser langen kollektiven Praxis nachweisen, und dies wahrscheinlich deutlicher seit dem Beginn der 90er Jahre als im vorausgegangenen Jahrzehnt. Immer wieder wird es aber auch von seinen Erfahrungen mit den Mechanismen des Ausstellens als einer Möglichkeit zur Ausweitung der künstlerischen Arbeit [9] begleitet, wie auch von dem Prinzip der Gleichwertigkeit aller Gattungen, einer Ökonomie des Werkes in bezug auf seine existentiellen Umstände [10], oder das Teilen der Erfahrungen mit anderen, sei es der spezialisierte Gesprächspartner, ein Student oder das Publikum seiner Ausstellungen [11]. Aber viel prägnanter ist ohne Zweifel, daß Armleder es jenen Jahren verdankt, seine Strategien der delegierten Autorenschaft entwickelt zu haben, Funktionen des „sozialen Vermittlers" in Frage zu stellen (so wie Foucault sie als eine dem Autor explizite beschrieben hat) und letztlich auch in seiner Arbeit ständig »die künstlerischen Karten neu zu mischen« [12]. So spiegeln die Plattformen in Dijon, Genf, Tremezzo, Paris oder Baden Baden nicht nur die Installation von 1967 oder die „Conversation. For John Cage", sondern evozieren dieses Bild des Magmas wieder neu, jener Verwirrung, des „puddings", der von Ecart-Tagen bis heute [13] seine künstlerischen Vorstellungen belebt, das Bild einer zu allem bereiten, aber allem völlig entbundenen Kultur. Und vielleicht sieht John Armleder gerade im Auge dieses Malströms den Spielraum, den Raum absoluter Indifferenz, in dem sich alle Diskurse aufheben, wo Sinn nicht „greift" und sich nicht erfassen läßt.

9 | Es sei an die vom Künstler organisierten Ausstellungen erinnert, von Peinture abstraite (Genf, 1984) bis zu 504 (Zentrum für Kunst und Design, Braunschweig 1997), Ne dites pas non! und Don't do it (MAMCO, Genf 1997 und 1998), wie auch an den Stand von Ecart auf der Basler Messe, den er bis heute bespielt.

10 | Cf. Nicolas Bourriaud, „L'économie d'échelle de John Armleder", Kat. cit. in der Fußnote 4.

11 | Hierzu wären die gemeinschaftlich mit Sylvie Fleury realisierten Arbeiten vom Anfang der 90er Jahre zu erwähnen, wie auch verschiedene Ausstellungen unter dem Kürzel „AMF" (für Armleder, Mosset, Fleury), worunter jüngst eine ironische „Retrospektive" im Genfer Mamco stattfand.

12 | Cf. Lionel Bovier, „Whatever by whomever" in: Parkett, Nr. 50 / 51, Zürich 1997.

13 | Cf. John Armleder et alii, Overloaded, Pudding, ..., Editions JRP, Genf 1995, (vgl. Abb. Nr. 23, S. 177); des weiteren noch zwei Texte in: John Armleder (Hrsg.), Never Say Never, Offizin Verlag, Zürich 1996.

Aus dem Französischen übertragen von Hinrich Sachs, bearbeitet von Margrit Brehm.

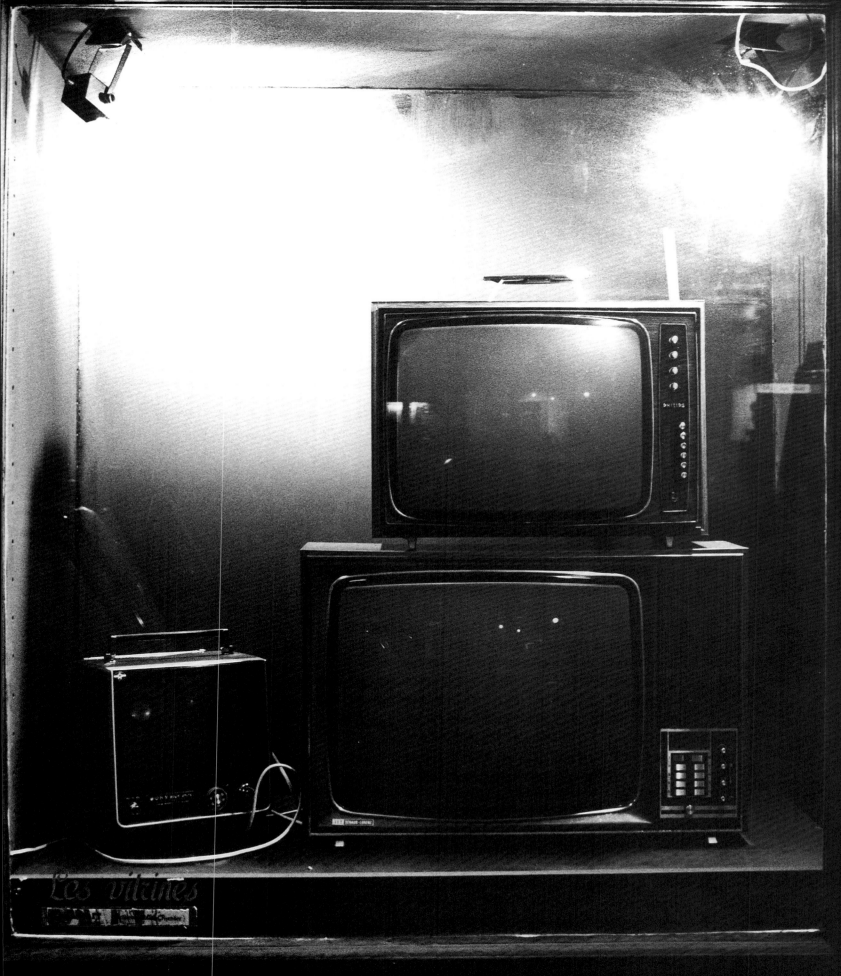

Les vitrines

JOHN ARMLEDER
AND ECART

LIONEL BOVIER &
CHRISTOPHE CHERIX

While the influence of Fluxus as well as Minimal, Conceptual and Body Art was omnipresent at the end of the 1960s, the decade that followed was characterised by a singular way of managing this heritage, through alternative models, networks or communal and political engagement. Numerous groups of artists, alternative spaces and places for showing art developed throughout Europe and America. From this there gradually emerged a mode of functioning in which information was more important than its object – understood here as a working principle, as in Kynaston McShine's 1970 exhibition, "Information" (organised at MoMA, New York). Among these many entities, Ecart, founded by John Armleder, Patrick Lucchini, and Claude Rychner, based in Geneva and active between 1969 and 1982, seems emblematic of a certain redistribution of artistic parameters. Ecart, which »many considered as the most important alternative space in Europe in the 1970s [...] even going beyond the American concept of the alternative«[1], was officially founded in 1969 during a performance festival. In 1972, Ecart established its activities as both book shop and gallery in premises located at 6, rue Plantamour, Geneva. And, from 1973 to 1982, Guiseppe Chiari, Braco Dimitrijevic, Dick Higgins, Olivier Mosset, Annette Messager, Daniel Spoerri, Ben, Manon, and many other artists prominent on the 1970s' art scene exhibited at this space, or, later, at 14, Rue d'Italie.[2] At the same time, Armleder, Lucchini and Rychner started up a publishing activity, printing and distributing artists' projects in the form of books and multiples. Peter Downsborough, Robert Filliou, Genesis P-Orridge, Sarkis, Endre Tót, Dan Graham, Maurizio Nannucci, and Lawrence Weiner all produced one or more publications with them. If we add to this the foundation in 1974 of the Ecart Performance Group, which gave "recitals" of performances until 1981, we begin to have an idea of the group's rich and multifaceted production – of which, indeed a recent, two-part exhibition at the Cabinet des estampes and Mamco, Geneva, undertook to provide the first real survey.[3]

To borrow the words of Christian Besson, as he works backwards along the line of »›hydropathes‹, ›zutistes‹ and other shirkers, Zwanze art, the Incoherents, Dada and Fluxus,« »what would later become the Ecart group was originally a circle of friends who liked to go ›rowing‹ and whose first performances were given without an audience – which, in Jules Romain's sense, may be understood as a group of pals who liked to cause a ›row‹.«[4] And in fact, most of the original members of the group first met between the ages of 12 and 15 (Armleder, Rychner, Wachsmuth, Dufour, Faigaux, Gottraux), under the

1 | Ken Friedman, "Young Fluxus: Some Definitions", Young Fluxus, exhibition catalogue (New York : Artists Space, 1982), [p. 25].

2 | Both were next door to the Centre d'art contemporain, directed by Adelina von Fürstenberg, with whom the Ecart group frequently collaborated.

3 | ECART, Genève 1969 – 1982 ou l'irrésolution commune d'un engagement équivoque, Mamco et Cabinet des estampes du Musée d'art et d'histoire, Geneva, curators: the authors, from October 28 to December 21, 1997; exhibition catalogue: Lionel Bovier & Christophe Cherix (éd.), L'irrésolution commune d'un engagement équivoque. Ecart, Genève 1969-1982 (Geneva: Mamco and Cabinet des estampes, 1997). The following texts have been taken from the catalogue of the exhibition and have been partially reworked.

4 | Christian Besson, "De quelques figures du désœuvrement dans l'œuvre de John M Armleder", John M Armleder, exhibition catalogue (Fréjus: Le Capitou, 1994/published by Electa, Milan), pp. 154 – 155.

two wings of their drawing teacher, Luc Bois, and their rowing instructor, Pierre Laurent (known as »the Jellyfish«). Their first pursuits soon became dedicated to these "mentors," and were "artistic productions" conceived as so many deviations [in French : écarts] from the group's everyday activities. They included the creation of the Max Bolli Prize (a trophy awarded to boats that sank or came in last at official regattas), ephemeral installations made during "research camps," and the urban "drifts" of "bi-weekly workshops." The first thing that set this group, initially named Bois or Bolli, then Ecart, apart from other artists' collectives is clearly manifest here: its existence did not depend on any manifesto, any distinct theoretical positions, any political solidarity, any orthodoxy − not even on any real engagement on the artistic scene of the time. It was enough for its members to have tea together, to organise a hike, or to celebrate one of the occasions punctuating their personal calendars, for them to affirm at the same time the existence of a collective identity and open up the possibility of group artistic practice. Moreover, the time frame in which this identity and practice were situated was not that of a traditional artistic context, with its accelerations or its "delays," its linearity and its cursors, but that of life, of friendships spanning childhood and adulthood, of games, of Zen philosophy − in short, a temporality that the group defined in accordance with its inclinations, scattered with stories, intermissions, books, and five o'clock tea. Obviously, then, the group was taking advantage of the Fluxus principle of the "equivalence of life and art," just as it was applying Robert Filliou's "permanent creation" attitude to life. In more general terms Ecart emerged against the background of the gradual abandonment of the traditional aesthetic field in favour of procedures linked to the random and the everyday, or of critical and political concerns and participatory approaches. However, while the group certainly made use of the instruments provided by the times, whereby the commercial dimension of art, the categories of "beauty," and questions of originality and authenticity had already been under challenge for some years, it did so as part of a collective undertaking whose singularity cannot be reduced to its context. Under these circumstance, we can appreciate why Ecart should have seen no fundamental difference between the collective practice of art, the organisation of an exhibition at the gallery, or the publication of an artist's book. The repeated contacts between the group and its work and other European or American art scenes via mail art, the exchange of publications, festivals and performances, seem to go well beyond the specific and temporally limited contributions by the international artists they invited. What is more important is the mixing of networks, the fact that Al Souza should be in contact with Olivier Mosset, or that Robin Crozier should stand on the same horizon as Lawrence Weiner. The play of influence and complementarity thus gains in complexity, and leads us ineluctably to a reassessment of the period.

The group's first public exhibition,"Linéaments 1," in 1967, was introduced by the phrase »ce qui dessine« – in other words the sketch, the rough version of a forthcoming work. The poster for this show quoted a text by Victor Hugo which seems to be a commentary on the activity of the Bois / Bolli group, and, by extension, on the future development of Ecart: »gradually, however, vague lineaments began to take shape and fix themselves in his thoughts, and he was able to glimpse with the precision of reality, not the entire situation, but a few details.« The information sheet for this show states that »The desire to understand kills the desire to participate. A few young artists invite visitors to share an experience for a month. Their experimental exhibition is in fact the experience of a call for public participation. The aim is to establish contact. The exhibition is divided up into two contrasting parts. The first is conventional in style. The room is organised in order to contain the public and to facilitate the contemplation of autonomous works. Everything depends on the intellectual creative faculties of the visitors. The second part is a composition based on the room itself. The people who enter it thus constitute its concrete, random element.« And indeed, if, in the terms of a period witness, the art critic Arnold Koller, the first part of "Linéaments 1" presented »seven sculptures [by Andre Tièche], seven rather strange, small heads«; »troubling forms [by John Armleder], some of which seem to be of vegetal origin, others of a tectonic nature«; »kinds of monsters [by Joseph Forte] made of organic assemblages, with obsessive eyes«; »object-paintings [by Floydene Coleman] made up of everyday utensils – dolls' hands, belt buckles, egg holders, intact and dented ping-pong balls, etc. etc ...«[5], what really attracted attention was an installation to which Armleder, Bois, Rychner, Tièche and Wachsmuth had all contributed. This ensemble was described by the participants as a »composition« and as »variations without a theme integrated into a limited space«, while Arnold Koller broke down its components as follows: »first of all, there are tubular frameworks which fill the space; sheets of aluminium hang inside them and vibrate to the slightest movement of the air; on the floor two fixed projectors send their rays onto two reflective mobiles, so that their light sweeps regularly across the room. Against one of the walls, torn posters have been stuck up. A magnetic strip emits sounds of percussion instruments.«[6] As Koller says, a scaffolding of metal tubes did indeed take up the main part of the space. On one side, the metal bars were fixed together in a highly irrational manner, on the other, the structure remained very simple, with sheets of aluminium and acetate hanging from the tubes. The room was bathed in a semi-darkness punctuated by zones subjected to additional lighting. This came from spotlights placed on the floor or lashed to the planks across the ceiling. On the floor was placed a record player; its deck served as the moving base for an illuminated piece of copper, sending its luminous reflections around the room.

5 | Arnold Koller, "Vive l'impertinence !", Tribune de Genève (Geneva), June 16, 1967, p. XXI.

6 | Ibid.

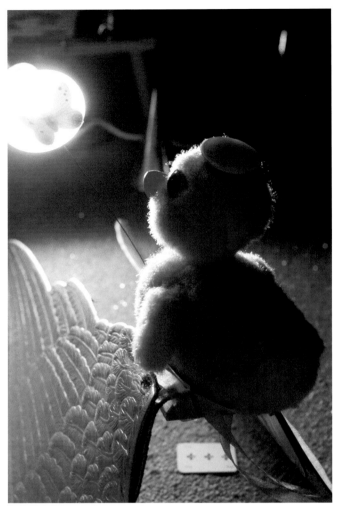

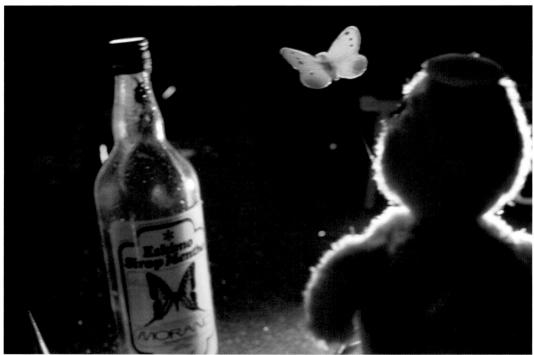

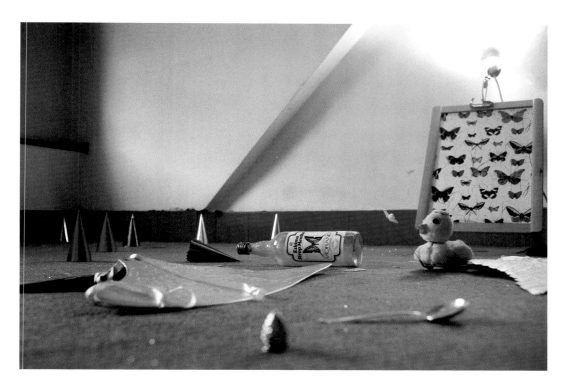

Two sound sources simultaneously emitted recordings made by Armleder: the first, a tape of birdsong played at the wrong speed; the second, a series of repetitive sounds produced by a spring. To this was added a sheet of curved Plexiglas which rose from the metal construction, a fan, a dead pigeon nailed on a peeling wall, and a transparent plastic sheet covering parts of the walls. This staging aimed to immerse spectators in a "total installation" in which sound, movement, light, the rhythm of the metal bars and the effects of transparency and opacity all joined forces. This installation was not so different from the contemporaneous realisations of kinetic and optical art (works by the GRAV or the Group Zero, for example). Here however, the rotary motion was produced by an instrument associated with music rather than by a motor. It therefore coincided with the sound aspect of the installation. Likewise, the components were indeed steel, aluminium, and light, but they were "found," recuperated elements. Lastly, the ensemble embodied a number of Ecart's working principles: the disappearance of individual signatures behind a collective identity, an active relation with the viewer (the flyer announced that »the public's desire to participate will engender Linéaments 2«), and a singular way of utilizing what it knew about the contemporary scene.

The group's second public showing, the Ecart Happening Festival of 1969, would prove constitutive of the activities pursued by the three main protagonists over the coming decade. The two posters, with texts written by Armleder, presented the event as a »Deviation [in French: ECART] ... but a blind deviation, deviating collective prospection towards this field of incredible poverty cancels the accumulation of research involving any insignificant realisation whatsoever and the random modification of observation following on from the incident reveals the continuous vacuity of the object spreading out [in French : s'étirant à l'ECART ECART ECART] (and) this involuted movement in its digression/moving further and further away from the line where the images of a presupposed initial realisation coincide /and babbling in divergent directions the terms of the common irresolution of an equivocal/engagement that is a deviation [écart] ...«. This anti-manifesto thus proposes a paradoxical definition of both the evenings, the objectives of the organisers and the future of the collective practice embodied by the Ecart group from 1972 onwards. The first evening, entitled, "The White Flights of the Imagination and Other Pieces," is one of the only ones that was presented as a performance. In a rectangular room with two entrances, spectators were invited to watch various actions through a semi-opaque plastic screen stretched from floor to ceiling. Dressed in white, their faces powdered, the actors repeated the same action all evening long. Only Bibollet and Armleder — who was in charge of the production aspect — played different roles. Squatting in front of a bucket, Dufour kneaded a pulp made of water and paper; Bibollet drew white stripes on the

white walls; Wachsmuth used a pipette to collect water seeping from a pipe and transfer it into a sewer; an American who was passing through at the time (and who has remained anonymous) tore up sheets of paper; Rychner silkscreened a self-portrait on paper; Bois climbed onto a stepladder with a bucketful of gravel which he attempted to empty into another container on the floor; Armleder paced around the room with a white ball, occasionally dusting the participants with flour. Later, Bibollet sprayed white stripes on the plastic separating the audience from the stage, while Armleder lit a white smoke bomb, thus putting an end to the evening. This programme is redolent of the "18 Happenings in Six Parts" organised by Allan Kaprow at the Reuben Gallery, New York, in 1959. Kaprow's notes for this event indicate the roles of the different "performers" and of the audience, whose participation at that time was still directed. For this piece, lasting 90 minutes in all, Kaprow divided the gallery into three sections using transparent sheets of plastic. The performers, including Kaprow himself alongside Robert Whitman, Sam Francis, George Segal, Dick Higgins, and Lucas Samaras, carried out their different activities (such as flapping their arms like wings, hitting a balloon, reading posters, playing records or an instrument, painting) in time with programmed sequences of slide projections and lighting effects. The first evening of the Ecart festival thus referred to the first event to be given the name "happening." The themes of the subsequent evenings were chosen collectively with the audience, from one day to the next, working from a proposition posted on the wall. These propositions included musical pieces in which the musicians' actions were determined by their position in the room and by a recorded tape. Or again, a grid of choreographic movements was traced out on the floor, over which the audience was invited to move as dictated by successive dice throws. The programme of the Ecart Happening Festival also mentions "improvised readings," a "light show," a "poem-cum-meal" and an accumulation spread over four days. "Acculmulations 4 jours" consisted of a sculpture made of found materials added together over the evenings of Wednesday 27 to Saturday 30 November. The objects were set out in a cage divided into compartments for cardboard, wood, plastic, baguettes and various materials.

From December 1972 to March 1979, the Ecart gallery was housed at Rue Plantamour. Armleder, Lucchini, and Rychner were the main protagonists by virtue of their publishing and exhibition activities, as well as, for the occasion, their collective works. Before developing its programme of invitations to other artists, the members of Ecart decided to place their own activities in the context of the gallery and present them to the local public. As Rainer Michael Mason noted at the time, »John Armleder, who, unless I am mistaken, was the first person to present happenings and actions in Geneva, in 1967, would like to make this gallery not so much a room for exhibiting acquired

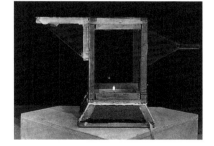

or traditional works as a place of creation, experimentation, and participation too.«[7] For the official inauguration on February 10 and 11, 1972, Armleder made a piece for ten magnetic tapes entitled "Conversation. Etude pour John Cage." This was an installation of ten tape recorders each playing without interruption a sound work or the voice of an artist whose photograph was placed above, each artist being one of Ecart's tutelary figures (George Brecht, William Burroughs, John Cage, Merce Cunningham, Marcel Duchamp, Naum Gabo, Raoul Hausmann, Dick Higgins, Richard Huelsenbeck, and Kurt Schwitters). The resulting mixing of voices in a "sound magma" showed very clearly the freedom with which Ecart approached its relation to history and, in this particular case, to Dada and Fluxus in particular. This in a way set the tone for subsequent events in the gallery. It also illustrates the kind of work that Armleder was publicly initiating at the time, oscillating as it did between collective practices and the recurrent features of his own personal approach.

The work entitled "Trois à quatre pièces" (1968/1976) is another example of this. Made up of four sheets of paper taped together, this is a piling-up of elements from varied origins, as indicated by the legend written in pencil in the lower left part: »a) photos of the vampire / b) portrait of Daniel Spoerri / c) shower of confetti d) putting them together [these last words in English]«. The three "photos of the vampire" taped to the centre of the piece came from the artist's own collection of images relating to vampires. They were taken in 1968 and bring together various different shots, such as one of a mysterious shadow on the artist's window, or one of the inside of a gramophone horn. As for the "portrait of Daniel Spoerri", it shows how two silkscreen frames were used to make the poster for the Spoerri show at Ecart in 1973. The first, showing the letter announcing the show and a photograph of the artist, was printed twice in white. The image on the second silkscreen frame, showing Spoerri wearing a chef's hat, was printed three times; the colours were different each time, alternating purplish red, green, and gold. Finally, an empty screen, with a only a few traces of confetti left on it, was printed in white on each of the sheets. The "shower of confetti" signals the fact that, at the moment of printing, Armleder threw a handful of round and star-shaped confetti on the paper before printing. The last annotation, "putting them together," names the action of 1976, that is to say, the assemblage of heterogeneous procedures and images. As it happens, the three moments of the work are marked in pencil on the lower left side of the board: »1968/1973/1976«. While the piece is signed by Armleder, it nonetheless indicates that the silkscreening operations – a technique which here is seen as an integral part of the creative process – were carried out »with Claude Rychner«. Apart from the superposition of images, which makes the plate teeter on the brink of illegibility, "Trois à quatre pièces" is notable for the combination of different procedures used at the time

7 | Rainer Michael Mason, "Faire de l'autre un artiste", Tribune de Genève (Geneva), February 28, 1972.

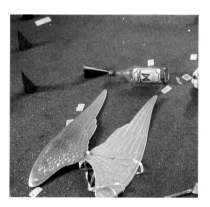

by the artist and other members of the Ecart group: the work was
accepted individually in terms of its status, but was made collectively;
it brings together found objects (a collection), ephemera (a poster),
and an action (throwing the confetti); it accords an emblematic role
to recycling, one of the mechanisms most regularly used by Ecart,
and, finally, it gives rise to a playful object, one far removed from
any formal concerns and thus showing how everyday events were
re-charged with affective content. The 1973 "Ecart Yearbook" also
illustrates these principles: using leftover printed paper from the
year's publications, the book, chopped with a paper cutter to the size
of a mini-calendar, was made in homage to Dieter Roth (who had
produced similar books in the past). "Trois à quatre pièces" and the
"Ecart Yearbook" are both symptomatic of the paradoxical move-
ment of the works produced by Ecart: at once the signal of a closure,
of turning back to oneself, to one's own history, thus confiscating the
procedures for interpretation thereof, and the indication of an
openness, a way of putting meaning back in circulation whenever a
work seems to express it.

8 | John Armleder, recorded in-
terview with Lionel Bovier, June 1995,
unpublished, Ecart archives.

Retrospectively, John Armleder has recognised that the group
had »a taste for using one thing to point to something else, not in
the Surrealist sense of a revelation, but according to a principle of
equivalence between all possible forms of knowledge. In order to
induce doubt. When you supply an explanation, that indeed implies
that there is a prior agreement concerning these explanations and
the way they have been given. But we know that things are not as
clear-cut as that. The very definition of art rests on the fact that
there is no clear agreement between all receivers about a given
object. There may be an agreement, a discourse of agreement, but
without this being either definitive or more relevant than another
one. By taking as our starting point an agreement between us,
something we all knew, an anecdote that belonged to us, the idea
was to replace knowledge that was considered ›right‹ with some
nondescript piece of knowledge, which worked just as well as any
other. In the activities of the group, certain mechanisms made sense
to us and so we considered them as universals. It was enough to
reinject them into a system to put in place a real mechanism. As the
product of this mechanism, the object was therefore not totally
›innocent,‹ even if the references injected into it could not be read
from the outside.« [8] This is no doubt the most compelling aspect of
Ecart, but also the most difficult to transpose. How, indeed, can we
approach the two versions of the "Livre de la Méduse" (the Jellyfish
book) without noting that the repetition on every page of the same
image – a portait of Pierre Laurent, "the Jellyfish" – owes as much
to Laurent's particular position in their collective mythology as to
any aesthetic method from which it might derive? The same applies
to most of the group's contributions to artistic events: the internal
logic of their approach led to formal decisions whose motivations were

irremediably opaque to viewers. However, on several occasions, viewers were also invited to take part in an event ("Ecart Happening Festival," 1969), its preparation ("Troc de boîtes," 1975), or its extension ("CV Nut Art Show," 1974). Clearly, then, Ecart had no intention of hiding behind some hermetic stance. Still, the issues involved in their negotiation of their position and their collective identity reside in this mixing of artistic and intimate discourses, of reference and anecdote. This is attested, for example, by the series of drawings entitled "3x(2x1)" and executed in 1977 for a group show at the Galerie Apropos in Lucerne. Here Armleder, Rychner, and Lucchini each show in succession a set of 14 plates, each set being a version of an »exhibition that the others could also have done«. The method pretends to adopt mathematical logic: three artists, three functions (copying, creation in the manner of, memory), and a grouping of propositions, thus mimicking the mechanism of work in which the art is the product of x and y coordinates on a preconceived graph. However, in contrast to the BMPT exhibition at Galerie J (Paris, 1967), where each artist presented a personal work as well as his version of the works by the two others, the interchangeability of the works by Ecart is not the result of a deliberate "line of conduct" or a political programme aiming to undermine the individual signature: it flows, almost naturally, from the predominance of what the group members shared over what was strictly personal.

One can detect multiple traces of this long practice of collaboration in John Armleder's current production (more so, perhaps, since the beginning of the '90s than in the previous decade). Of course, it will always be accompanied by those experiments with the mechanisms of the exhibition which serve as an extension of the artist's own work[9], as well as experiments with the principle of the equivalence between styles or between the economy of the artwork and its existential circumstances[10], or with sharing experiences with others, be it a specialist, a student, or visitors to his exhibitions.[11] But, more importantly, it was during this period that Armleder learnt his strategies for delegating the signature, for challenging the "social cursor" function implicit in the role of the author, as Foucault describes it, and, finally, for constantly putting his own work "back into play."[12] Thus the platforms at Dijon, Geneva, Tremezzo, Paris, and Baden-Baden not only evoke the installation of 1967 or "Conversation. For John Cage," but convoke this image of the magma, the confusion, the "pudding" that the artist has always sought, from Ecart to the present day[13] – that is to say, the image of a culture made entirely available but entirely disposable as well. For, perhaps, in the eye of this maelström, John Armleder has managed to make out a space for play, a space of absolute indifference, where all talk cancels itself out, where "meaning" does not take nor let itself be "taken." A form of fluidity, a suspension that would foil the implacable signifying machine of society, of the Doxa.

9 | As shown in the exhibitions curated by the artist : Peinture abstraite (Geneva: rue Plantamour, 1984), 504 (Braunschweig: Zentrum für Kunst und Design, 1997), Ne dites pas non ! (Geneva: Mamco, 1997), Don't do it (Geneva: Mamco, 1998), and the Ecart booth at the Basel Art Fair which he continues to run today.

10 | Cf. Nicolas Bourriaud, "L'économie d'échelle de John Armleder" in John M Armleder, see note 4.

11 | For instance, in his collaborations with Sylvie Fleury at the beginning of the 90s, or the different events under the name "AMF" (for Armleder, Mosset, Fleury) of which the artist recently gave an ironic "retrospective" at Mamco, Geneva.

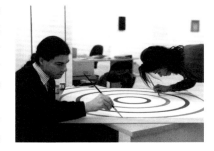

12 | Cf. Lionel Bovier, »Whatever by whomever«, Parkett (Zurich) 50/51 (1997).

13 | Cf. John M Armleder et alii, Overloaded, Pudding (Geneva, Editions JRP, 1995); as well as his two texts in Never Say Never, exhibition catalogue (Zurich : Offizin Verlag, 1996).

Translation from French by Charles Penwarden, Paris

* The authors are very grateful to Madeleine Noble, Geneva, for her revision of this translation.

ECART BOOKSHOP,
LEATHERN WING SCRIBBLE PRESS & ALII

JOHN M ARMLEDER
PATRICK LUCCHINI
& ALII

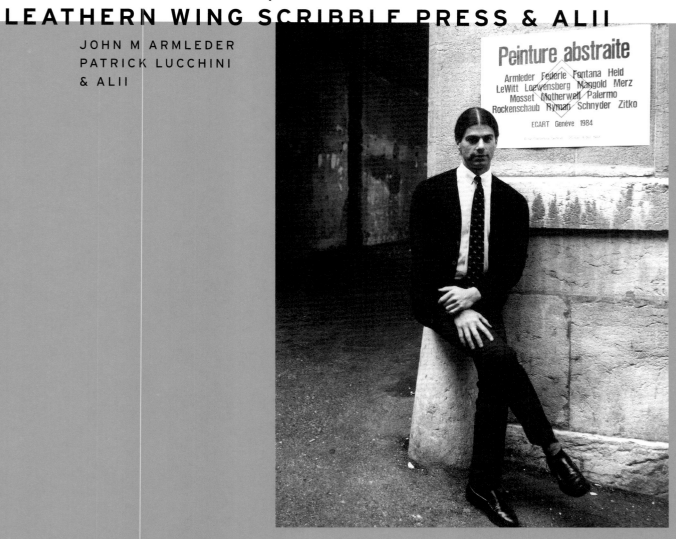

1

8

2 5 6

1 John M Armleder und Patrick Lucchini
 COLLAGE COLLECTIF PAR CORRESPONDANCE NO. 1
 (1972 / 1973)
 297 x 213 mm, 20 Seiten
 Ecart

2 **RAINBOWS IN HEAVEN**
 Zeichnungen, 1972 – 1973
 297 x 210 mm, 9 Seiten
 Ecart / Palais de l'Athenée

3 **LÉZARDS SAUVAGES I**, 1973
 Double Sphinx Serie No. 2
 205 x 146 mm, 7 Doppelseiten
 Ecart (o. Abb.)

4 **ECART YEARBOOK**, 1973
 (Hommage à Dieter Roth)
 49 x 53 x 25 mm, ca. 200 Seiten
 Ecart (o. Abb.)

5 **AYACOTL-EXCERPTS**, 1973
 Double Sphinx No. 3
 205 x 146 mm, 10 Doppelseiten
 Ecart

6 **AYACOTL**, 1973
 Paris - Biennale
 146 x 205 mm,
 Ecart

7 **IT-S AN OLD STORY**, 1973
 31 x 32 x 34 mm, 146 Seiten, ungebunden
 Ecart (o. Abb.)

8 John M Armleder und Patrick Lucchini
 LE PREMIER LIVRE DE LA MÉDUSE, 1973
 Leathern Wing Scribble Press
 Vol. XXVI, No. 1
 293 x 209 x 5 mm, 51 Seiten
 Ecart

9 **LEATHERN WING SCRIBBLE PRESS**
 Vol. XXVIII, No. 3, 1973 / 75
 210 x 297 mm, 10 Seiten
 Ecart

9

13

9b

10

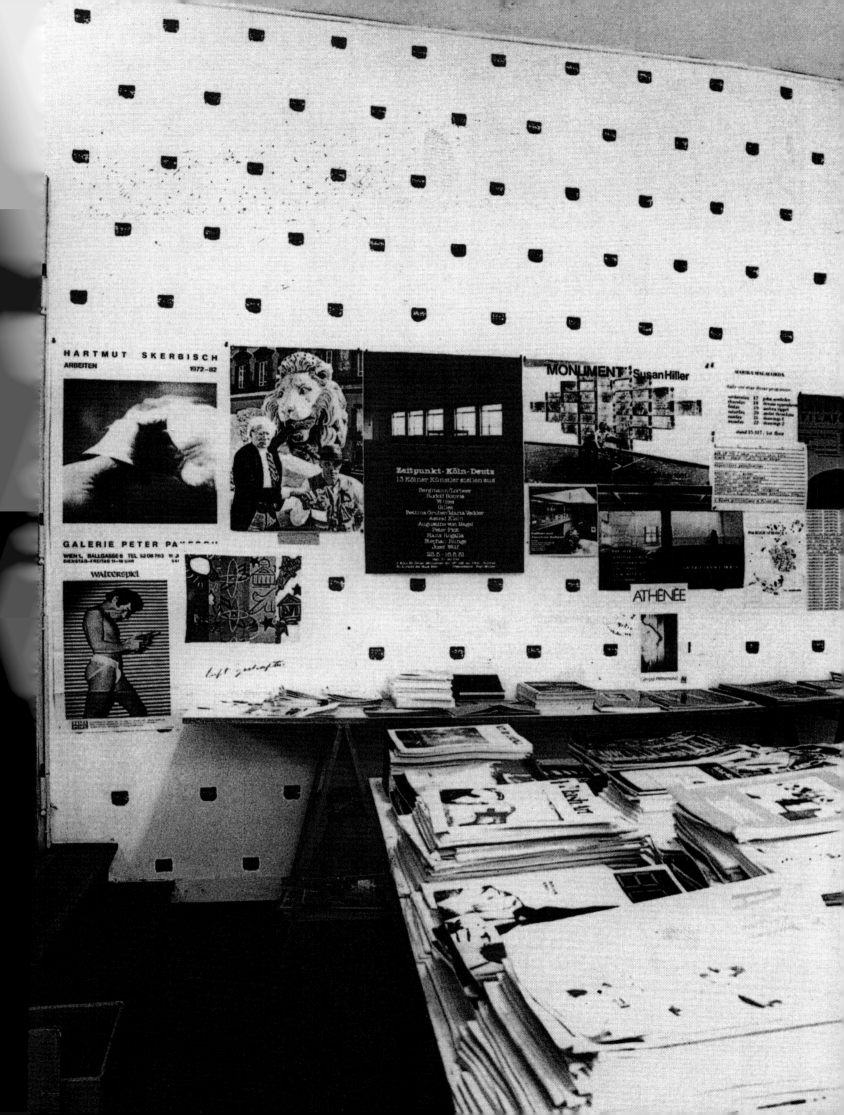

14

15 19 20 23

18 John M Armleder,
Helgi P. Fridjónsson, Dadi Gudbjörnsson
und Kristinn G. Hardarson
THE REX HEADED MASTER
136 x 99 mm, 20 Seiten doppelt gefalzt,
Wachsumdruck, Exemplar 105 / 141
Selbstverlag, Reykjavik, 1982 (o. Abb.)

19 John M Armleder, Björgvin Olafsson, Gudmundur Gudjónsson,
Gudny B. Richards, Hanna K. Hallgrimsdóttir, Harpa Björnsdóttir,
Helgi P. Fridjónsson, Ingiriour Hardardóttir, Margrét Enarsdóttir
Laxness, Sigurour K. Pórisson und Ragna Hermannsdóttir
MECHANICAL THEORICS
295 x 106 mm, 12 Doppelseiten, gefalzt,
Wachsumdruck, Exempar 114 / 150
Selbstverlag (? Reykjavik), 1982

20 John M Armleder, Björgvin Olafsson, Gudmundur Gudjónsson,
Gudny B. Richards, Hanna K. Hallgrimsdóttir, Harpa Björnsdóttir,
Helgi P. Fridjónsson, Ingiriour Hardardóttir, Margrét Enarsdóttir
Laxness, Sigurdur K. Pórisson und Ragna Hermannsdóttir
THEORETICAL MECHANICS
279 x 103 mm, 12 Doppelseiten, gefalzt,
Wachsumdruck, Exemplar 8 / 15
Selbstverlag (? Reykjavik), 1982

21 John M Armleder, Helgi P. Fridjónsson
und Dadi Gudbjörnsson
ONE YEAR LICK
144 x 104 mm, 6 Doppelseiten ungebunden,
Wachsumdruck, Auflage: 175 Exemplare
Selbstverlag Reykjavik - Genève, 1982 – 83 (o. Abb.)

22 John M Armleder, Helgi P. Fridjónsson
und Pór Vigfússon
ONE YEAR NET
142 x 103 mm, 6 Doppelseiten ungebunden,
Wachsumdruck, Auflage: 175 Exemplare
Selbstverlag, Reykjavik-Genève, 1982 – 83 (o. Abb.)

23 **OVERLOADED / PUDDING / OVERDOSE /
OVERDRIVE / OVERRIDE / THE ULTIMATE
PUDDING / THE PUDDING OVERDOSE /
IN THE EYE OF THE PORRIDGE**
149 x 105 mm, Heft mit 4 Doppelseiten,
Umschlag, Blaupause,
Exemplar 5 / 41 (die ersten 5 ungebunden)
L. Bovier & C. Cherix [JRP Editions], Genève 1995
Alle Künstlerbücher wurden für die Ausstellung in Baden-Baden
freundlicherweise vom Cabinet des estampes du Musée d'art
et d'histoire, Genf, zur Verfügung gestellt.

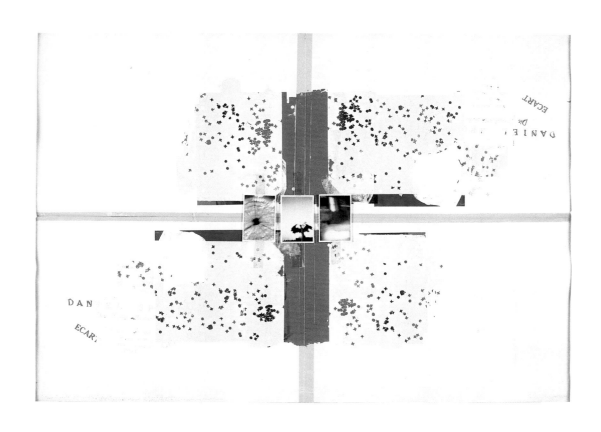

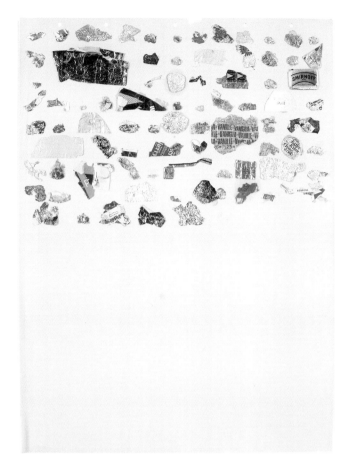

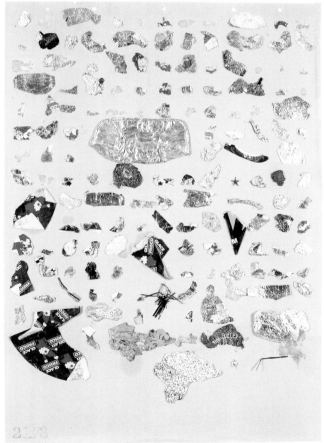

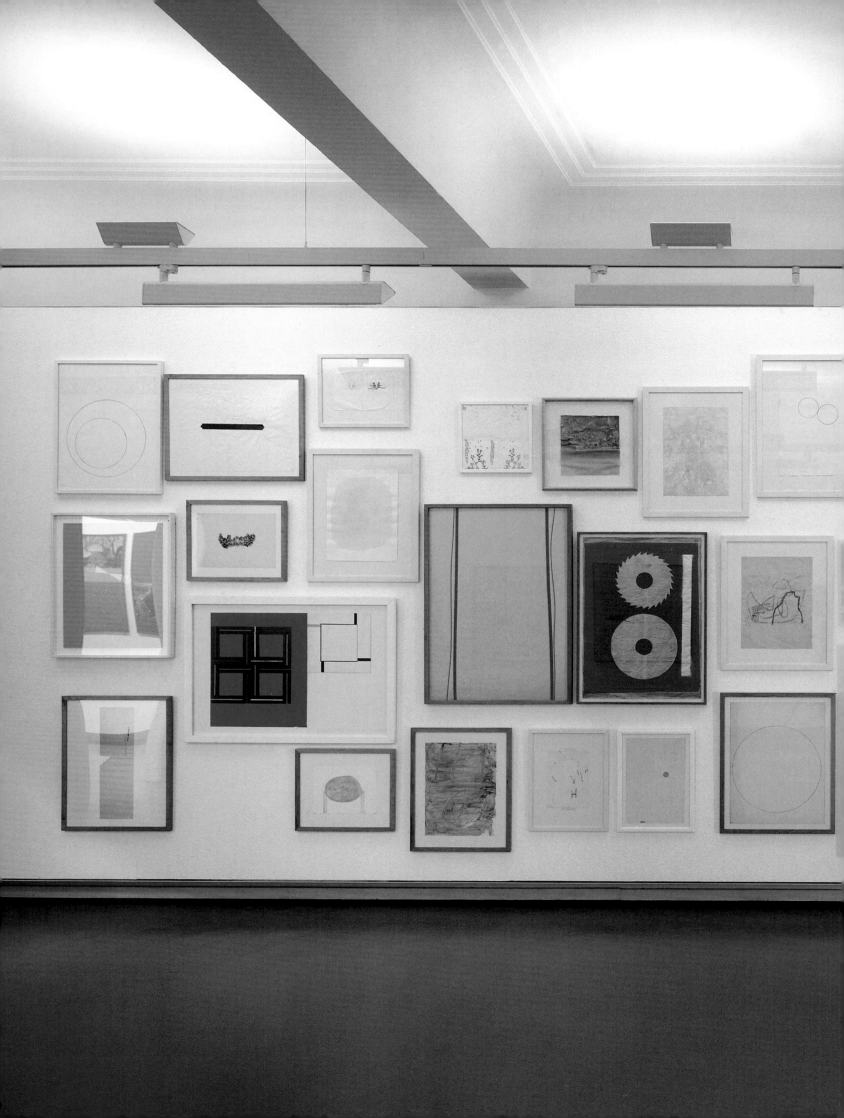

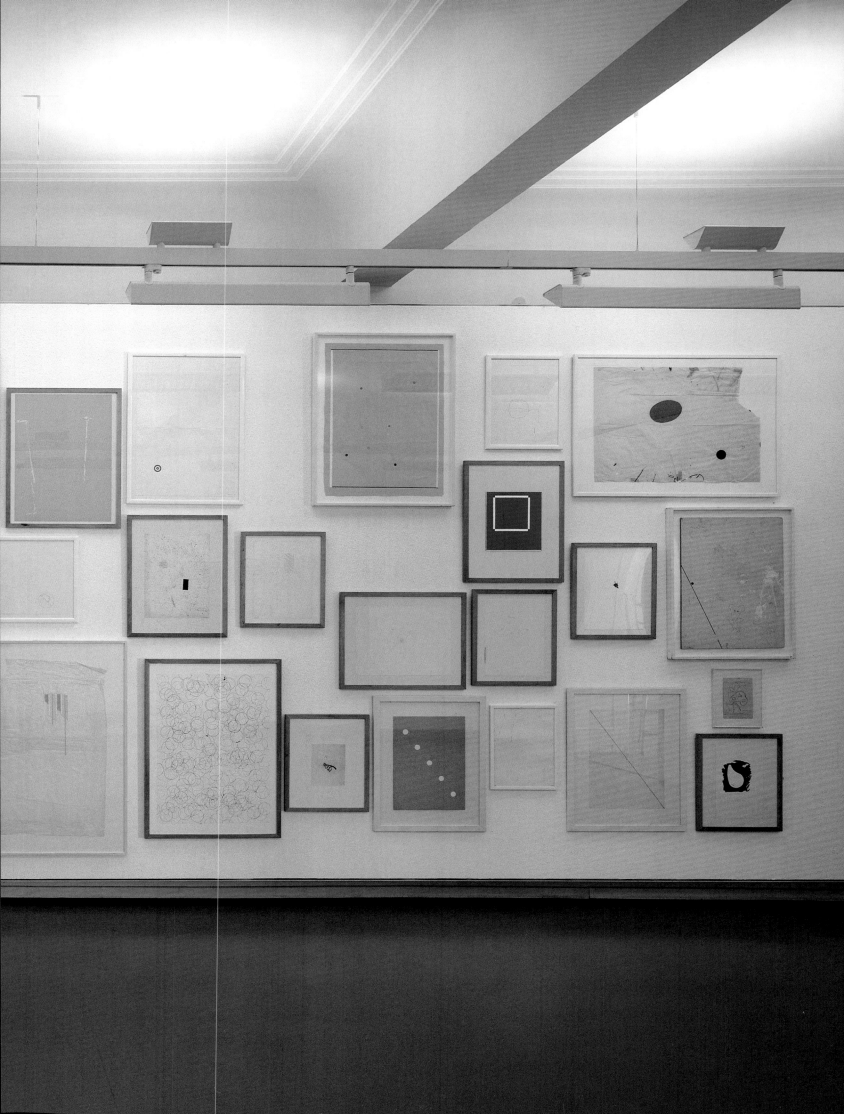

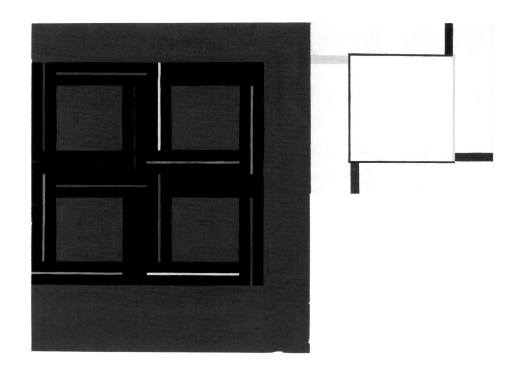

JOHN M ARMLEDER

BIOGRAPHY
EXHIBITIONS
BIBLIOGRAPHY

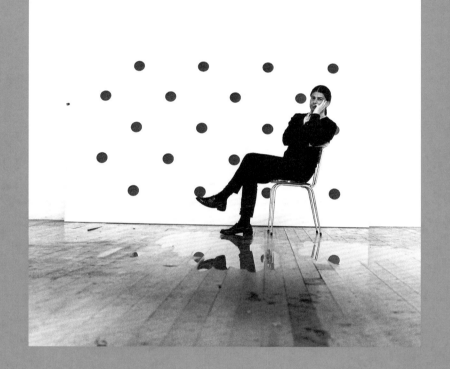

JOHN M ARMLEDER

wurde 1948 in Genf geboren, er lebt und arbeitet in Genf und New York
born 1948 in Geneva, he lives and works in Geneva and New York

EINZELAUSSTELLUNGEN / ONE MAN SHOWS (Auswahl)
* Katalog / Catalog

1973	Galerie Ecart, Genève
	Palais de l'Athénée, Genève*
1975	Galerie Gaëtan, Carouge
1976	Palais de l'Athénée, Genève*
1977	Galerie Marika Malacorda, Genève
1980	Galerie Marika Malacorda, Genève
	Kunstmuseum, Basel*
1982	Musée d'art et d'histoire, Fribourg
	Gangurinn, The Living Arts Museum, Reykjavik
	Galerie Toni Gerber, Bern
	Galerie Marika Malacorda, Genève
	Vitrine Fri-Art, Fribourg
	Nylistasafnid / The Living Arts Museum, Reykjavik
1983	Kunstmuseum Solothurn
	Gymnase cantonal du Bugnon, Lausanne
	Galerie Grita Insam, Wien
	Galerie Rivolta, Lausanne
	Galerie Susanna Kulli, St. Gallen
	Le Coin du Miroir, Le Consortium, Dijon*
1984	Galerie Marika Malacorda bei Ecart, Genève
	John Gibson Gallery, New York
	Galerie Claudia Knapp, Chur
	Künstlerhaus, Stuttgart
1985	Galerie Marika Malacorda, Genève*
	John Gibson Gallery, New York
	Galerie Media, Neuchâtel
	Galerie und Lager Rudolf Zwirner, Köln
1986	Musée d'art et d'histoire, Genève
	Galerie Susanna Kulli, St. Gallen
	Ecole nationale d'art décoratif, Limoges
	Galerie Rivolta, Lausanne
	John Gibson Gallery, New York
	Galerie Tanit, München
	Schweizer Pavillon, 42e Biennale di Venezia*
	Galerie Cathérine Issert, Saint-Paul de Vence
	Galerie Toni Gerber, Bern
	Galerie Bama, Paris
	Lisson Gallery, London*

1987	Piero Cavellini, Milano
	Galerie Vera Munro, Hamburg
	Galerie Daniel Buchholz, Köln
	Galerie nächst St. Stephan, Wien
	Galerie Susanna Kulli, St. Gallen
	Galerie J. F. Dumont, Bordeaux
	Kunstmuseum Winterthur* (Wanderausstellung)
	ARC Musée d'art moderne de la ville de Paris
	Kunstverein für die Rheinlande und Westfalen, Düsseldorf
	Nationalgalerie, Berlin
	John Gibson Gallery, New York*
	Pat Hearn Gallery, New York*
	Daniel Newburg Gallery, New York
	Musée de peinture et de sculpture, Grenoble
	Galerie Marika Malacorda, Genève
	Galerie Tanit, München
	Hoffman Borman Gallery, Santa Monica, CA
	Galerie Joost Declercq, Gent
	Kunstverein Aachen
1988	Galerie Tanit, München
	Daniel Newburg Gallery, New York
	Galerie Kees van Gelder, Amsterdam
	Galerie des Beaux-Arts, Nantes
	Grammo Fine Arts, Antwerpen
	John Gibson Gallery, New York
	Fred Hoffman Gallery, Santa Monica, CA
	Galerie Anselm Dreher, Berlin
	Stichting Nieuwe Musik, Middleburg
	Galerie Marika Malacorda, Genève
1989	Galleria Massimo De Carlo, Milano
	Le Consortium, Dijon
	John Gibson Gallery, New York
	Galerie Marika Malacorda, Genève
1990	Louis Ferdinand Centre d'Art Contemporain, Châteauroux
	Galerie Jean-François Dumond, Bordeaux
	Galerie Sollertis, Toulouse
	Galerie Georges Dezeuze, Montpellier
	Musée Rath, Genève*
	Galerie Vera Munro, Hamburg
	Galerie Catherine Issert, Saint-Paul de Vence
	Galerie Susanna Kulli, St. Gallen
	Galerie Tanit, Köln*
	Galerie Daniel Buchholz, Köln*

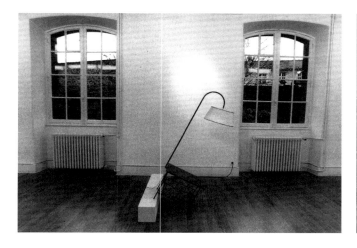

1991 Galerie Paolo Vitolo, Roma*
Galerie Porte-Avion, Marseille
John Gibson Gallery, New York
Daniel Newburg Gallery, New York
Castello di Rivara, Torino
Galerie Kees van Gelder, Amsterdam
Tresor d'Art Gallery, Gstaad
Galerie Marika Malacorda, Genève

1992 »Pour Paintings 89 – 92«, Centraal Museum, Utrecht *
»Works on Paper 66 – 92«, Centraal Museum, Utrecht
Galleria Massimo De Carlo, Milano
Galerie Sollertis, Toulouse
Centre Genevois de Gravure Contemporaine, Genève
Centre Culturel, Dax
Kunstnernes Huus, Oslo (+Artschwager, Bickerton,
 Vercruysse)
Tadei Museo, Pori (idem)

1993 Villa Arson, Nice
»Travaux sur papier 1966 – 1993«,
 Galerie Marika Malacorda, Genève*
Galerie Gilbert Brownstone, Paris
Wiener Secession, Wien*
Galerie Daniel Newburg, New York
Galerie Catherine Issert, Saint-Paul de Vence
Galerie Vera Munro, Hamburg
Centre Genevois de Gravure Contemporaine, Genève

1994 Le Capitou, Centre D'Art Contemporain, Fréjus*
Factory, Genève
Galerie Art et Public, Genève
Galerie Sollertis, Toulouse
Abbaye de Saint-André, Meymac*
»Les assiettes«, Daniel Baumann & CPLY, Thômex, Suisse*
Coop Gallery, Sydney

1995 »L'œuvre multiplié«, Cabinet des estampes, Genève*
La Maison, Douai
Maison de Jeunes, Neuchâtel
Galerie J-F. Dumont c/o Galerie Air de Paris,
 avec la collaboration de la
 Galerie G. Brownstone, Paris
Galerie Jean-François Dumont, Bordeaux
Galerie Massimo De Carlo, Milano
André Sfeir-Semler, Kiel
Schloss Wolfsberg, Ermatingen (Suisse)

1996 Villa Carlotta, Fondation Ratti, Tremezzo*
»Wall painting«, Art & Public, Genève
Galerie Tanit, München
Galerie Sollertis, Toulouse
Galerie 1991 João Graça, Lissabon
Art & Public, Genève
Galerie Susanna Kuli, St. Gallen
ECAL, Lausanne
Territorio Italiano, Piacenza
Galerie 360 Degrés, Tokyo
Gallery Klaus Nordenhake, Stockholm
Le Consortium, Dijon

1997 »Peintures murales« (1967 – 1997)«, La Box, Bourges*
(Idem) Le Parvis, Ibos-Pau
»Perspex Sculptures«,
 Galerie Gilbert Brownstone & Cie, Paris
(Avec) »ECART«, MAMCO + Cabinet des estampes du
 Musée d'art et d'histoire, Genève*

1998 »Arbeiten auf Papier 1967 – 1995«
 Galerie Susanna Kulli, St. Gallen
»Wall Paintings 67 – 98« Casino Luxembourg,
 Forum d'art contemporain*
Galerie Erna Hecey, Luxemburg
Galerie Massimo De Carlo, Milano
Galerie Mehdi Chouakri, Berlin
»AT ANY SPEED – rewind & fast forward show«,
 Staatliche Kunsthalle Baden-Baden*
Ace Gallery, Los Angeles / New York

PREVIEW

1999 ACE Gallery, Los Angeles
Artspace, Auckland, NZ
»AT ANY SPEED – rewind & fast forward show«,
 Holderbank, Aarau, Switzerland*
Anselm Dreher, Berlin
The Box, Torino
1999/ »Works 1967 – 1997«, Galerie Gilbert Brownstone, Paris
2000 ACE Gallery, New York
Galerie Susanna Kulli, St. Gallen, CH
Galleria Massimo De Carlo, Milano
Galerie Tanit, München
Galerie Kees van Gelder, Amsterdam
Le Consortium, Dijon
20.21 Galerie, Essen

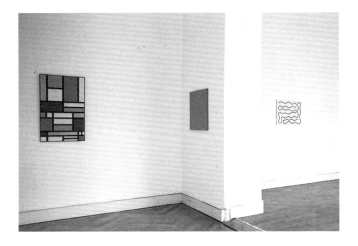

AUSSTELLUNGSBETEILIGUNGEN / GROUPSHOWS

1998 »The Music Box Project«, Tarble Arts Center,
Charleston (Illinois)*
»Immerzeit«, Galerie am Fischmarkt, Erfurt*
»oops«, Magasin CNAC, Grenoble / l'elac, Lausanne*
»Regel und Abweichung«, Musée d'art et d'histoire,
Neuchâtel / Frankfurt Kunstverein, Frankfurt*
»Reservate der Sehnsucht«, Dortmunder U,
Dortmund*
»Métissages«, Musée du Luxembourg, Paris*
»Arrêt sur Image«, Galerie Art & Public, Genève
»Freie Sicht aufs Mittelmeer«, Kunsthaus Zürich /
Schirn Kunsthalle, Frankfurt* (co-curator)
»Suite Substitute III«, Hotel du Rhône, Genève
»Lifestyle«, Kunsthaus Bregenz*
»Weather Everything«,
Galerie für Zeitgenössische Kunst, Leipzig*
»Swiss Contemporary Art«, Sung-Kok Art Museum,
Séoul*
»Fast Forward«, Kunstverein in Hamburg*
»Supérette«, Forde Espace d'Art Contemporain,
Genève
»Losse werken, rake klappen«,
Galerie Kees van Gelder, Amsterdam
»Wall Work«, Trabant, Wien*
»Gravure vous avez dit gravure?«,
Musée Jurassien des Arts, Moutier*
»Le cercle, le ring«, Maison Levanneur, Chatou*
»Poussière (dust memories)«, FRAC Bourgogne, Dijon /
FRAC Bretagne, Galerie du Tub Rennes*
»L'Envers du Décor«, Musée d'art Moderne
Lille Métropole, Villeneuve d'Ascq*
»Fiat Lux!«, Galerie Anselm Dreher, Berlin
Ace Contemporaries, Los Angeles
ART-Itinéraires, Villa Moynier, Genève
»Les Collections d'Art Contemporain«,
Musée de Grenoble, Grenoble
»Painting: Now and Forever – Part I«,
Pat Hearn Gallery / Mathew Marks Gallery, NY
»In Vitro e Altro«, Cabinet des estampes du Musée
d'art et d'histoire, Genève

»Dramatically Different«, Centre National D'art
Contemporain de Grenoble*
»dijon / le consortium.coll –
tout contre l'art contemporain«
Centre Georges Pompidou, Paris*
»La Collection«, Le Consortium / L'Usine /
FRAC Bourgogne, Dijon
»Addressing the Century / 100 years of Art and
Fashion, Hayward Gallery, London*
»Editions de l'école cantonale d'art
de Lausanne 1995 – 1997«, l'elac, l'espace
lausannois d'art contemporain
»Si je t'attrape ... « Galerie Catherine Issert,
Saint-Paul de Vence

AUSSTELLUNGSKATALOGE (Auswahl)

**JOHN M ARMLEDER
891 UND WEITERE STÜCKE**
Kunstmuseum Basel 1980
Text: Dieter Koepplin

**JOHN M ARMLEDER
ARBEITEN AUF PAPIER,
1962 – 1983**
Kunstmuseum Solothurn,
Graphisches Kabinett
26. März – 23. Mai 1983
Text: André Kamber,
Christoph Schenker

**JOHN M ARMLEDER
SUCCÈS DU BEDAC**
Le coin du miroir, Dijon
Bureau d'étude et de diffusion
de l'art contemporain
Le Consortium, Centre d'art
contemporain, Dijon
25. April – 14. Mai 1983
Text: Jean-Hubert Martin

**JOHN M ARMLEDER –
PEINTURE 1985**
Galerie Maria Malacorda, Genève
Text: John M Armleder

**JOHN M ARMLEDER
BIENNALE DE VENISE**, 1986
Pavillon Suisse
Hrsg. Office fédéral de la culture ,
Bern 1986
Text: Bernhard Bürgi

**JOHN M ARMLEDER
PAINTINGS AND FURNITURE
SCULPTURES**
Lisson Gallery, London
10. Oktober – 8. November 1986
Text: Stuart Morgan

JOHN M ARMLEDER
Wanderausstellung:
Kunstmuseum Winterthur;
Kunstverein für die Rheinlande und
Westfalen, Düsseldorf;
ARC, Paris; Nationalgalerie Berlin,
April – Oktober 1987
Hrsg. Dr. Dieter Schwarz,
Kunstmuseum Winterthur
Text: Maurice Besset,
Dieter Schwarz
Interview: Suzanne Pagé

JOHN M ARMLEDER
Musée de Peinture, Grenoble
Grenoble, 1987

**JOHN M ARMLEDER
FURNITURE SCULPTURES,
1980 – 1990**
Musée Rath, Genève
3. Mai – 24. Juni 1990
Hrsg. Musée d'art et d'histoire,
Genève
Text: Charles Goerg, Claude
Ritschard, John M Armleder

**JOHN M ARMLEDER
VERZEICHNIS DER
AUSGESTELLTEN ARBEITEN,
1982 – 1990**
Hrsg. Daniel Buchholz, Köln
Galerie Tanit München - Köln, 1990

JOHN M ARMLEDER 1990
Hrsg. Daniel Buchholz, Köln
Galerie Tanit München - Köln, 1990

JOHN M ARMLEDER
Galleria Paolo Vitolo, Roma
Januar – Februar 1991
Text: Paolo Vitolo

**JOHN M ARMLEDER
POUR PAINTINGS,**
1982 – 1992
Centraal Museum Utrecht
1. Februar – 23. März 1992
Hrsg. Centraal Museum Utrecht, 1992
Text: Ellen de Bruijne

JOHN M ARMLEDER
Wiener Secession, 1993
7. April – 16. Mai 1993
Text: Markus Brüderlin
Gespräche John M Armleder und
Helmut Federle (1984/1985),
Briefinterview von Doris Rothauer
Two Taped Conversations: Alistair
Setton, Derek Barley and John
Armleder / Jack Flasten and John
Armleder, March 1993

**SYLVIE FLEURY UND JOHN M
ARMLEDER**, 1994
Hrsg. Kunsthalle Palazzo, Liestal
Muttenz, Basel, 1994
Text: Philip Ursprung, Hedy Graber

JOHN M ARMLEDER
le capitou – Centre d'art
contemporain de Fréjus
3. Juli – 21. August 1994
Hrsg. le capitou, Ville de Fréjus,
Mailand 1994
Text: Jean-Michel Foray, Christian
Besson, Nicolas Bourriaud,
Catherine Pulfer

Weitere Publikationen von und zu
John Armleder:

**JOHN ARMLEDER / HELMUT
FEDERLE / OLIVIER MOSSET –
ECRITS ET ENTRETIENS**
Hrsg: Yves Aupetitallot, Alain
Coulange, Serge Lemoine
Maison de la Culture et de la
Communication, Saint Etienne,
Musée de Peinture et de Sculpture,
Grenoble, 1987

NEVER SAY NEVER. ART TODAY
John M Armleder (Hrsg.)
Ein Jubiläumsgeschenk der
Providentia, Schweizerische Lebens-
versicherungs-Gesellschaft, Nyon
Text: John Armleder, Lionel Bovier,
Markus Brüderlin, Christophe
Cherix, Emmanuel Grandjean, Daniel
Kurjakovic, Michelle Nicol, Hans-
Ulrich Obrist, Christoph Schenker
Gespräch: John Armleder, Cristina
Farwood and Parker Williams

**JOHN M ARMLEDER
CORSO SUPERIORE DI ARTE
VISIVA / ADVANCED COURSE
IN VISUAL ARTS**
Fondazione Antonio Ratti, Como,
1997
Hrsg: Anna Daneri, Giacinto Di
Pietrantonio, Angela Vettese
Text: John Armleder, Anna Daneri,
Giacinto Di Pietrantonio,
Angela Vettese, u.a.
Gespräch: John Armleder und
Parker Williams

**L'IRRÉSOLUTION COMMUNE
D'UN ENGAGEMENT ÉQUIVOQUE**
Ecart, Genève, 1969 – 1982
Hrsg: Lionel Bovier / Christophe Cherix
Mamco et Cabinet des estampes du
Musée d'art et d'histoire,
Genève, 1997
Text: Jean-Christophe Ammann,
John Armleder, Anna Banana,
Christian Besson, Lionel Bovier &
Christophe Cherix, Giuseppe Chiari,
Adelina von Fürstenberg, Dick
Higgins, Rainer Michel Mason,
Olivier Mosset, Cathérine Quéloz,
Dieter Schwarz

I'VE ALWAYS BEEN WONDERING
Hrsg: Margrit Brehm
Staatliche Kunsthalle Baden-Baden,
1998
Text: Axel Heil

»I am interested in all the ways it's possible to make works disappear.
Abusing one's own production is a solution,
misusing statements by others as well perhaps.«

JOHN M ARMLEDER AT ANY SPEED

UNTITLED, 1978 / 1989
Tinte, Bleistift, Papier, 63 x 48 cm
Courtesy Galerie Vera Munro, Hamburg
UNTITLED, 1980 – 1983
Acrylfarbe, Fettkreide, Bleistift, 57 x 17,5 cm
Courtesy Art & Public, Genf
UNTITLED, 1981
Gouache, Offset, 29,5 x 21 cm
Courtesy Art & Public, Genf
UNTITLED, 1981
Gouache, 31 x 28,4 cm
Collection A. L'H.
UNTITLED, 1982
Gouache, Lack auf Serviette, 33 x 33 cm
Courtesy Susanna Kulli, CH – St. Gallen
UNTITLED, 1982
Öl, Papier, 49 x 66 cm
Courtesy Galerie Vera Munro, Hamburg
UNTITLED NO. 18, 1983
Bleistift, Gouache auf Pappkarton, 64,1 x 49,5 cm
Courtesy Art & Public, Genf
UNTITLED, 1983
Mixed Media, Papier, 84 x 60 cm
Courtesy Art & Public, Genf
UNTITLED, 1991 – 93
Gouache, Tinte, Papier, 70,5 x 50,5 cm
Courtesy Galerie Vera Munro, Hamburg
UNTITLED, 1993
Tinte, Papier, 76,5 x 57 cm
Courtesy Galerie Vera Munro, Hamburg
UNTITLED, No. 3, 1994
Collage, 97,5 x 68,5 cm
Courtesy Art & Public, Genf
UNTITLED, o. J.
Encre de Chine, Papier, 24 x 29 cm
Courtesy Art & Public, Genf
SHOTS, NO DOTS, 1976 – 96
3 Computerprints, 40 x 100 cm
hARTware projekte e.V., Dortmund
UNTITLED ("36"), 1998
Transparentes, fluoreszierendes
Perspex "light green"
mit Serigraphie (weiß), 100 x 100 cm
Auflage: 5 Exemplare +1EA
Fluid Contempo Editions, Basel

**Leihgaben aus dem Cabinet des estampes
du Musée d'art et d'histoire, Genf:**

UNTITLED, (PLAFOND), 1994
Siebdruck, 90 x 90 cm
Auflage: 24 Abzüge + 5EA + 1HC
Galerie Sollertis, Toulouse
UNTITLED (FS 255), 1990
Rote Rettungsboje, 48,5 x 28 x 13,5 cm
Auflage: 24 Exemplare + 5 EA, Exemplar 19 / 24
Porte-Avion éditeur, Marseille
UNTITLED, 1997
3 Farbphotographien je: 70 x 70 cm
Auflage: 13 Exemplare, Exemplar 11 / 13
Ecole cantonale d'art, Lausanne
UNTITLED (SPLASHES), 1994
Siebdruck, 5 Blätter, je: 100 x 100 cm
Auflage: 12 Abzüge + 2EA + 1HC
Galerie Sollertis, Toulouse
UNTITLED, 1988
Plüsch, Schaumstoff, 40 x 48 cm,
Exemplar 16 / 30
Edition van Gelder, Amsterdam
UNTITLED (EDITION FÜR PARKETT), 1997
Transparentes, fluoreszierendes Perspexblatt
23 x 36 x 15,2 cm,
Auflage: 50 Exemplare, Exemplar 16 / 50
DIEU EXPULSÉ DU PARADIS, 1976
John M Armleder und Claude Rychner
Leathern Wing Scribble Press, vol. XXIX, n° 7
Durchsichtige Plastikdose, Naphtalinekugeln, maschinen-
geschriebenes Doppelblatt,
15,7 x 5,8 x 5,8 cm (Dose)
Einziges bekanntes Exemplar einer geplanten Auflage von 10
WHATEVER BY WHOEVER (extended version), 1994
14 Leer-Kassetten und -Disketten in Plexiglaskasten
25,6 x 17,2 x 13,8 cm (Kasten),
Auflage: 50 Exemplare
Art & Public, Genève, Exemplar 10 / 50
OLIVIERS'S REJECTS, 1994
Blatt einer Folge von 11 Abzügen
Aquatinta, Papierschnitt auf Papier,
41,2 x 40,2 cm
UNTITLED, 1987
Rot lackierte Metallscheibe, Durchmesser: 12 cm
Auflage: 30, Exemplar AP 1 / IV, Vice Verlag, Remscheid
ARDOR, 1992
Automatische Wärmeplatte, Karton,
Durchmesser: ca. 19,5 cm
Auflage: 111 Exemplare, Exemplar 19 / 24
Massimo De Carlo, Mailand
UNTITLED, 1988
3 Porzellanteller, Winterling, 20 cm, 22 cm, 25 cm
Unbeschränkte Auflage
Saint-Paul de Vence, éditions Catherine Issert
PHILOSOPHIE UND JURISPRUDENZ, 1993
Stoff orig. Wiener Werkstätten, verschiedene Bildmaterialien,
Pizzakarton, 32,5 x 32,5 x 3 cm
Auflage: 150 Exemplare, Exemplar 11 / 111
Wiener Secession, Wien
UNTITLED, 1994
Spiegelscheibe, Durchmesser: 12 cm
Auflage: 30 Exemplare + 1EA,
Deichtorhallen Hamburg
Exemplar 22 / 30

AUTOREN | AUTHORS

(in order of appearence)

MARGRIT BREHM
Acting director of the Staatliche Kunsthalle Baden-Baden. Margrit Brehm majored in art history and literature at the universities in Freiburg, Vienna and Rome, subsequently writing her doctorate on Caravaggio's "Fortuna Critica." The complex patterns of art reception – and particularly the reception of art by art – form one focus of the exhibitions she has curated and essays she has written on contemporary art. Her publications include works on Chuck Close, Mat Collishaw, Tracey Emin, John Isaacs, Alex Katz, Pipilotti Rist & Samir, Cindy Sherman and Richard Tuttle.

PARKER WILLIAMS
(born 1952, lives in Taos and Seattle). Parker Williams studied with Buckminster Fuller and Allan Watts, and is an independant writer. He founded the garage-punk-rock-band "Snow Peas in Tutus" that hit the charts in Minneapolis in 1978. His interest in foam sculptures of the sixties and the seventies and perspex material made him a specialist in restoring these works after having published the seminal study "Foam, Rubber, Dunlopino in Art Today". He has been conducting interviews with artist John Armleder on various fields of interest over fifteen years. "The Botanical Speedboat ..." was first published in "John M Armleder", Fondazione Ratti, Como 1997.

GIACINTO DI PIETRANTONIO
Professor of Art History at Brera Academy and Domus Academy in Milan. Curator at Fondazione Antonio Ratti, Como. He owns and runs GLOBAL VISION *Giacinto Di Pietrantonio Productions*, an agency for contemporary art which he founded in 1996. He also works as an independent curator and art critic for Flash Art Magazine. He is editor and founder of the discussion magazine PERCHE/? – WHY/?

AXEL HEIL
Artist, freelance curator and writer. In his work as indirect associate of the World Society for Futile Pastimes, he specializes in the strategy of the Great Water-Bearer. Since 1990 he realized several editions, is still executive producer of the "Institut für die Beobachtung von Abdingbarem" (Institute for the Observation of Futilities) and wrote the book on the permanent setup, or the indespensable component, or the thoroughly unshakeable nature.

LIONEL BOVIER
Independent writer and curator. Lionel Bovier is Professor for Art History at the Ecole cantonale d'art de Lausanne. He has published several texts in exhibition catalogues and in magazines such as Flash Art, Documents, or Parkett. Co-founder and director of JRP Editions based in Geneva.

CHRISTOPHE CHERIX
Writer and curator attached to the Cabinet des estampes of the Musée d'art et d'histoire of Geneva. He mounted there several retrospectives devoted to Mel Bochner, Robert Morris, Maurizio Nannucci or John M Armleder. He regularly contributes to Documents, among other publications and founded JRP Editions with Lionel Bovier.

PHOTOGRAPHIC CREDITS

We wish to thank the owners and custodians for permitting the reproduction of the works of art in their collections. The photographers – as far as known – whose courtesy is gratefully acknowledged, are listed alphabetically below.

John Armleder, Susannah Bosanquet, Jean Brasille, Margrit Brehm, Lila Cambanis, Catherine Ceresole, Barbara Deller-Leppert, François Fernandez, Sylvie Fleury, Egon von Fürstenberg, Ed Glendinning, Axel Heil, Alain Humerose, Ilmari Kalkkinnen, Image Nuit Blanche – François Lagarde, Serge Lemoine, Franz Mäder, Giorgio Mussa, Susan Ormerod, Georg Rehsteiner, Fabrizio Rovesti, Jean-François Schlemmer, Lothar Schnepf, Beatrice Schoppmann, snuk studio (Hamburg), Marc Vanappelghem, Daniel Vittet (Genf), Roger Vuilliez, Jens Ziehe (Berlin).

All photographs taken in Baden-Baden, if not otherwise mentioned: Heinz Pelz, Karlsruhe

Die Deutsche Bibliothek – CIP-Einheitsaufnahme

John M. Armleder – at any speed / ed. by Margrit Brehm [Conception of the catalogue: Axel Heil. Transl.: Albert Beedi …]. – Ostfildern: Cantz, 1999
Ausstellungskatalog
ISBN 3-89322-970-1

FONDATION NESTLÉ POUR L'ART

IMPRESSUM / IMPRINT

JOHN M ARMLEDER *at any speed*

Editor: Margrit Brehm

The exhibition in Baden-Baden and Holderbank was curated by Margrit Brehm
Final Arrangement: John Armleder
Installation: Hans-Peter Steurer

Conception of the catalogue: Axel Heil
Graphic design: Torsten Schmitt, Ilona Hirth
Translations: Albert Beedi, Margrit Brehm, Mary Fran Gilbert & Keith Bartlett, Charles Penwarden, Hinrich Sachs, Fumiko Wellington
Scans, Colour reproductions: HWD M. Vogel
Printed by Dr. Cantz'sche Druckerei, Ostfildern-Ruit

Published by Hatje Cantz Publishers
Senefelderstraße 12
D-73760 Ostfildern-Ruit
Tel. 0049/711/44050
Fax 0049/711/4405220
Internet: www.hatjecantz.de

Distribution in the US
D.A.P., Distributed Art Publishers, Inc.
155 Avenue of the Americas, Second Floor
USA-New York, N. Y. 10013-1507
Tel. 001/212/6271999
Fax 001/212/6279484

ISBN 3-89322-970-1

Printed in Germany

»Somehow I'm by nature available...
I mean I don't believe in a strategy which would explain my work,
would frame it or position it. There is no place I want to be.
There are no wrong places to put me.«